VISION AND ART

VISION AND A

ART

THE BIOLOGY OF SEEING

BY MARGARET LIVINGSTONE
FOREWORD BY DAVID HUBEL

ABRAMS, NEW YORK

Project Manager: Eric Himmel
Editor: Sharon AvRutick
Designer: Helene Silverman
Photo Research: Laurie Platt Winfrey, Peter Tomlinson, Carousel Research, Inc.

Library of Congress Cataloging-in-Publication Data

Livingstone, Margaret.
 Vision and art : the biology of seeing / by Margaret Livingstone.
 p. cm.
 Includes bibliographical references and index.
 ISBN 978-0-8109-9554-3
 1. Visual perception. 2. Color vision. 3. Painting–Psychology. I. Title.

N7430.5 .L54 2002
750.1'8—dc21

 2001046508

Original hardcover edition published in 2002

Printed and bound in China
10 9 8 7 6 5 4 3 2

HNA ▮▮▮▮▮
harry n. abrams, inc.
a subsidiary of La Martinière Groupe
115 West 18th Street
New York, NY 10011
www.hnabooks.com

Pages 2–3: Jean-Auguste-Dominique Ingres. *Princess Albert de Broglie, née Joséphine-Eléonore-Marie-Pauline de Galard de Brassac de Béarn (1825–1860)*. 1853. Oil on canvas, 21.3 x 90.8 cm. The Metropolitan Museum of Art, Robert Lehman Collection

TO MY SONS,
David, Dwight, and Bevil

contents

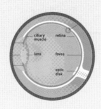

 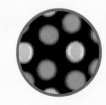

MARGARET LIVINGSTONE and I have been colleagues for over twenty-five years. We collaborated, like a team of horses pulling a sled, for the first fifteen years, and since about 1990 we have worked independently in adjacent laboratories, sharing graduate students and postdoctoral fellows, and carrying on a continuous dialogue about our science. Given Marge's longstanding interest in art and its relation to visual neurobiology, it has been natural for her to ask whether what we have learned about visual science in the last few decades can lead to a deeper understanding of the visual arts. Her work in vision has covered all the main aspects of visual neurobiology, including movement, depth perception, color, and form.

Over the last fifty years our knowledge of how the brain interprets the information it receives from the eyes has made huge strides, largely because for the first time we have had the tools to ask the appropriate questions. Among these tools are the microelectrode, which allows us to listen in on the activity of single cells in the brain; electronic apparatus that lets us amplify and record these signals; and new techniques in neuroanatomy, which make it possible to know how the cells are interconnected. We now know, in broad outline if not in full detail, how the brain begins to deal with the basic components of vision. Our appreciation of the visual arts can only be deepened by such knowledge. In the future, visual neurobiology will enhance art in much the same way as a knowledge of bones and muscles has for centuries enhanced the ability of artists to portray the human body.

This relationship between art and present-day science would be just a vague and unrealistic dream if visual neurobiology were a subject so abstract and highly evolved as to be out of reach for someone not thoroughly trained in science and mathematics. Luckily our science is not abstruse, in the way that relativity or quantum mechanics is. I have never had the least doubt that given two hours I could make anyone with a good high-school education fully aware of the main accomplishments of the last half-century of visual science. I once gave a private lecture in neurobiology to Françoise Gilot (of Picasso fame) and from her questions it was clear that she fully grasped everything I was saying, including concepts such as receptive fields and complex cells. The possibility of communicating our science to our friends and neighbors is exhilarating, and in many ways I feel sorry for my friends in physics, whose lives must be relatively lonely.

Given how easy it is to convey these ideas, it seems unfortunate that people in general and artists in particular should be so insulated from them. This is largely our fault for not taking more time to communicate, and perhaps for assuming that the ideas will not be comprehensible to those outside our field. Here are two examples of things most people don't know: In an article having to do with weaving I once read that a yellow warp plus a blue weft gives a green cloth—even though since Newton's time, in the 1600s, we have known that what you get is white or gray. And most people seem to regard a charcoal drawing or a black-and-white movie as something artificial and out of the reach of our normal experience, whereas our vision in dim light *is* black-and-white, and consequently color blindness *is* part of everyday—or everynight—experience.

This is not to say that we now have a sufficiently deep or incisive understanding of visual science to explain why a Vermeer is superior to an everyday newspaper cartoon. Our knowledge of visual science is rudimentary; it goes as far as three or four stages of visual cortex, whereas we know that there are at least several dozen further stages in the occipital lobes alone, none of which are yet explored. We know about some of the early building blocks of vision, much more than we did fifty years ago, but we still have no idea of what happens in the brain when we recognize a hat, a safety pin, or a boat, or when we look at a painting that has intense emotional content. But we are beginning to understand some elementary things fairly well: why yellow plus blue light makes white, why equiluminant colors shimmer, why a black object remains black whether seen in dim light or on the beach.

The book you are about to read answers some of these questions. It also makes the point that art depends ultimately on our brains and that by understanding what goes on in our brains when we look at a work of art we can hope to deepen our appreciation of both the art and the science. That the two are so separated is an artificial product of the way our knowledge is subdivided in academic circles. One of the purposes of this book is to overcome the separation, and no one is more capable of starting the process than Margaret Livingstone.

DAVID HUBEL

I AM A NEUROPHYSIOLOGIST. I spend my time investigating why some nerve cells in our visual systems are sensitive to color whereas others are not. In the process I have become particularly interested in something that artists have been aware of for a very long time: that color and luminance (or lightness) carry different kinds of visual information.

The elements of art have long been held to be color, shape, texture, and line. But an even more fundamental distinction is between color and luminance. Color (in addition to reproducing objects' surface properties) can convey emotion and symbolism, but luminance (what you see in a black-and-white photograph) alone defines shape, texture, and line. Pablo Picasso described it aptly in a letter to the poet Guillaume Apollinaire: "Colors are only symbols; reality is to be found in lightness alone."

While most people are comfortable talking about color, luminance—even though it is more fundamental—seems less familiar. Given two patches of gray, it is easy to say which is lighter, but given two colors, it is often difficult to make such a distinction. Artists, however, must learn to distinguish differences in luminance independent of color. "If one is not able to distinguish the difference between a higher tone and a lower tone, one probably should not make music. If a parallel conclusion were to be applied to color, almost everyone would prove incompetent for its proper use," wrote artist and art teacher Josef Albers. "Very few are able to distinguish higher and lower light intensity (usually called higher and lower value) between different hues. . . . Only a minority can distinguish the lighter from the darker within close intervals when obscured by contrasting hues or by different color intensities."

In this book I will explore luminance and color, from the physics of light to information processing in the brain. Then I will examine how the neurophysiological differences between the color and luminance pathways can elucidate the different roles color and luminance play in art. The research I've been involved in shows that color and luminance do carry quite different kinds of visual information, and those differences can explain how color and luminance can play such different roles in art. Throughout, I will analyze how various works of art reflect different properties of our visual system. I will draw most heavily from the work of Impressionist artists because they developed many techniques whose effects derive from the parallel architecture of our visual systems.

Of course our visual systems do not process color and luminance separately in order to see illusions in art, but rather for evolutionary reasons. Other scientific observations about the way our brains work can explain such things as why a concept like "line" is so fundamental in art, when in natural scenes there are no lines.

We will explore these—and many other phenomena related to light and vision as well as color and luminance—in the chapters that follow.

TWO PEOPLE, Bevil Conway and Sharon AvRutick, contributed substantially to this book. Bevil was my graduate student and is now a postdoctoral fellow. He is an artist and a scientist, a rare combination; many of the ideas, or clarifications of ideas, in this book arose from discussions I had with him. Sharon edited this book. If you tore up all the pages, tossed the fragments in the air, and then read them as you picked them up, you'd have some idea of what she started with. All the dashes are hers. Thanks to Helene Silverman for doing such a wonderful job with the layout.

John Shearman, Roy Perkinson, Elizabeth Panzer, and Michael Fisher kept me from making more stupid mistakes about art history than I have. Wade Regehr and David Hubel caught some of the mistakes I made about science. Thanks to Eric Himmel for making me read Gombrich. The Mind Brain Behavior Initiative made it possible for Bevil and me to go to Paris and measure the luminance of the sun in *Impression Sunrise*.

Special thanks to Mei Tseng.

1:

FIAT LUX:
LET THERE BE LIGHT

YOU MAY BE SURPRISED, or perhaps chagrined, to find that this book about art begins with a chapter on physics. This book is actually about the science of vision—the process of receiving and interpreting light reflected from objects—and what it can tell us about how artists achieve various effects. To enable you to get the most from what I've written, this first chapter will refresh your knowledge about the nature of light, what makes colored objects colored, and how different ways of generating light can produce vastly different mixtures of wavelengths. As the nineteenth-century English physicist Thomas Young said, "The nature of light is a subject of no material importance to the concerns of life or to the practice of the arts, but it is in many other respects extremely interesting."

LIGHT

As early as the fifth century BC the Greeks recognized that there had to be some kind of link between the eye and objects seen. The nature of this link (which we now know is light), along with the most basic facts about vision, however, eluded people for thousands of years. Some schools of thought held that there was an emission, or fire, emanating from the eye that traveled to and palpated the object seen. Others favored the inverse: that objects seen emitted a substance that traveled into the eye. And a third faction suggested that both sorts of emissions existed; when they met, it was said, vision resulted. In the fourth century BC Aristotle rejected the idea of a visual fire emanating from the eye, because, he asked, "If vision were produced by means of a fire emitted by the eye,

Opposite: The electromagnetic spectrum comprises all energy that moves at the speed of light. In this diagram wavelength and frequency of the electromagnetic spectrum are on the left and right axes, respectively. The different classes of energy are indicated for each region of the spectrum, with some familiar items for length comparison (left). Visible light is a relatively narrow region of the entire electromagnetic spectrum.

THE ELECTROMAGNETIC SPECTRUM

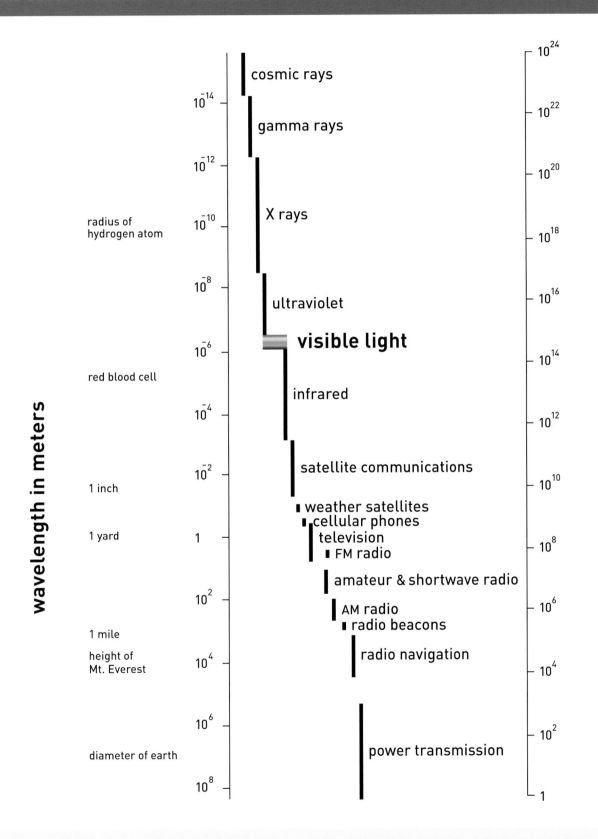

wavelength in meters

frequency in cycles per second (Hz)

cosmic rays

10^{-14}

gamma rays

10^{-12}

X rays

radius of
hydrogen atom
10^{-10}

10^{-8}

ultraviolet

10^{-6} **visible light**

red blood cell

infrared

10^{-4}

satellite communications

1 inch
10^{2}

weather satellites
cellular phones
1 yard 1
television
FM radio

amateur & shortwave radio

10^{2}

AM radio
radio beacons

1 mile

height of
Mt. Everest
10^{4}

radio navigation

10^{6}

diameter of earth

power transmission

10^{8}

10^{24}

10^{22}

10^{20}

10^{18}

10^{16}

10^{14}

10^{12}

10^{10}

10^{8}

10^{6}

10^{4}

10^{2}

1

like the light emitted by a lantern, why then are we not able to see in the dark?"

The Arab physicist Alhazen in around AD 1000 concluded from experimental observations that light actually travels into the eye. The first observation was that "the eye, when looking at a very strong light, feels pain and may be damaged." The second was that the eye registers an afterimage after looking at a bright light. Nevertheless, five hundred years later, at the time of Leonardo da Vinci, the idea that rays emanate from the eye to palpate the viewed object was still prevalent enough that Leonardo objected, "It is impossible that the eye should send the power of vision outside itself through visual rays, because, on opening the eye from whence such rays must depart, the power of vision could not reach out to the object without a lapse of time. This being so, the rays could not climb in a month to the height of the sun, when the eye wished to see it."

In 1604 Johannes Kepler first elaborated the modern idea that light is emitted by sources like the sun and is then reflected from objects into the eye. He thought that light is intrinsically colorless but is "broken" and becomes colored when it encounters a colored object. His contemporary Galileo nevertheless felt that no one yet really understood the nature of light. "I have always considered myself unable to understand what light was," he said, "so much so that I would readily have agreed to spend the rest of my life in prison with only bread and water if only I could have been sure of reaching the understanding that seems so hopeless to me."

A major leap in the understanding of light came in 1672 with the work of Isaac Newton. He darkened a room by closing his window shutter, and then he made a small hole in the shutter. He put a triangular piece of glass in the sunbeam passing through the hole and discovered that such a prism divides white light into various colors, which he called "variously refrangible" (that is, they were bent to a greater or lesser degree by the prism). He discovered that the color of a beam of light is a permanent feature of that light; it cannot be further broken into some other color. He also discovered that colored lights can be recombined to yield white light.

The nature of light was hotly disputed in Newton's time, in particular the question of whether it was formed of particles or waves. Some of Newton's results, such as the variable bending of different colors of light by prisms, suggested that light had characteristics of waves, but the fact that light does not bend around obstacles in the manner of sound or water waves was thought to favor a particulate nature. Newton, sensibly, presented evidence supporting both hypotheses and tried not to be definitive. Still, in his great work *Opticks*, published in 1704, he came down marginally in favor of the particle ("corpuscle") theory of light, and he proposed that the different colors of light have different masses. Though Newton had reservations about his conclusion, because of his stature, the corpuscular theory reigned supreme for a hundred years.

The ascendance of the wave theory, however, was eventually brought on partly by experiments Newton himself had performed. In 1802 Thomas Young carefully pointed out that despite Newton's ultimate preference for the corpuscular theory, he had recognized that light must have some characteristics of "undulations" or must somehow induce "vibrations" in the "æther" it passed through. Newton had extended observations first made by Robert Hooke (the inventor of the compound microscope) on the brilliant colors often seen in thin films of water or oil and found that the colors varied systematically with the thickness of the film. Young argued that this indicated that light was

WAVELENGTHS IN DAYLIGHT AND FLUORESCENT LIGHT

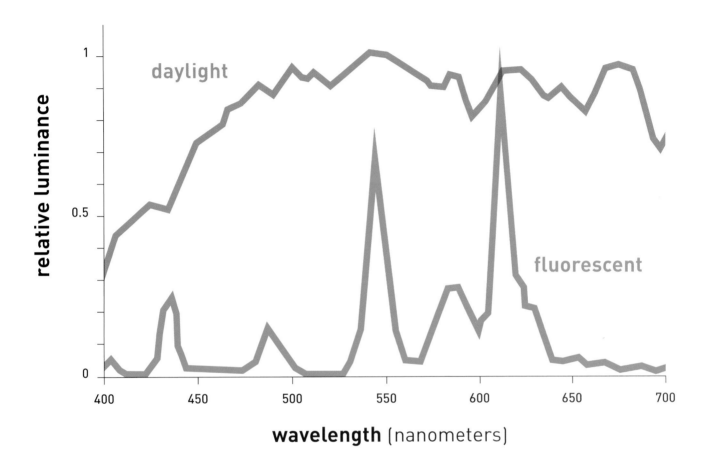

wavelike in character. In 1802 it was almost sacrilegious to suggest that Newton, who by that point was synonymous with the particulate theory, might have been wrong about something. Despite the fact that Young lauded Newton throughout his treatise, the wave hypothesis was initially very unpopular. British statesman Henry Brougham harshly reviewed Young's ideas: "It is difficult to deal with an author whose mind is filled with a medium of so fickle and vibratory a nature . . . ; We now dismiss . . . the feeble lucubrations of this author, in which we have searched without success for some traces of learning, acuteness, and ingenuity, that might compensate his evident deficiency in the powers of solid thinking." But in the end Young's logic prevailed. By the mid-nineteenth century other scientists had provided strong evidence that light consists of waves.

In 1905 Albert Einstein postulated that the wave theory of light might be incomplete, and that light has some characteristics of particles after all. He proposed that there are indivisible units (or quanta) of light energy, which we now call photons, and that these bits of energy travel in a wavelike manner. Quantum mechanics is a mathematical explanation

of how electromagnetic radiation can have both wavelike and particle-like characteristics. Fortunately we don't need quantum mechanics in order to explain the phenomena we shall discuss in this book.

The most basic question about light—what is it made of?—also was not settled until the nineteenth century, when the great theoretical physicist James Clerk Maxwell finally deduced that light is just one part of a huge continuous spectrum of electromagnetic radiation. All electromagnetic radiation, including light, travels through a vacuum at exactly the same characteristic speed of 186,000 miles per second. Visible light is not qualitatively distinguishable in any way from the rest of the spectrum. It shares many characteristics with X rays and microwaves. The only reason it is so special to us is that we have receptors in our eyes that are selectively responsive to just its range of wavelengths, wavelengths between 370 and 730 nanometers (0.00000037 to 0.00000073 meters).

Electromagnetic radiation, including light, is emitted when charged particles, like electrons, move. The wavelengths emitted can cover a wide range or be very specific. Applying heat is one way to create electromagnetic radiation; the hotter objects get, the shorter the wavelengths emitted. If you heat up a piece of metal, it gives off shorter and shorter wavelengths until around 1000° F, at which point it begins to emit visible light. You may have noticed that light from a lamp on a dimmer switch looks reddish (longer wavelength) when it is turned down low, and bluer (shorter wavelength) when you turn it up. You may also have seen that you can set the "white point" on a computer monitor by defining it as a temperature.

A different way atoms can emit radiation is when specific electrons are bumped from one energy level to another. This can happen when free electrons, like ones from an electric current, collide with the electrons already present in a compound like neon or mercury vapor. When the electrons jump back down to their resting state, they emit a photon of a particular wavelength.

These two ways of creating electromagnetic radiation result in different kinds of light: incandescence and luminescence. Incandescence is the production of light by heated materials: the sun, fire, and tungsten lamps (regular lightbulbs) produce incandescent light. Fluorescent lights, fireflies, televisions, computer monitors, and lasers produce luminescent light, which results from specific excitation and emission of electrons and is a lower-temperature reaction. Since incandescence is the result of heat, a nonselective process, incandescent light is nonselective, containing many wavelengths. Luminescence, on the other hand, tends to be more specific. The photon emitted when an electron drops back into an unexcited state usually has a characteristic wavelength, so the light emitted is usually a single color. Different compounds undergoing excitation/emission processes release different characteristic wavelengths of light.

White light can be created equally well by incandescent and luminescent light sources. The multiple wavelengths of incandescent light mix together, as do the narrow emission peaks of fluorescent light, and both appear white.

COLOR

Within the range of visible light, different wavelengths appear to us as different colors. Even though most hues can be matched by light of a single wavelength, like the red of a laser pointer or the yellow of a sodium vapor lamp, most colors that we see are composed of a range of wavelengths.

This breadth in waveband (range of wavelengths) arises because what we see is usually reflected light. As light falls on an object, the surface of the object absorbs specific wavelengths. The light that isn't absorbed is reflected. Any specificity in reflected light must arise from a complementary specificity in absorbed light. For an object to appear colored, it must selectively absorb some part of the visible spectrum and reflect the rest.

It was Isaac Newton who discovered that objects appear colored because of the character of the light they reflect. He divided light into different colors using a prism and

When light falls on an object, some is absorbed. The light that isn't absorbed is reflected off the object's surface; this is the light we see. The object on the left in this diagram absorbs shorter (blue and green) wavelengths better than long (red) wavelengths and therefore appears red. The object on the right, which looks green, absorbs red and blue better than green.

OBJECTS APPEAR COLORED IF THEY REFLECT SOME WAVELENGTHS OF LIGHT BETTER THAN OTHERS

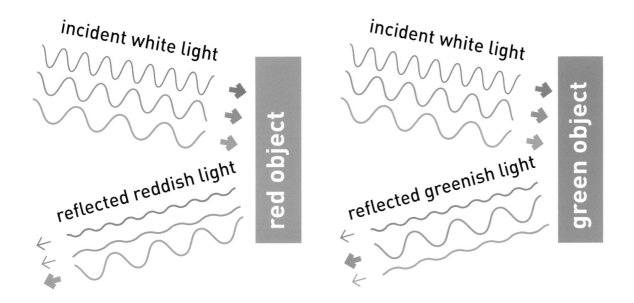

then isolated a small part of the resultant spectrum, one color, by placing a black board with a small hole in it across some part of the spectrum. The hole would let through only part of the spectrum, that is, one color of light. Newton discovered that, contrary to expectation, he could not then change that light into any other color. By shining isolated parts of the spectrum onto various objects, he discovered that red objects reflected red light, and green objects reflected green light, and so on. Newton's own words, from his

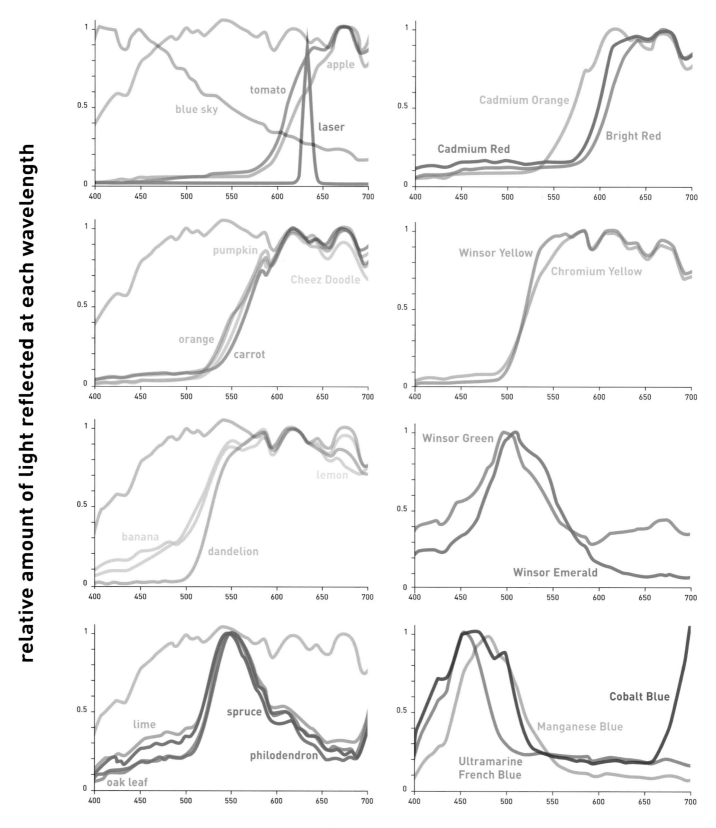

relative amount of light reflected at each wavelength

wavelength (nanometers)

1672 initial report to the Royal Society on this fundamental discovery, are quite readable. I enjoyed it because I can just picture him doing everything he can think of to turn one color of light into another, as he expected to be able to do. Here is an excerpt: "Colours are not Qualities of Light, derived from Refractions, or Reflections of natural Bodies (as 'tis generally believed,) but Original and connate properties, which in divers Rays are divers. Some Rays are disposed to exhibit a red colour and no other; some a yellow and no other, some a green and no other, and so of the rest. The species of colour, and degree of refrangibility proper to any particular sort of Rays, is not mutable by Refraction, nor by Reflection from natural bodies, nor by any other cause, that I could yet observe. When any one sort of Rays hath been well parted from those of other kinds, it hath afterwards obstinately retained its colour, notwithstanding my utmost endeavours to change it."

When light waves are measured, we discover that light of 640 nanometers looks red, and light of 540 nanometers looks green; this is a difference of only a hundred nanometers (a mere 0.000004 of an inch). Objects in the

Below: Day-Glo pigments absorb short-wavelength light, and their electrons then emit light over a narrow range of longer wavelengths. Sample Day-Glo spectra are shown here, compared with the light reflected from an adjacent patch of white paper (graphed in black). Each Day-Glo pigment reflects more light in some wavebands than does the white paper, and the pigments reflect relatively low levels of light in the other regions, which supply the light energy that is converted to energy in the characteristic narrow band. The Day-Glo pigments shown are, with peaks going from left to right: Signal Green, Saturn Green, Arc Yellow, Blaze Orange, Rocket Red, and Neon Red.

Opposite: These graphs illustrate the relative amounts of each wavelength of light reflected from some everyday colored objects (left column) and from some oil paints I purchased at an art supply store (right column). You can see the patterns of wavelength reflectance that characterize different colors. These spectra were obtained while these objects and paint samples were illuminated by daylight, which, as Newton discovered, contains a broad distribution of all the wavelengths of visible light. I used Winsor & Newton oil paints: Cadmium Red, Bright Red, Cadmium Orange, Chrome Yellow, Winsor Yellow, Winsor Green, Winsor Emerald, Manganese Blue, Cobalt Blue, and French Ultramarine Blue.

The oil paints and the everyday objects all reflect light from the entire visible spectrum, but they reflect some wavelengths more efficiently than others. The laser pointer, on the other hand, emits a narrow band of long wavelength, and appears intensely red.

For the objects on the left I have superimposed, in gray, the light reflected from a white paper illuminated by the same daylight, so you can see that the objects reflect essentially all of the incident light over one region of the visible spectrum and absorb light over another range.

SPECTRA OF SOME DAY-GLO PAINTS

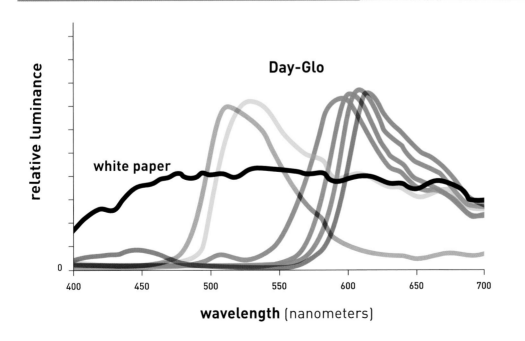

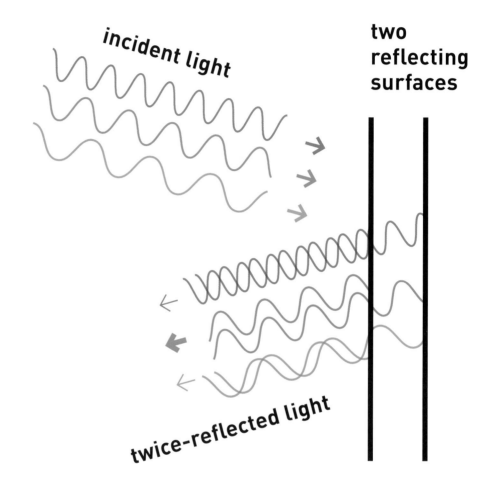

An oil slick looks colored because of a phenomenon called interference. If the reflections of light striking the top and bottom layer of the oil are in phase (the peaks and troughs of the waves coincide) the lightwaves will reinforce each other; if they are out of phase (the peaks of the light from one reflection coincide with the troughs of the other), they will cancel each other. So, if the thickness of an oil film is, for example, 540 nanometers (the wavelength of green light), then the two reflections of greenish light will be in phase, as shown in the diagram, and add, and the two reflections of other wavelengths will be out of phase and interfere, so the slick will look greenish.

world certainly can absorb different wavelengths selectively, as evidenced by the fact that many objects appear colored. And they usually do this because of differences in chemical or physical composition. That is, different molecules absorb and reflect different wavelengths of light because of differences in molecular structure or in the energy characteristics of their electrons.

Reflected light usually covers a broad range of the spectrum because most chemicals absorb a fairly wide range of wavelengths. Day-Glo pigments, however, absorb energy in the short-wavelength range of visible light, and then the electrons in these pigments re-emit light over a narrow range of longer wavelengths. Thus the light we see coming from orange Day-Glo paint actually contains more 590-nanometer light than was present in the light source (or more than is present in the light reflected from an adjacent white area) because the Day-Glo pigment converts other wavelengths of light to orange and re-emits the light.

Occasionally, physical structure alone can produce colors by processes called inter-

WHY WE SEE COLORS ON THE SURFACE OF A CD

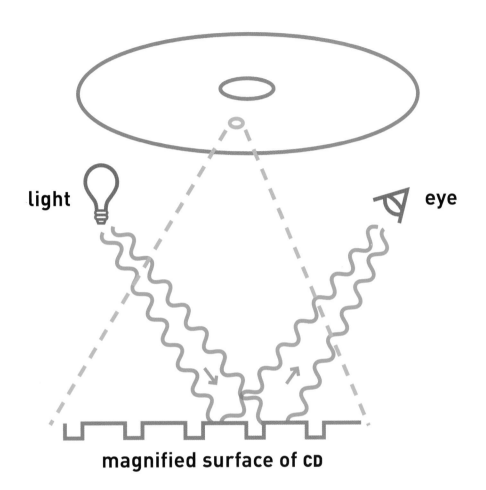

light **eye**

magnified surface of CD

Diffraction colors occur when light is reflected from a surface that has striations spaced on the scale of the wavelength of light, so that some wavelengths reflect in phase and others out of phase. A particular wavelength of light is shown reflected out of phase in the diagram, so that the complement to that wavelength will be seen at that angle. At other angles different colors will be out of phase.

ference and diffraction. The colors we see in butterfly wings, beetle wings, pearls, opals, hummingbird and peacock feathers, soap bubbles, and oil slicks are examples of interference or diffraction colors. Interference colors occur when white light is reflected from two parallel surfaces that are very close to each other, like the top and bottom of an oil film on water. Colors are seen when the distance between the two surfaces is in the range of the wavelengths of visible light. White light falling on an oil film is partially reflected from the top surface, and the light that is not reflected from the top surface is partially reflected from the bottom surface. Because light is a wave, it can interact with itself, one wave adding to another if their peaks coincide, and one wave canceling the other if peaks of one reflection coincide with the troughs of another. You may have noticed that an oil slick varies gradually in color, usually reddish in the center, fading to green and then blue around the edges. This is because the oil layer is thicker in the center and thinner around the edges, so the wavelength of red light matches the oil-layer thickness in the center, and shorter wavelengths match around the edge. The slick will look black where its thickness

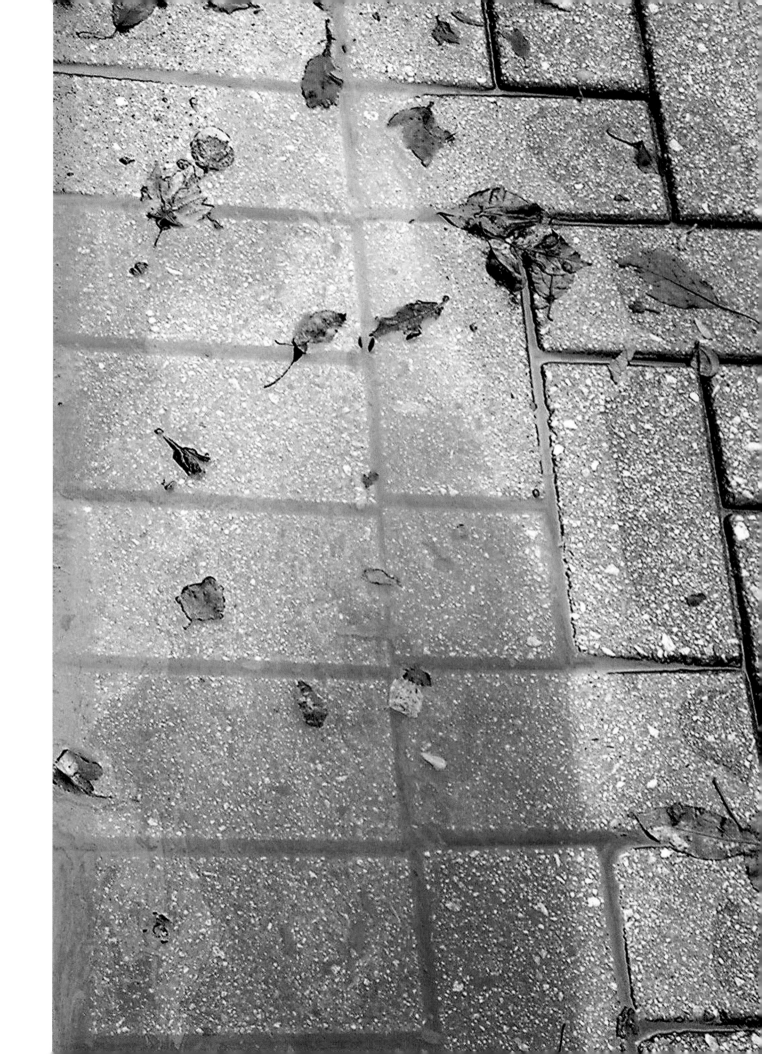

is just less than half the wavelength of visible light because all visible light is reflected out of phase and therefore cancels. You can sometimes see concentric rings of colors because thicknessess that are multiples of the wavelengths of light act similarly.

Some of the colors in butterfly wings, oyster shells, opals, and beetle carapaces are produced by interference between reflections of light from the top and bottom of thin layers of tough transparent biological films. Other butterfly and bird-wing colors are caused by diffraction. Diffraction occurs when light is reflected from a surface that has very fine, regular striations, with a spacing of the scale of the wavelength of light, so that, again, some wavelengths reflect in phase and others out of phase. You can see diffraction colors easily by looking at the back of almost any ordinary compact disk. Because the optical grooves of CDs are spaced regularly, they generate different colors at different viewing angles. If you hold one up to some light source, you can see a very nice spectrum.

Both interference and diffraction colors change with viewing angle, giving them an often lovely dynamic quality. This happens because the distance light travels between the grooves of a CD or through the film of an oil slick changes with the angle of the light hitting the surface.

In later chapters we will progress to asking what properties of our visual systems make vastly different combinations of wavelengths (like daylight and fluorescent light) appear the same. We will explore how our eyes compensate for the huge differences in wavelength composition of different illuminants, so that our perception of objects' colors is constant. The ways reflected colors combine will come up again when we look at Neo-Impressionism. The fact that pigments reflect, rather than emit, light limits the range of luminances, or values, available to artists, who must therefore use various tricks to extend the apparent range of luminances in their paintings. We will examine what it is about our visual systems that makes this possible.

I took this photograph of an oily puddle on my way to work. In some oily puddles we can see interference colors because the thickness of the oil film is in the range of the wavelengths of visible light. The oil film is thick in the center and thinner toward the edges. Over different ranges of oil-film thickness, between 370 and 730 nanometers (or multiples of 370 to 730 nanometers), different colors of light are reflected in and out of phase from the top and bottom surfaces of the oil slick.

2:

THE EYE AND COLOR VISION

THE VERTEBRATE EYE is so complex that it was (and sometimes still is) used as an argument against evolution and in favor of divine intelligence: how could a random process like evolution produce something so intricate and beautiful? It is commonly thought that the eye is like a camera, and that its function is to send a high-resolution image of the visual world to the brain. Some people even think of the entire visual system as a kind of fancy camera. This misperception is so common that it has a name: the homunculus fallacy. (*Homunculus* is Greek for "little man.") The fallacy is the idea that when we see something, a small representation of it is transmitted to the brain to be looked at by a little man. The fact is, of course, that there is no little man in the brain to look at that or any other image. The function of the visual system is really to process light patterns into information useful to the organism.

The eye initiates this process of the extraction of information. Light passes through the opening in the front of the eye, the pupil, and the lens focuses the image on the retina, a sheet of layers of neural tissue that lines the back of the eyeball. The first layers are the ganglion, bipolar, and horizontal cells; the cells that respond directly to light, the photoreceptors, are, surprisingly, in the outermost layer. The photoreceptors contain light-absorbing chemicals, pigments that generate a neural signal when they absorb light. The signals pass toward the front of the eyeball through the bipolar and horizontal cells to the ganglion cells, which send their signals from the eye via the optic nerve to the brain. The place where the optic nerve passes out of the eyeball is called the optic disk, as it appears round and pale through an

THE ESSENTIAL FEATURES OF THE EYE

- photoreceptors
 - rod
 - cone
- pigment cells
- horizontal cell
- bipolar cell
- ganglion cell

iris

ciliary muscle

retina

pupil

lens

fovea

iris

optic disk

optic nerve

ophthalmoscope. There are no photoreceptors or other neuronal cells in the optic disk, so we cannot see with that part of the retina.

One wouldn't expect the photoreceptor cells to be located in the outermost layer of the retina. To reach the photoreceptors, light first has to pass through the fluid in the center of the eye, through three cell layers and the layers where these cells make contact with each other. This works just fine, though, as these many layers are mostly transparent. However, for maximal sharpness in the center of gaze, at that central point—the fovea—all the layers except the photoreceptor layer are shifted aside so that the light has fewer impediments in its path.

When light passes into the photoreceptor layer, some of it is absorbed by the photo-

This graph illustrates the density of rods and cones across the human retina. The cone density is much higher in the center of gaze than in the periphery, and there are no rods at all in the very center of gaze. (That is why a dim star often seems to disappear when you look straight at it, but then it reappears when you look slightly away.) Our visual acuity parallels the cone distribution and is correspondingly much higher in the center of gaze than in the periphery. We are not aware of how low our visual acuity is away from our center of gaze, because we move our eyes around to look at all parts of a scene (from Osterberg, 1935).

receptors, and any leftover light is absorbed by a layer of pigment cells at the back of the eye. (In fact, that is why pigment looks dark: light does not escape from it.) The existence of this pigment-cell layer in our eyes is consistent with the fact that we are diurnal animals, evolved to be active when there is plenty of light. Our eyes are optimized for acuity rather than for light sensitivity. By contrast, nocturnal animals, like cats, do not have this absorptive layer but instead have a reflective layer, the tapetum, that bounces unabsorbed light back into the photoreceptors, giving them a second chance at catching it. While this results in higher sensitivity to the scarce light at night, it also means lower acuity, because the light is scattered by this reflection. Reflections off the tapetum are what make cats' eyes seem to glow at night.

We have two kinds of photoreceptors, rods and cones, both of which generate neural signals in response to light. Cones are less sensitive than rods and are used in daylight vision. Rods, which are much more sensitive, are used under dim (nighttime) lighting conditions. Rods and cones are not evenly distributed across the retina: cones predominate in the center of gaze, and rods prevail in the periphery.

Most of us have three different kinds of cones, each of which contains a different kind of pigment and responds best over a different range of visible wavelengths. The neural signal is binary—that is, a neuron either signals or it doesn't—and does not itself carry information about the color of the light that produced it. The information about color is indicated by which cells signal and how frequently they do so. We all have only one kind of rod, which means that we cannot distinguish colors in very dim light, because to see colors we need to be able to compare the activity in at least two different classes of photoreceptors.

PHOTORECEPTOR DENSITY ACROSS THE RETINA

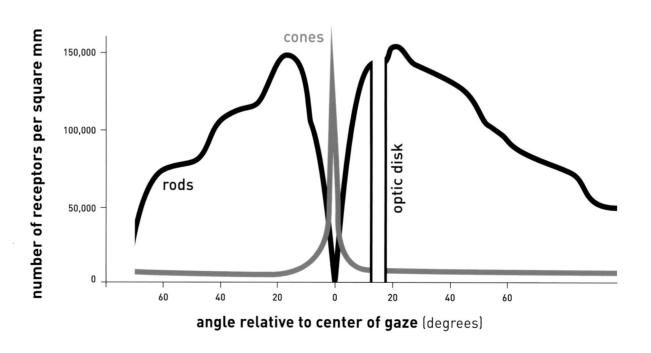

RESPONSES OF THE THREE CONE TYPES TO DIFFERENT WAVELENGTHS OF LIGHT

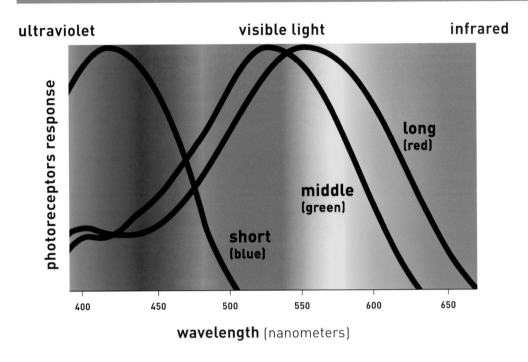

ultraviolet visible light infrared

photoreceptors response

long (red)

middle (green)

short (blue)

400 450 500 550 600 650

wavelength (nanometers)

These curves, superimposed on the visible spectrum, show the sensitivity of each of the three human cone types to different wavelengths of light. The three cone types are referred to as long-, middle-, and short-wavelength (or red, green, and blue) cones. If we had a large number of cone types, we would be able to distinguish mixtures of light from each other and from unmixed, spectral colors. For example, we would be able to distinguish a mixture of red and green light from a pure yellow if we had separate cone types peaking in the red, yellow, and green ranges, but we cannot: red and green light mixed together can look exactly like narrow-band yellow light. The fact that we can perceive millions of colors with only three cone pigments is particularly stunning if you consider what music would sound like if we could perceive the relative loudness of only three fixed notes.

The three cone types are referred to as long-, middle-, and short-wavelength cones. Because most people feel more comfortable referring to them by color, rather than by wavelength, they are sometimes called red, green, and blue cones, even though the longest wavelength cone response is actually in the yellow region of the spectrum, short of red. The response of each cone type depends on both the wavelength of light and its amount, or intensity.

Because of this dual dependency, there is an ambiguity in the meaning of the response of any individual photoreceptor. In fact, the magnitude of the response alone cannot tell us anything about the color of the light. For example, if a single long-wavelength photoreceptor gives a particular magnitude response to a given amount of red light (say, 100 photons of wavelength 650 nm), it would give twice as large a response to twice as bright a red light. But a still larger response would be elicited by a mere 100 photons of orange (625 nm) light, because the long-wavelength cone responds better to orange light than to red.

Given this ambiguity, and given the broad spectral sensitivity of each of our cones, how can it be that we can distinguish millions of colors? Furthermore, unlike some fish, we do not have any cones that peak in red light, so how can we possibly distinguish red? The answer to both these questions is that the visual system compares the activation of each type of cone with the others. If part of the retina is stimulated by red light, even though the red cones covering that part of the retina would be more effectively activated by shorter wavelength light, the red cones nevertheless will be activated more than the green cones. If the amount of red light increases, increasing the response from both cones, the red cone signal will still be bigger than the green signal. Thus the ratio between the red and green cone responses gives an unambiguous code for the wavelength of light in the yellow-to-red range of the spectrum.

THE SIGNIFICANCE OF PRIMARY COLORS

The number of primary colors (the minimum number of colors that when mixed can generate all possible colors) has been of interest to artists and scientists for a very long time. Pliny tells us that the ancient Greek painters knew how to prepare all colors using only four pigments. Leonardo da Vinci wrote that one needed only four colors of paint—yellow, blue, green, and red. Since of course green can be made by mixing blue and yellow, this suggests that the number of primaries for pigments might be as low as three.

Similarly, you can generate all colors of light by mixing together different proportions of three primary colors of light. Newton not only discovered that white light consists of a mixture of light of various colors, but he also found that he could recombine various pure spectral (narrow-band) colors to obtain other colors, including white. Newton found that though mixed red and yellow narrow-band light appears indistinguishable from spectral orange, the two orange lights are not in fact identical: by passing them through a prism he could separate the mixture into its component parts, but the spectral orange remained pure. Newton regarded our inability to distinguish mixtures of light from pure spectral colors as a mistake of the eye, but Thomas Young realized that this inability had important implications for understanding how our eyes process color.

Many physicists, including Newton, had tried to deduce what physical properties of primary colors—of light or pigments—made them so fundamental, and a number of theories were proposed based on analogies with musical harmony. In 1802 Thomas Young deduced that there was nothing about primary colors themselves that was special, but rather that we have only three classes of receptors. Young reasoned that we cannot have a very large number of kinds of wavelength detectors because if we did we would need one of each—potentially a prohibitively large number of "vibration-sensitive particles"—at each tiny point on the retina. Hermann von Helmholtz did more precise mixing experiments to show that this small number must be precisely three.

James Clerk Maxwell applauded Young's insight by saying, "It seems almost a truism to say that colour is a sensation; and yet Young, by honestly recognizing this elementary Truth established the first consistent theory of colour. So far as I know, Thomas Young was the first who, starting from the well-known fact that there are three primary colours, sought for the explanation of this fact, not in the nature of light, but in the constitution of man. Even of those who have written on colour since the time of Young, some have supposed that they ought to study the properties of pigments, and others that they ought to analyze the rays of light. They have sought for a knowledge of colour by examining something in external nature—something out of themselves."

It is now known that human visual acuity is determined by the cone spacing at the center of gaze, which means that the number of cone types does limit our acuity; what's more, in the very center of gaze, probably to maximize acuity, we have only two cone types—long- and middle-wavelength—and no short-wavelength cones at all. There are no rods in the center of gaze, which gives us the tightest possible cone packing and therefore the highest possible daylight acuity.

THE POWER OF THREE

What is special about having three kinds of cones? Is three in any sense optimal? In theory, two classes of cones would be sufficient to distinguish all the colors in the visible spectrum, as long as the ratio of their responses changed systematically with wavelength. Since that is not the case for any pair of cone pigments that we have, we need three to distinguish all spectral colors. That is, if two of our cone pigments were better designed and covered the entire spectrum, we would not need three to distinguish all spectral colors.

Why weren't our cone pigments designed so that we could distinguish all spectral colors using only two and not three cone types? Probably because they were not "designed" in the first place. They evolved. It is clear from gene sequences that our red cone pigment evolved by a duplication of and very minor modifications (mutations) in our green cone pigment, modifications that shifted the absorption peak slightly toward the red end of the spectrum. The red cone pigment differentiated from the green cone pigment only as recently as Old World (African) monkeys and apes (macaques, apes, orangutans) diverged from New World (South American) monkeys (spider monkeys, squirrel monkeys, cebus monkeys), thirty to forty

We wouldn't need three cone types to distinguish all spectral colors if two of our cone types covered the entire spectrum. For example, if we had the two imaginary cone types with spectral absorptions as diagrammed in red, below, we could distinguish all spectral colors simply by knowing the ratio of the activity of the two types of cones. The cyan line shows that the ratio of these two imaginary cone pigments is a unique value for every point on the spectrum.

RESPONSES OF TWO IMAGINARY IDEAL PHOTORECEPTORS

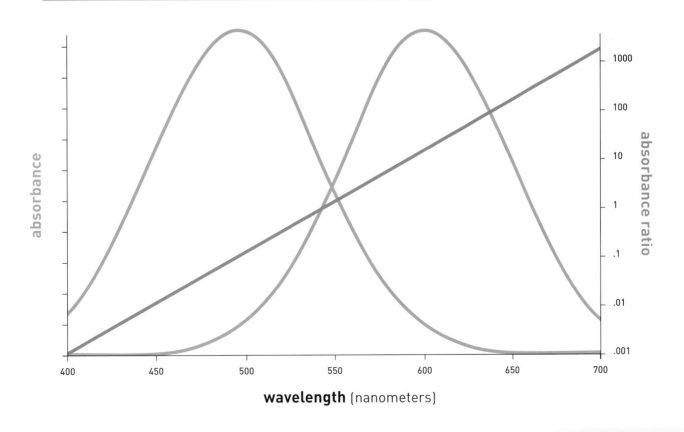

absorbance

absorbance ratio

1000

100

10

1

.1

.01

.001

wavelength (nanometers)

NONSPECTRAL AND OTHER SPECIAL COLORS

White is a nonspectral color; that is, it cannot be generated by any single wavelength of light. It can be made in many other ways: from a mixture of all wavelengths of visible light, or from a combination of appropriate quantities of red and cyan (a greenish blue), yellow and blue, green and purple, or many other mixtures of appropriate wavelengths of light.

Purple is a mixture of blue and red light, and is particularly interesting, both to scientists and artists. In fact nineteenth-century French art dealer Paul Durand-Ruel said, somewhat fancifully, in discussing an Impressionist exhibition in New York, "One of the greatest stumbling-blocks in the Impressionist work, as shown here, was the prevalence of violet shadows. In considering this, it must be remembered that there are more violets in the shadows in many parts of France than in this country."

There are two quite different ways to get a reddish blue. I will use the terms violet and purple to distinguish these two sometimes-indistinguishable hues. Violet is the color of the shortest wavelengths of light we can see. Light of wavelengths around 460 nanometers looks blue; light of wavelengths shorter than 440 nanometers looks blue, but also slightly reddish. This is because the short-wavelength cone contributes to our impression of redness, and also because the absorption spectrum of the long-wavelength cone has a secondary peak in the very short wavelength range of the visible spectrum. (Look carefully at the graph on page 27 and you can see a little peak at 400 nanometers in the red-cone curve). Therefore very short wavelength light activates both the blue and the red cones, and violet is a spectral color that looks reddish blue.

Another way to get a reddish blue is to mix red and blue light, and this mixture is called purple. A bluish purple can be identical in appearance to violet, but it is a mixed, not a spectral, color. Most pigments that look reddish blue are really purple, reflecting both long and short wavelength light. Interference and diffraction colors that look reddish blue, like those in butterfly or hummingbird wings, on the other hand, are likely to be genuinely violet.

The fact that purple objects reflect both red and blue light means that they must absorb light selectively in the green range of visible light, which is right in the middle of the visible spectrum. This is physically much more restrictive than reflecting either only long or only short visible wavelengths. You might think that absorbing, say, only red light might be just as tricky as absorbing only green light, but that is not the case. It is easier to find compounds that absorb just red light because their absorption peak does not have to be narrow—it just has to lie above 600 nanometers; the absorption can extend into still longer, infrared, wavelengths that are not visible to us.

Therefore, to appear purple, objects have to selectively absorb a very narrow range of light. For this reason purple objects are uncommon. Indeed purple dyes were historically rare and expensive, and at times they were restricted to royalty: hence the term "royal purple." This is still true today, to some extent. Most of the oil paints I bought from an art supply store were around five dollars each. The Cobalt Violet, however, cost forty-five dollars.

Some other colors are special, but not nonspectral: brown, for example, is orange light that is surrounded by something lighter. That is, you can make a brown patch by producing a spot of orange (any orange will do, spectral or a mixture) and then surrounding it by a brighter light of any color. Similarly, maroon is red light surrounded by something lighter.

A pastel is simply a desaturated (mixed with white) version of a spectral color. That means you can make pink, for example, by adding a nonspectral mixture of white light to spectral red light.

Opposite: I measured the spectra of light reflected from the flowers of two African violets, a purple cabbage, and some purple paints. All three spectra are combinations of long and short wavelengths. The spectra of the Ultramarine Blue and the Ultramarine Violet are very similar below 620 nanometers; the Ultramarine Violet has more reflectance of longer wavelength light than the Ultramarine Blue, accounting for its purple (not violet) color. Cobalt Violet, on the other hand, really does reflect violet light, but it also reflects a lot of red, so it is a reddish violet. I have not yet found a genuinely violet pigment or object, except for diffraction or interference colors.

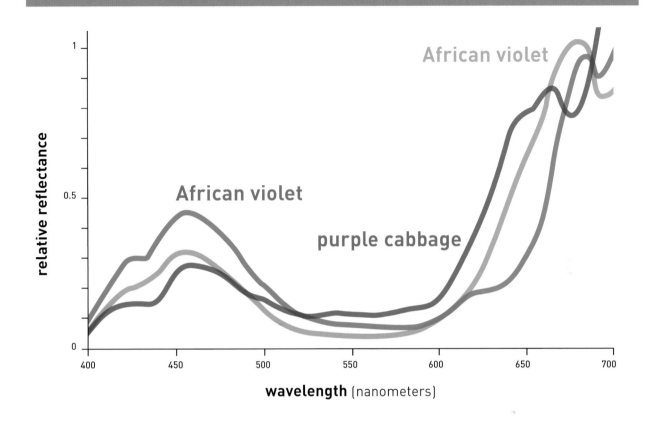

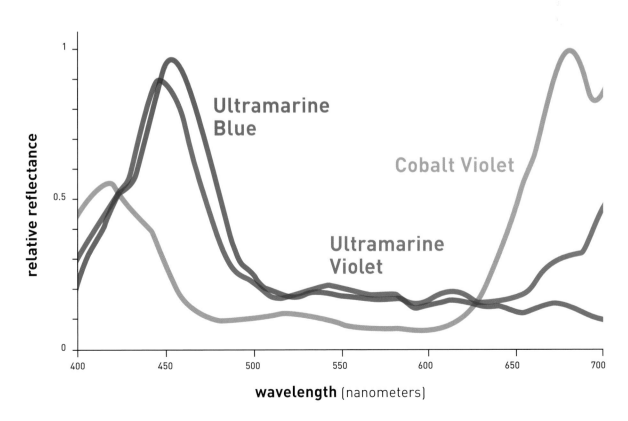

million years ago. Only other higher primates (Old World monkeys) have the same kind of three-cone color vision we do. Lower primates (New World monkeys) have a two-cone kind of color vision, which is the same kind of color vision as people with red/green colorblindness, which is discussed below. Some birds, fish, and insects, like humans and other Old World primates, have more than two kinds of cone pigments, but they evolved them independently.

It is important to remember that the definition of "visible light" is merely the range of the absorption spectra of all our light-absorbing photoreceptor pigments. Visible light as we know it is defined by the region of the electromagnetic spectrum to which our cone pigments can respond.

Presumably the fact that we evolved to have three cone types reflects a balance between two opposing evolutionary forces: the benefit in color discrimination—being better able to distinguish differences between light reflected off various surfaces—that having more cone types gives versus the higher acuity that comes from having a small number of cone types. In the olfactory system, where spatial resolution is not an issue, we evolved about a thousand types of receptors to distinguish different kinds of chemicals. Being able to distinguish differences in reflected light is biologically advantageous because it allows us to differentiate surfaces of different chemical compositions. If we had only one cone type we could distinguish lights on the basis of their luminance alone. If we had only two cone types we could distinguish different lights on the basis of both wavelength and luminance, but we would not be able to distinguish some mixtures of light that people can normally distinguish. If you look at the absorption spectra of the long-, middle-, and short-wavelength human cone types, it might seem strange that we bothered to evolve the long-wavelength cone pigment at all, since it is so similar to the middle-wavelength cone pigment. But it turns out that the ability to distinguish ripe (red) fruit on green foliage is much improved by having that third cone pigment.

Would having four cone types let us see even more colors? Yes, an additional cone type with its absorption peak somewhere between the cones we already have might allow us to distinguish pairs of light mixtures that normal people cannot distinguish. What would these colors look like? Would they be somehow different from the colors we can already see? These nonspectral (mixture) colors would be distinguishable from spectral colors, but they would probably not look qualitatively different. For example, reddish purple—which cannot be generated by a single wavelength of light but only by a mixture of red and blue wavelengths— does not seem qualitatively different from the colors that can be generated by single wavelengths, like orange or turquoise. In a sense we already experience vision using four photoreceptor pigment types around dusk, when the light is dim enough that our rods become active, but not so dim that our cones can't operate. Under those conditions we do see colors differently than during daylight, though, as we shall see, that is more a function of altered luminance perception than of the presence of new and peculiar colors. I am not aware of perceiving any particular colors at dusk that I cannot perceive under daylight conditions, even though I use four kinds of photoreceptors with different peak absorptions.

We might also imagine having a fourth cone with its peak farther up or down the electromagnetic spectrum than the receptors we already have. Some birds, insects, and fish have photoreceptors that respond to ultraviolet light (shorter wavelengths than humans can see), and some snakes, insects, and vampire bats have receptors that can respond to infrared radiation, or heat (longer wavelengths than humans can see). Certainly those animals can see spectral "colors" that we cannot, and their perceptions are presumably different from ours.

DO YOU SEE RED LIKE I SEE RED?

For centuries philosophers have pondered the question of whether one person's subjective experience is the same as another's. Why, I don't know, since any experience is simply a manifestation of a particular combination of neurons within the brain signaling or not signaling, an area of inquiry that does not seem approachable to me by introspection. At some level, of course, your experience of red must be different from mine in that your neurons are different from mine, even though they may be wired up in an almost identical way. But is that a fundamental distinction?

We can consider low-level perceptions, such as hearing single tones, or seeing particular wavelengths of light, and we can consider higher-level perceptions, such as understanding speech or recognizing one's uncle. Clearly, higher-level perceptions involve experience (learning), which invariably differs between individuals: you are probably not going to recognize my uncle in the same way I do, and neither of us are likely to understand some combinations of sounds in the same way a Swahili speaker would. Lower-level perceptions would seem to be less dependent on learning, though they can also involve previous experiences. A single tone might sound different to a musician than to a telephone operator; single colors might evoke different subjective impressions depending on previous experiences one had in rooms of that color or while seeing fluid of that color flow out of painful wounds.

Yet, at the most basic physiological level, we know that in most people similar locations on the cochlea (a structure in the ear) are set in vibration by similar tones, and we know that the same ratios of the same classes of cones, identifiable by the photopigments they contain, are activated by a given wavelength of light. Therefore the similarities and differences between your experience of red and mine lie somewhere between the similarities between the classes of cells activated in our retinas, thalamuses, and visual cortices, and the similarities between the memories activated by that color in our frontal lobes.

Another way of asking if you see red the way I see red is to ask whether you see as identical in color various objects reflecting different mixtures of wavelengths that I see as identical. In this case, some people clearly do see colors differently from other people; they are usually missing one or more of the three photopigments. The first person to explore colorblindness in a systematic way was John Dalton, a natural scientist and professor of mathematics and natural philosophy at New College in Manchester, England.

Dalton reported in 1794, when he was twenty-eight years old, that he had come to the realization that he must perceive colors differently from other people. He wrote: "I was always of the opinion, though I might not often mention it, that several colours were injudiciously named. The term pink, in reference to the flower of that name, seemed proper enough; but when the term red was substituted for pink, I thought it highly improper; it should have been blue, in my apprehension, as pink and blue appear to me very nearly allied; whilst pink and red have scarcely any relation. . . . Since the year 1790, the occasional study of botany obliged me to attend more to colours than before. With respect to colours that were white, yellow, or green, I readily assented to the appropriate term. Blue, purple, pink, and crimson appeared rather less distinguishable; being, according to my idea, all referable to blue. I have often seriously asked a person whether a flower was blue or pink, but was generally considered to be in jest."

So it seems to me that the question of whether you see red like I see red is basically semantic. There are indeed many people for whom the experience of red is quantifiably different from my experience of red, starting with the kinds of cells in their retinas that are activated. But, because our brains are built by both genes and experience, we can also say that your experience of red differs from mine simply on the basis of knowing that our life experiences have been different.

Neurologist Oliver Sacks asked two of his patients, as part of a vision test, to try to reproduce the image in the leftmost panel. The center panel shows a reproduction of this image made by a red/green colorblind person; the right panel shows a reproduction made by a man with a lesion in the color processing part of his brain. A red/green colorblind person is clearly far from colorblind.

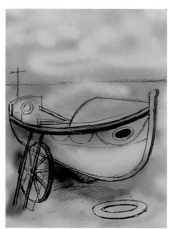

Opposite: People with different kinds of color-vision deficits perceive the spectrum differently. The top row shows how the spectrum (white light broken up by a prism) appears to people with normal color vision. No part of the spectrum is achromatic, or neutral. The second and third rows show how the same spectrum appears to people having a defect in either the red or the green cone. This is the commonest type of red/green colorblindness, in which 10 percent of men see the spectrum as variations between two hues, with a neutral point where the spectrum looks white; the neutral point occurs in a slightly different place depending on which cone is missing. The fourth row shows what the spectrum looks like to people missing the short-wavelength cone (a much rarer type of colorblindness). These people also see the spectrum as being made up of two hues, but the neutral point is at much longer wavelengths than the neutral point for red/green colorblindness. Some colorblind people are missing both the long- and the middle-wavelength cone pigments, and they really are colorblind, as seen in the fifth row, in that all regions of the spectrum are achromatic, and the world looks to them like varying shades of gray. Night vision (sixth row), or rod vision, of all people is also colorblind; we all see the world in shades of gray at night. The lowest panel shows how the spectrum looks to part of the normal human visual system. As we will discuss in the next chapter, a very basic part of our visual system is completely colorblind, seeing the world in luminance only, that is, as shades of gray.

People with different kinds of color-vision deficits perceive the spectrum differently. Many people lack (or have a mutation in) either the red or green cones; this is called red/green colorblindness. The genes for the long- and middle-wavelength cone pigments are located on the X chromosome. Women have two X chromosomes, and men have only one. Therefore a woman carrying a mutation in one of these genes is very likely to have another, normal, pigment gene on her other X chromosome and will consequently have normal color vision. Men who carry such a mutation do not have another copy of the gene and will have abnormal color vision. Ten percent of men (and less than one percent of women) are red/green colorblind due to a mutation in either the long- or middle-wavelength cone pigment genes. Red/green colorblind people are not really colorblind; that is, they do not see the world in shades of gray. They can distinguish many colors just as sensitively as people with normal vision, but they see certain pairs of colors as identical to each other that people with normal vision see as different.

Short-wavelength cone pigment defects are much rarer than red/green color defects because everybody has two copies of the blue-cone gene. The rare individuals who do lack the short-wavelength cone pigment have trouble distinguishing some bluish colors from some yellowish greens.

THE DIFFERENT APPEARANCES OF THE VISIBLE SPECTRUM

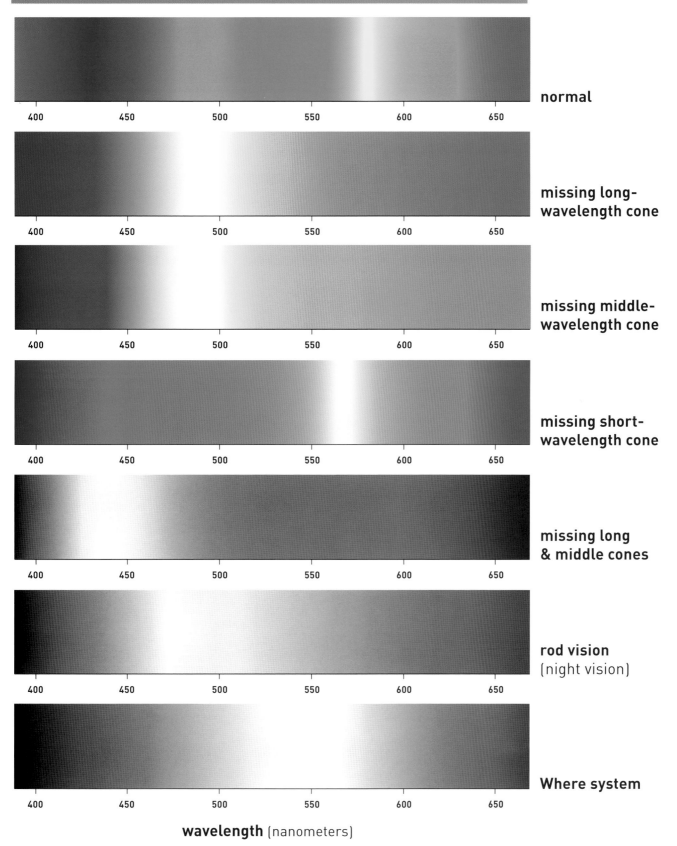

normal

missing long-
wavelength cone

missing middle-
wavelength cone

missing short-
wavelength cone

missing long
& middle cones

rod vision
(night vision)

Where system

wavelength (nanometers)

3:
LUMINANCE AND NIGHT VISION

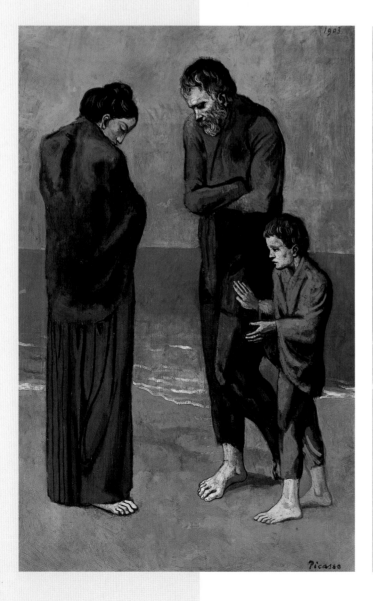
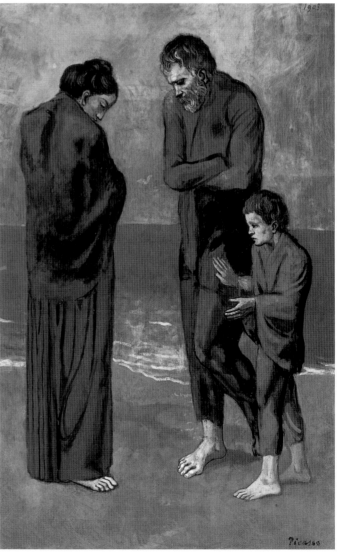

LUMINANCE, OR WHAT artists refer to as value, is perceived lightness. It is defined by how the human visual system responds to light; in particular, how bright the average human judges a light to be. It is sometimes thought of as the amount of light (the number of photons), but that is not correct. Luminance is not a physical measurement, and the luminance of any particular number of photons varies depending on the wavelength of that light; it is determined by how sensitive our eyes are to that color of light. Understanding luminance is important because our perception of depth, three-dimensionality, movement (or the lack of it), and spatial organization are all carried by a part of our visual system that responds only to luminance differences and is insensitive to color.

It is not hard to measure the amount of light reflected off an object. This is exactly what physicists do, and they have many instruments to do it. But psychologists, neurobiologists, and artists are interested in human responses to light. Luminosity is measured by asking human subjects to indicate how much light of each wavelength is needed for them to see it or to match some standard brightness. This varies, depending on the color of the light: if you look at a spectrum you will see that the blue end appears very dim and the yellow part seems very bright, even though there are just as many blue photons as yellow. There are photometers available that measure light and correct for human visual sensitivity.

When we look at an image, it can be easy to confuse color and luminance. Rare or unusual colors can look brighter than they really are. One way to separate color and luminance is to take the color away and examine the work in grayscale. Let's use Pablo Picasso's *The Tragedy (Poor People on the Seashore)* as an example. When we look at this painting in color, we see that it is rendered in various blues. The colors carry the emotional content of the painting; the

The black-and-white version of Pablo Picasso's *The Tragedy (Poor People on the Seashore)* (1903) shows the painting's lightness (luminance) values and reveals how much information is carried by luminance alone.

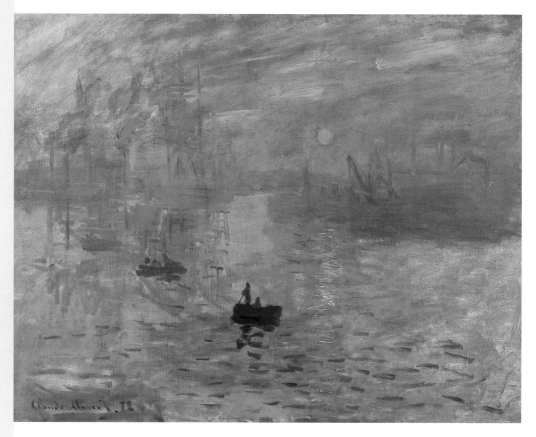

When Claude Monet exhibited *Impression Sunrise* (1872), it caused a furor. Parisian art critic Louis Leroy said the painting was "at once vague and brutal," and reviled it as being "worse than anyone has hitherto dared to paint." Such a reaction notwithstanding, history has acknowledged this work: from its title comes the name for the art movement Impressionism.

In the original version, right, Monet's sun appears to pulsate, an effect that may be based on the parallel structure of the visual system.

melancholy blue color is highly symbolic. But what is the role of color in composition? The black-and-white reproduction reveals that it is not the colors themselves, but their luminance, that makes it possible for us to recognize the figures and to perceive their three-dimensional shape and the spatial organization of this scene. (If you want to experiment with this yourself, you should know that different black-and-white films have different wavelength response functions, so only some films accurately mimic the human luminosity response. Kodak Panatomic-X does a fairly good job. Adobe Photoshop's grayscale is quite accurate.)

The biological basis for the fact that color and luminance can play distinct roles in the perception of art or real life is that color and luminance are analyzed by different parts of the visual system, each of which is responsible for different aspects of visual perception. The areas of our brain that process information about color are located several inches away from the areas that analyze luminance—they are as anatomically distinct as vision is from hearing. From the earliest stages of visual processing, in our eyes, color and luminance are analyzed separately.

Moreover, the parts of the brain that process color information are present only in primates. The luminance system, which is evolutionarily older, is common to all mammals. That is probably why the most basic—that is, the most primitive or necessary—visual information about a scene is found in luminance variations. It does not matter which color is used to convey the luminance signal, because the parts of our brains that analyze the most basic features of a scene are, quite literally, colorblind.

Some artists use unrealistic luminances to generate illusory sensations of brightness, depth, motion, and transience. A fine example of this—and of how difficult it is to judge luminance—is Claude Monet's *Impression Sunrise*.

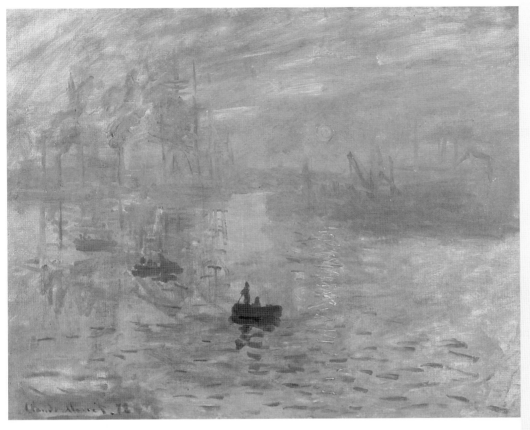

As the black-and-white reproduction reveals, the sun is exactly the same luminance as the gray of the background clouds. If the artist were painting in a strictly representational style, the sun should always be brighter than the sky, by a huge factor that would actually be impossible to duplicate with pigments. By making it the exact same luminance as the sky, he achieves an eerie effect; this technique can extend an artist's ability to represent the quality of light.

In this final version, the sun has been made lighter than in the original—which is closer to the way it would appear in reality—and it has lost its quavering luminosity. It now seems paradoxically less bright.

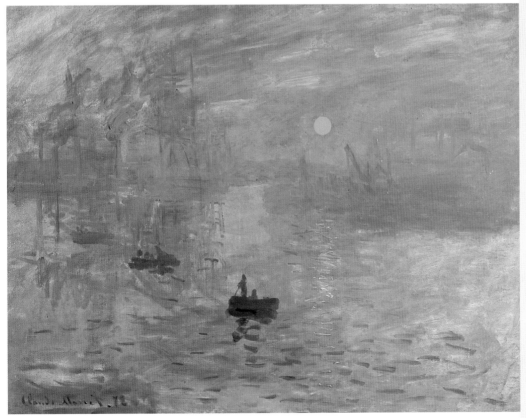

Opposite: The luminosity
response curve shows the
combined responses of the three
cone types to light of each
wavelength. The two red arrows
on this graph show that, under
daylight conditions, a given
amount of blue light (450 nm)
produces about one-twentieth
the response as the same
amount of green (540 nm) light.
An equal amount of blue and
green light (an equal number of
blue and green photons) will
have unequal luminances
because our visual system is less
sensitive to blue than to green
light (that is, the spectral
luminosity function is lower in
the blue region of the spectrum
than in the green region).

The sun in this painting seems both hot and cold, light and dark. It appears so brilliant that it seems to pulsate. But the sun is actually no lighter than the background clouds, as we can see in the grayscale version. It is precisely equiluminant with—that is, it has the same lightness as—the gray of the background clouds. This lack of luminance contrast may explain the sun's eerie quality: to the more primitive subdivision of the visual system (which is concerned with movement and position) the painting appears as it does in the grayscale version; the sun almost invisible. But the primate-specific part of the visual system sees it clearly. The inconsistency in perception of the sun in the different parts of the visual system gives it this weird quality. The fact that the sun is invisible to the part of the visual system that carries information about position and movement means that its position and motionless-ness are poorly defined, so it may seem to vibrate or pulsate. Monet's sun really is both light and dark, hot and cold.

If the sun is artificially made lighter than the sky, as of course the sun should be, it no longer has this eerie quality, and it paradoxically seems less vibrant. In the bottom version, the sun is technically brighter than in the original, but it has lost its quavering luminosity, and it now looks like a cutout applied to the clouds, rather than a source of light.

CHANGING LIGHT, CHANGING SIGHT

Strange things happen to color perception under different levels of illumination. If you explore your perception of your bedroom at night, when it is illuminated only by dim moonlight or by an outside streetlamp, you should note that you cannot see colors even if there is enough light to see forms quite clearly. If the room is a bit brighter—say, in full moonlight or illuminated by a single dim bulb—you may be able to see a hint of color, but the lightnesses, or luminances, of the colors will be very different from the way they appear during the day.

Photoreceptor response increases with increasing amounts of light. In other words, the brighter the light, the stronger the response. But the relationship between the response and the number of photons varies with the wavelength of the light. That is, our photoreceptors are most sensitive to light in the green/yellow range of the spectrum, which means that we need more photons in the red or blue regions of the spectrum to achieve an equivalent luminance. In reasonably bright light, this function is the curve shown on the opposite page, known as the luminosity response curve; it is the combined responses of the three cone types to light of each wavelength.

Is there any advantage to our perception of brightness depending, as it does, on wave-length? Not that we know of. The fact is that it is almost impossible to design a chemical (including a photoreceptor pigment) that will respond to light in a constant way across all parts of the visible spectrum. Most chemicals that absorb light (or any kind of electromagnetic energy) do so optimally at some wavelength, and gradually less well at different wavelengths. That is, most chemicals exhibit a spectral absorption curve with a broad peak or maximum at some wavelength, and our photoreceptor light-absorbing pigments are no different.

Though rods are the photoreceptors that we use in very dim light, it is frequently—and incorrectly—said that rods are for discriminating luminance and cones are for color. The fact is that value and color are not distinguished along the rod/cone dichotomy. The distinction is made by the next cells in the hierarchy, the retinal ganglion cells, which add or subtract the

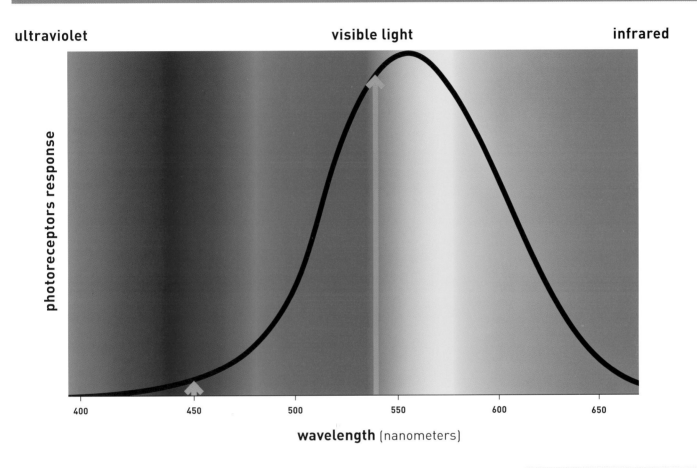

signals from different cone classes. In short, we see color by subtracting the different cone responses, and we see luminance by summing the different cone responses and the rod responses. This will be discussed in detail in a later chapter.

Rods do carry luminance information, but they do so only under very dim light. Under daylight conditions luminance is carried by a summed-cone signal. Therefore we can see luminance both at night and during the day. What differs between our day and night vision is the fact that our night vision is colorblind. Since we have only a single kind of rod, rods can signal only one kind of information about light—i.e., how much there is of it. It is impossible for the brain to know if variations in the rod signal arise from changes in wavelength or in the amount of light. Does this result in a confused color/luminance impression? No, it turns out that our brain interprets all rod activities—all night vision—as a pure luminance signal, as shades of gray. This happens because the rods are wired up to signal the same retinal ganglion cells, the luminance ganglion cells, that sum the inputs from different cone classes.

LUMINOSITY RESPONSE CURVES:
APPARENT BRIGHTNESS OF DIFFERENT WAVELENGTHS OF LIGHT (DAY VS. NIGHT VISION)

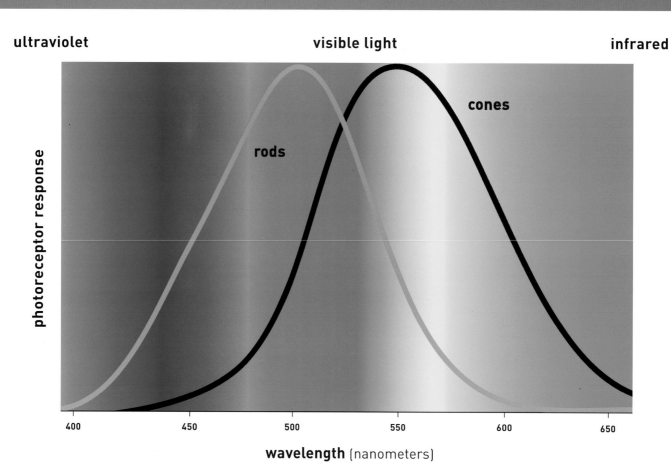

ultraviolet visible light infrared

rods

cones

photoreceptor response

400 450 500 550 600 650

wavelength (nanometers)

Rods, like cones, have a spectral response curve; the response of rods varies with both the amount of light and wavelength. The rod spectral response is graphed here in dark red and compared with the combined cone spectral response in blue. The two responses are shown here on the same scale, so we can compare their relative spectral responses, but rods are actually much more sensitive than the cones, so their curve should appear much higher on the same axes. (These are scaled sensitivities, with the maximum response for both set to the same level.) You can see that the rod curve peaks closer to the short-wavelength end of the visible spectrum than the cone response. That is, rods are relatively more sensitive to blue and green light than is the combined cone response. The brightest part of the spectrum is different for rods than for the summed cone luminance response.

Rods are relatively more sensitive than cones to shorter-wavelength (blue and green) light. This can be seen in a comparison of rod and cone spectral response curves. (See also the last two rows in the illustration on page 35.) There is an interesting phenomenon, known as the Purkinje shift, which is due to the difference in the rod and cone responses as a function of wavelength. As lighting conditions dim, the relative proportions of rod and cone contributions shift, resulting in the luminance of colors changing: the reds become darker and the blues become brighter.

Why does this happen? We have about twice as many red cones as green cones, but only about one percent of our cones are blue; thus the combined cone response is relatively insensitive in the blue range of the spectrum. Looking at the luminosity curve, we can see that it takes more blue photons (470 nm) to seem as bright as a given quantity of red (630 nm) photons. Rods, by comparison, are more sensitive to blue light and less sensitive to red. The rod curve indicates that in dim light a given quantity of blue light will seem 100 times brighter than the same quantity of red light. Thus in dim light blues look relatively lighter and reds look relatively darker than they do in daylight. Therefore, it is clear that values of various colors in a painting will change depending on the level of the ambient light.

In daylight real cherries may look lighter than a blue bowl in which they sit. So if you make a painting of them, it is likely that you will make them lighter there as well. If you look at your painting until dusk and don't turn on the lights, you will find that the blue of the bowl eventually looks lighter than the now almost-black cherries—and this will be true for both the real cherries and the ones in your painting. If you had eaten the cherries and didn't have them to compare to the painting, you might conclude that something is drastically wrong with your artistic talents.

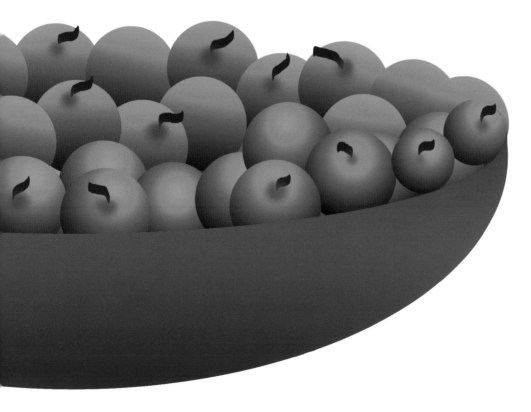

To see the Purkinje shift for yourself, try this some evening, remembering that in daylight the cherries look about as light as the bowl. Wait until it is dark enough that you can't see colors (and you should wait patiently for dusk to fall), or turn off the lights and give yourself at least ten minutes to dark adapt. You can tell if you are fully dark-adapted (that is, using only rods) if you can't distinguish colors. Eventually the blue bowl will look lighter than the cherries.

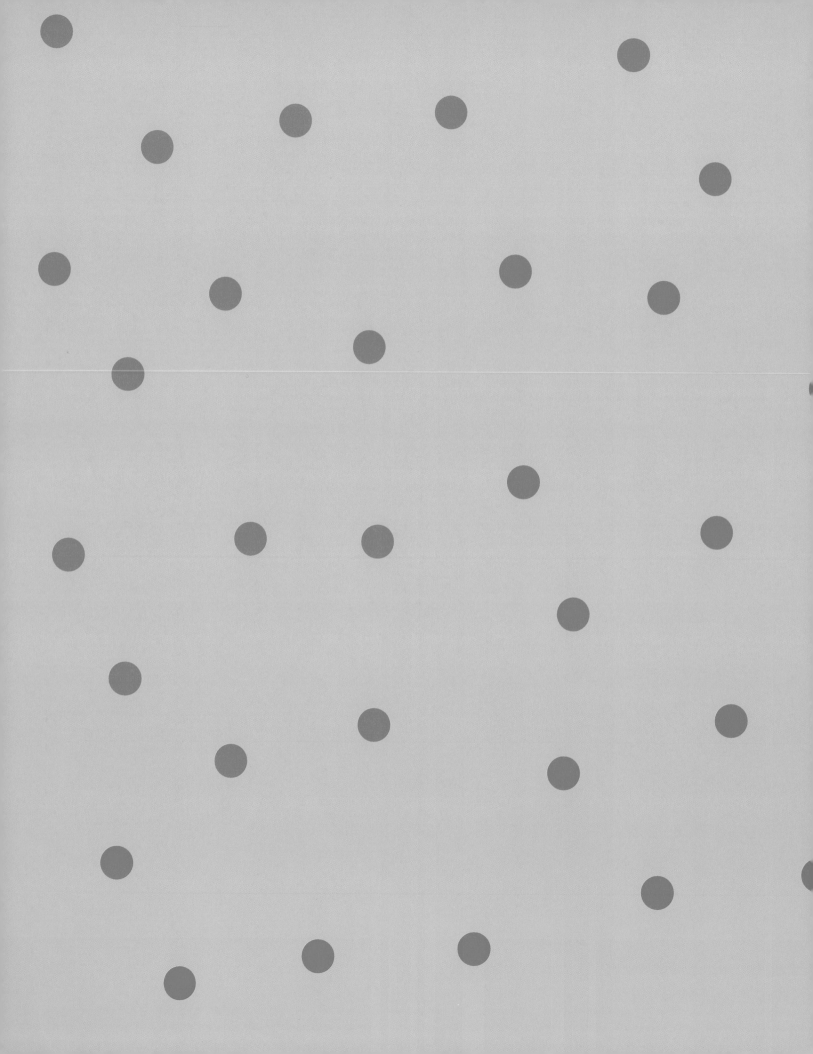

The appearance of blues and reds can change so dramatically that you might wonder which version of the colors is "correct." There is no absolute "correct," but if you want to see what an artist saw while painting a picture, you should view the painting under the same level of light he worked in. It works the other way, too: if a painter knows a work will be displayed in bright daylight, he would do well to create it in bright daylight, or he may be surprised by how it looks when displayed; a painting hung in a very dim corridor may evidence surprisingly bright blues, compared to its appearance in daylight.

To see dynamically how much luminance can change between cone and rod vision, look at this image at dusk or in full moonlight. The blue spots will flicker as your eyes move over it. Are the blue spots lighter or darker than the background? There is no single answer, as our perception of brightness changes depending on light level (and whether rods or cones are responding). Luminance is a perceptual measurement, not a physical constant, and it changes depending on whether we are talking about high or low light levels (whether we are using rods or cones).

Zoo designers take advantage of the insensitivity of rods to red light. They invert nocturnal animals' night and day by putting on white lights during the real night and red lights during the real day. Since the animals, who have rod-dominated retinas, can't see the red light very well, they think red light means night and are consequently active. This makes it possible for the animals to be awake (and more interesting) when the zoo is open, offering zoogoers a more enjoyable experience.

To see how much luminance can change between cone and rod vision, look at this image in moonlight. (For this to work you need to be in lighting conditions that are dim enough that your rods are active.) The blue spots will flicker. When you look directly at any blue spot, it will appear darker than the orange background because the cone-dominated center of gaze is relatively insensitive to blue light. But the surrounding spots will look brighter than the background because they will be perceived predominantly by rods, which are more sensitive to blue light. The flickering arises from the difference in wavelength sensitivity between the cone system and the rod system.

4:

THE FIRST STAGES OF PROCESSING COLOR AND LUMINANCE: WHERE AND WHAT

"IT IS UNFORTUNATELY the case that the analysis and interpretation of colour in paintings lags far behind other aspects of formal historical criticism," wrote art historian John Shearman in 1962. "The subject seems to be in some degree of disrepute, or at the best open to suspicion, and not without reason. It is rare that observations in this field descend from the general to the particular, or from frank subjectivity (even quasi-mysticism) to the admittedly more tedious but ultimately more rewarding objectivity that is, for example, normally regarded as indispensable in modern studies of perspective."

I agree with Shearman that much of what has been written about color in art is nonsense. I suspect that this is true at least in part because, until recently, very little was known about how our brain processes information about color. In order to meaningfully discuss color in art—or in anything else, for that matter—it is imperative to understand that color is important, even essential, in some areas of visual perception and completely irrelevant in others. Some aspects of visual perception—such as object recognition, face recognition, and, of course, color perception—depend heavily on color, and other aspects of vision—such as motion perception, depth perception, figure/ground segregation, and perceiving positional information—are colorblind. In this chapter we will

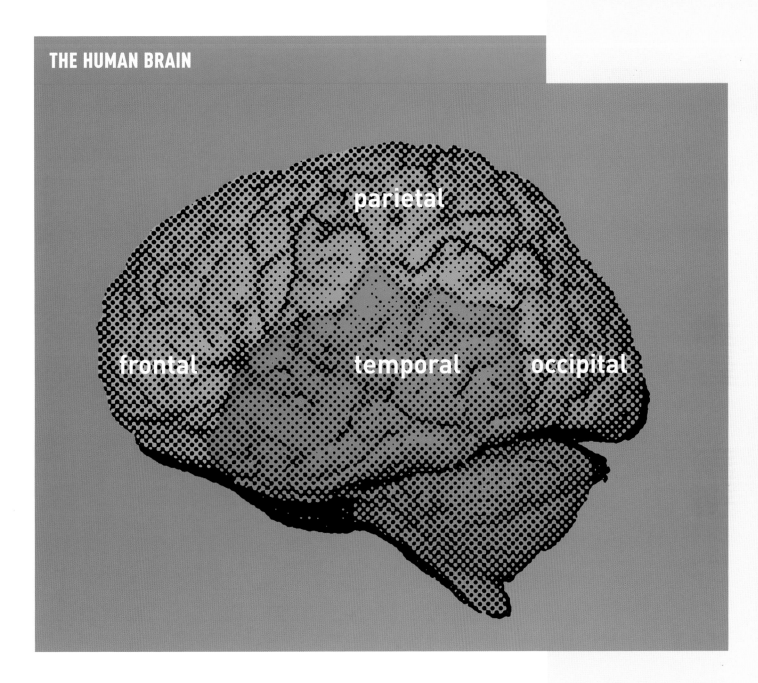

THE HUMAN BRAIN

parietal

frontal temporal occipital

discuss the different kinds of visual information carried by the color-selective and color-blind parts of the visual system.

 Different parts of the brain process different kinds of information. The most fundamental division is between the sensory (input) and motor (output) areas. Within the sensory system—which we will focus on—different areas are concerned with vision, hearing, touch, smell, and taste. The sensory system is hierarchical, with what are termed "lower" areas most directly connected with the sense organs in the periphery, and "higher" areas sequentially connected to each other, eventually converging in polymodal association areas (that is, those that receive inputs from many modalities, such as vision, hearing, and touch) located toward the front of the brain. Though neurobiologists do not yet understand consciousness or sense of self, it is generally agreed that they must

Visual signals are processed first in the occipital lobe, and then higher processing occurs in the parietal lobe and the temporal lobe.

47

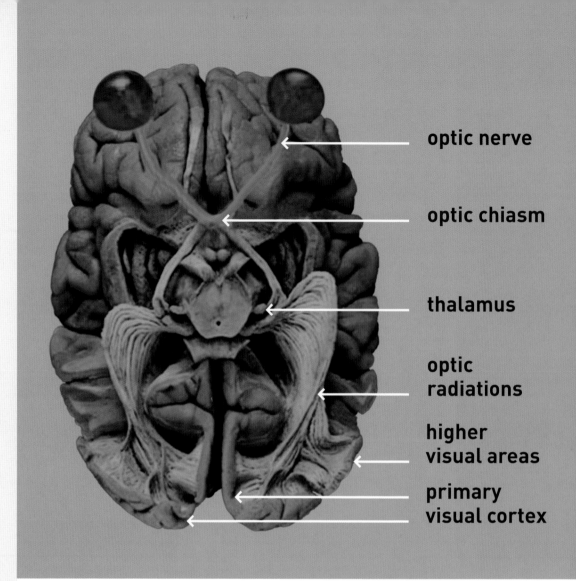

optic nerve

optic chiasm

thalamus

optic radiations

higher visual areas

primary visual cortex

This dissection of a human brain (seen from below) shows the visual fibers passing from the eyes to the thalamus, and from the thalamus through the optic radiations to the primary visual cortex at the back of the brain, in the occipital lobe (modified from Terence Williams).

largely be a consequence of neuronal activity in these higher association areas.

When we perceive someone talking, signals from our eyes are processed by a series of visual areas, the first of which is located at the very back of the brain, with the second, third, and so on, located sequentially farther forward. The person's speech is processed by a similar series of auditory areas. Still higher areas integrate our visual and auditory percepts of this person speaking. When we respond, high-level motor areas, which include speech areas, send signals to sequentially lower motor areas, the lowest of which directly signal the muscles in the mouth, larynx, diaphragm, and tongue to move appropriately to make speech.

On a gross level the visual system is one pathway. In mammals, it goes from the eyes to the thalamus, a way station in the middle of the brain, and from there to the first, or primary, cortical visual area, and then to sequentially higher visual areas. On a finer scale, however, this pathway consists of two major subdivisions. These two systems are anatomically distinct but interdigitated, and they carry different kinds of visual information, in parallel, from the retina to various hierarchical processing areas in the brain.

The segregation of the visual pathway begins in the retina. There are two major classes of retinal ganglion cells (the cells that receive input from the photoreceptors via the bipolar and horizontal cells)—large ones and small ones; you can find both kinds over the whole retina. Each ganglion cell receives input from a small number of photo-

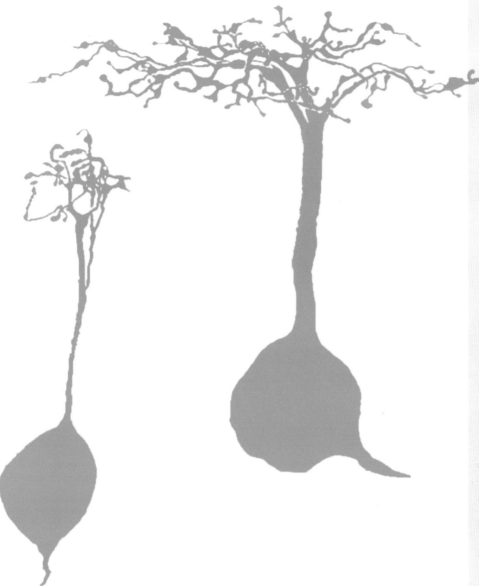

receptors, so each one responds to light over only a tiny part of the retina. The branchy structures at the top of ganglion cells are the dendrites, which receive these inputs. The bigger the dendritic arborization, the bigger the cell's receptive field, the region of visual space to which it responds. The size of the receptive field of a ganglion cell depends on its location. Peripheral ganglion cells have big, bushy dendritic arbors, and those near the fovea—the center of gaze—have very tiny arbors. The receptive fields of foveal ganglion cells are so tiny that they receive input from only a single photoreceptor; the very smallest thing you can see corresponds to the size of your foveal receptive fields. At any point in the retina the large ganglion cells have larger dendritic arbors than the small ones, and consequently have bigger receptive fields. Both large and small ganglion cells project out of the eye via the optic nerve to the thalamus. The little pointed bit at the bottom of each cell in the illustration above is the beginning of the process that projects to the brain.

The distinction between the two sets of information continues in the brain. The small and large ganglion cells project to different sets of layers in the visual subdivision of the thalamus. The two subdivisions of the thalamus then send processes to different layers of the primary visual cortex. This tangle of connections would not be of interest to anyone

The two classes of ganglion cells communicate with different parts of the brain. In this microscopic section of part of the thalamus, each purple dot is a single neuronal cell body (brain cell). The upper four layers receive inputs from the small retinal ganglion cells, and the lower two layers—with larger, darker-staining cell bodies—receive inputs from the large retinal ganglion cells. The two subdivisions of the thalamus project to different layers of the primary visual cortex.

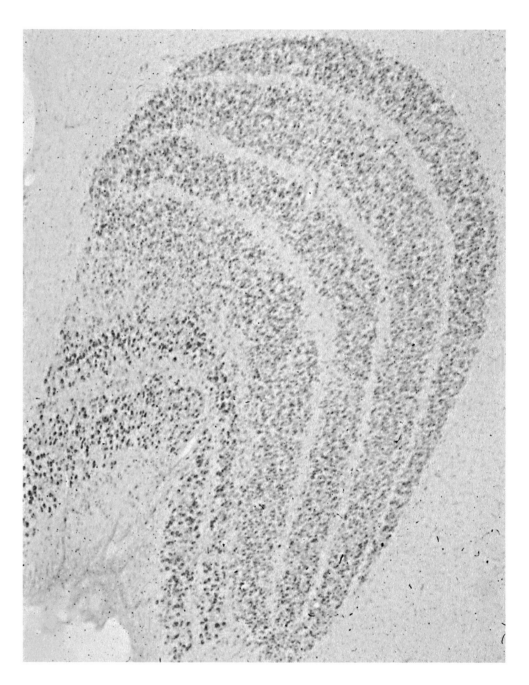

except anatomists, but for the fact that the different subdivisions carry different kinds of visual information.

The evolutionarily older large-cell subdivision, which we share with other mammals, is responsible for our perception of motion, space, position, depth (three-dimensionality), figure/ground segregation, and the overall organization of the visual scene. I will refer to this system as the "Where" system. The small-cell subdivision is well developed only in primates and is responsible for our ability to recognize objects, including faces, in color and in complex detail. I will refer to this newer system as the "What" system.

The Where and What systems differ not only in the kind of information they extract about the environment, but also in four fundamental ways in which they process the light signals they receive.

COLOR SELECTIVITY: the Where system is colorblind; the What system uses and carries information about color.

CONTRAST SENSITIVITY: the Where system has a very high sensitivity to small differences in brightness (high contrast sensitivity); the What system requires larger differences in brightness (low contrast sensitivity).

SPEED: the Where system is faster and more transient—its responses are of shorter duration—than the What system. This will not be relevant to most of our discussions of static art, though the temporal properties of the Where system are doubtless important for its role in the motion perception.

ACUITY (RESOLUTION): the Where system has a slightly lower acuity (by a factor of two or three) than the What system.

THE PRIMATE VISUAL SYSTEM, COMPRISED OF THE WHAT SYSTEM (TAN) AND THE WHERE SYSTEM (BLUE)

A diagram of the primate visual system, with the What system indicated in red and the Where system in gray. In the retina, thalamus, and early cortical areas, the Where and What system are physically interdigitated, yet they keep the information they process largely separate. At higher levels the two subdivisions become more physically segregated.

WHERE SYSTEM
motion perception
depth perception
spatial organization
figure/ground segregation

colorblind
fast
low acuity
high contrast sensitivity

higher
visual
areas

primary
visual
cortex

midbrain

retina

color selective
slow
high acuity
low contrast sensitivity

WHAT SYSTEM
object recognition
face recognition
color perception

The What system is itself subdivided into a Form system, which uses both color and luminance to define the shape of objects, and a lower resolution Color system that defines the colors of surfaces.

It is not immediately obvious, first, why the task of vision should be subdivided, and, second, why, given the subdivision of tasks, the two subsystems should differ in color, acuity, speed, and contrast sensitivity. There are two explanations for this situation, both of which have to do with evolution.

The first addresses the mechanism of how evolution goes about changing a system. The Where system in humans and other primates is similar to the entire visual system of lower mammals. Lower mammals are much less sensitive to color than we are, and they are not able to scrutinize objects and accurately discriminate them on the basis of visual attributes. Instead they are sensitive to things that move, because things that move— either prey or predator—are likely to be important. Also, since the primitive visual system must have been used for navigating through a three-dimensional environment, it must have been able to process depth information and distinguish objects from the background. As the more complicated primate visual system evolved, the original system was maintained, probably because it was simpler to overlay color vision and object recognition onto the existing system than it would have been to incorporate the two. The What system is a primate add-on.

The second level of explanation for the segregation of our visual system is that it is more efficient to carry information about—and make calculations about—an object's appearance (its shape and color) separately from information about its position and trajectory. The different subdivisions can then be optimized for the different kinds of information processing they need to do. The brain needs to connect cells carrying the same kind of information in order to process this information, and it is more efficient to make connections between nearby cells than to wire together ones that are anatomically segregated.

Engineers in high-definition TV (HDTV) development and in computer graphics and animation arrived at similar design strategies eons after they evolved in our visual systems: the engineers have devised highly efficient ways of transmitting images to avoid having to constantly redefine every pixel in an image. One method is to redefine only those pixels that change (just as our Where system does). A more sophisticated algorithm is to define an object's shape and color independently from its position and trajectory— echoing the subdivisions of our visual systems.

Of the differences between the What and the Where systems, we will focus mostly on the difference in the way they use color. The Where system is colorblind—it sees in shades of gray—whereas the What system is color selective. By "color selective" I mean two things: first, that cells in the Color subdivision of the What system actually code the color of surfaces. Second, the cells in the Form subdivision of the What system can use color differences to detect borders, without caring about which colors define those borders.

CENTER/SURROUND: THE FIRST STEP IN VISUAL INFORMATION PROCESSING

As we have said, vision is information processing, not image transmission. At every stage in vision, neurons perform calculations or operations on their input signals, so that the end result is information about what is out there in the world, and how to act on it—not a picture to be looked at.

In 1953 the neuroscientist Stephen Kuffler discovered the first and most fundamental step in visual information processing. He recorded activity from retinal ganglion cells and found that he could activate the cells (make them signal) with small spots of light. This alone was not news, since it had been clear for centuries that the eye responds to light. What was surprising, though, was that small spots activated the cells better than large spots. Each ganglion cell was optimally activated by a tiny spot of light at some particular spot on the retina, its receptive field. Kuffler deduced that the reason large spots of light were ineffective was that ganglion cells were not only excited by light impinging on their receptive-field centers, but they were also inhibited by light falling on the immediately surrounding region. This organization is called center/surround.

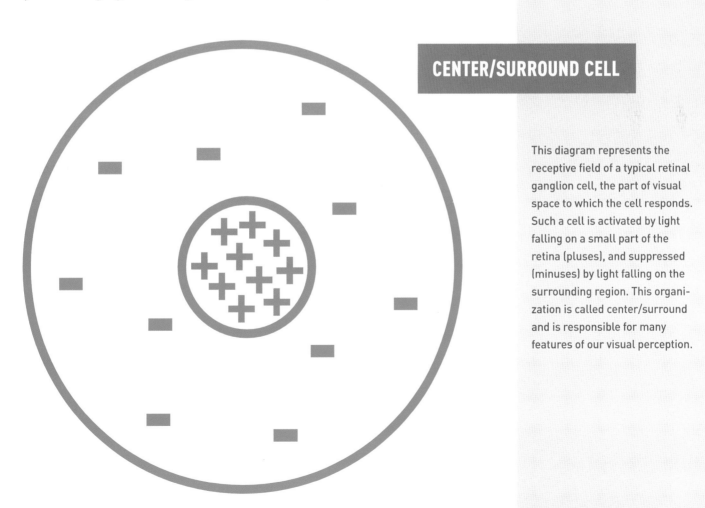

CENTER/SURROUND CELL

This diagram represents the receptive field of a typical retinal ganglion cell, the part of visual space to which the cell responds. Such a cell is activated by light falling on a small part of the retina (pluses), and suppressed (minuses) by light falling on the surrounding region. This organization is called center/surround and is responsible for many features of our visual perception.

David Hubel and Torsten Wiesel made this figure, showing the center/surround organization in the thalamus. These responses are exactly like those of retinal ganglion cells. The diagrams on the near right indicate the visual stimuli: a tiny spot of light, a slightly larger spot of light, a large spot of light, and an annulus of light. The corresponding responses of a thalamic cell are shown on the far right. The horizontal axis represents time (three seconds for each trace), and the line above each trace indicates the period during which the light was turned on. The vertical lines reflect the cell's electrical signals; each line represents a single signal (action potential). The cell responds to the tiny spot of light with a barrage of action potentials. It gives an even better response to the slightly larger spot, but the response to the largest spot is much reduced. The cell shows a suppression of spontaneous activity in response to an annulus of light, which indicates surround inhibition. In the bottom row, the firing after the annulus is turned off is called an after discharge and represents a release from inhibition.

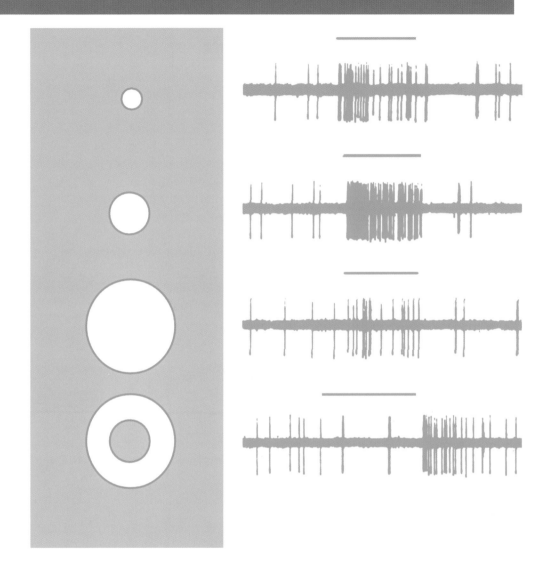

Cells at the next stage of processing, in the thalamus, show a similar center/surround organization. David Hubel and Torsten Wiesel, both of whom trained with Stephen Kuffler, measured the electrical impulses generated by thalamic neurons in response to spots of light of different sizes. The cell shown here gave a barrage of responses to small spots, responded much less to the largest spot, and was suppressed by an annulus (a ring) of light, which reflects the surround inhibition.

Center/surround organization makes cells at these early stages of the visual system sensitive to discontinuities in the pattern of light falling on the retina, rather than to the absolute level of light. Because of center/surround organization, neurons respond best to sharp changes, rather than to gradual shifts in luminance. The visual system is wired up in this way so that it can ignore gradual changes in light and the overall level of the illuminant, which are usually not biologically important.

It makes biological sense for our visual system to be designed in this way, because it is

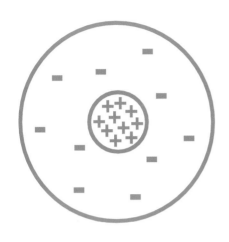

diffuse white light

tiny white spot

light/dark contour

much more efficient to encode only those parts of the image where there are changes or discontinuities than to encode the entire image. The most information in an image is in its discontinuities.

This issue of efficiency of information coding may be familiar to you as the problem of storing computer image files. If you want to make a digital image of a simple scene consisting of a red square on a black background, you could record the luminance of each of the pixels at every point in the scene (e.g., as an RGB Photoshop image); this could result in a file many megabytes in size. Alternatively, you could code the image more efficiently by defining the two colors present, defining the border of the square, and indicating which color is on the inside and which on the outside. Image compression algorithms, such as JPEG, do just that and can save a lot of memory. For example, I made a large Photoshop image of a red square on a white background, and JPEG compressed it from 300 megabytes to 1.

The visual system also compresses images, first of all because it takes energy for nerve cells to signal, so the fewer cells that signal, the better. Second, higher-level visual processing, such as object recognition, is essentially the end result of extracting the information content of an image.

Center/surround organization makes retinal ganglion cells selectively responsive to discontinuities in light. White indicates light falling on some part of the receptive field; dark represents reduced light falling on that region. This particular cell is shown as having just as many excitatory inputs as inhibitory inputs (ten each), though cells are in reality not always perfectly balanced. Left: Surround antagonism means that this cell will not respond well to diffuse light because the surround inhibitory inputs (minus ten) exactly balance the excitatory center inputs (plus ten) giving an overall response of zero. Center: This cell will respond strongly (plus ten) when stimulated by an optimal-ly sized spot of white light on a dark background, since the entire center is excited (plus ten), but the surround is unaffected (no minuses). Right: This cell will also respond, though not as strongly, to a border between light and dark because, although part of the surround is stimulated by the white half of the stimulus (minus six), the entire center is stimulated (plus ten), giving an overall plus four response. This cell would respond even better to a corner. Responding to spots, corners, and edges is informationally more efficient than responding to light at every point in the scene.

Whoa, did you see that?

From knowing how cells respond to big and little spots of light, you may be able to figure out why you see twinkling black dots over the white dots in the "scintillating grid" illusion on the endpapers of this book. The scintillating grid illusion was recently discovered by Elke Lingelbach and is a more powerful version of the Hermann grid illusion, shown here, discovered in 1870 by Ludimar Hermann. When you look at this image you probably see faint dark dots at the intersections of the white lines. These illusory spots are perceived because the center/surround cells that signal the white of the intersections are more suppressed (by the four bits of white lines in their surrounds) than are the center/surround cells that signal the white of the lines between the intersections (because they have only two bits of white line in their surround), as diagrammed in the lower right corner. Thus the cells responsible for signaling whiteness at the intersections are more suppressed, and therefore less active, than the cells signaling whiteness along the lines between the inter-sections, so the intersections look less white, and therefore dark.

In the scintillating grid illusion, the dots at the intersections flicker, probably because there is a slight timing difference be-tween center responses and surround responses, with the center responses being brisker and more transient than surround re-sponses. Thus, every time our eyes shift position, the cells signal-ing white at the intersections first give a strong center signal in response to the white dots at the intersections, but then their signal is reduced (and this reduction is perceived as a darkening of the spot) as the surround inhibition kicks in.

Because the size of our receptive fields changes with distance from the center of gaze, the size of the intersections will match our receptive-field center size only at a certain distance from the center of gaze, so we see the flashing dots in our peripheral vision only at arm's length. The flashing dots can be seen more centrally if viewed from ten or twenty feet away.

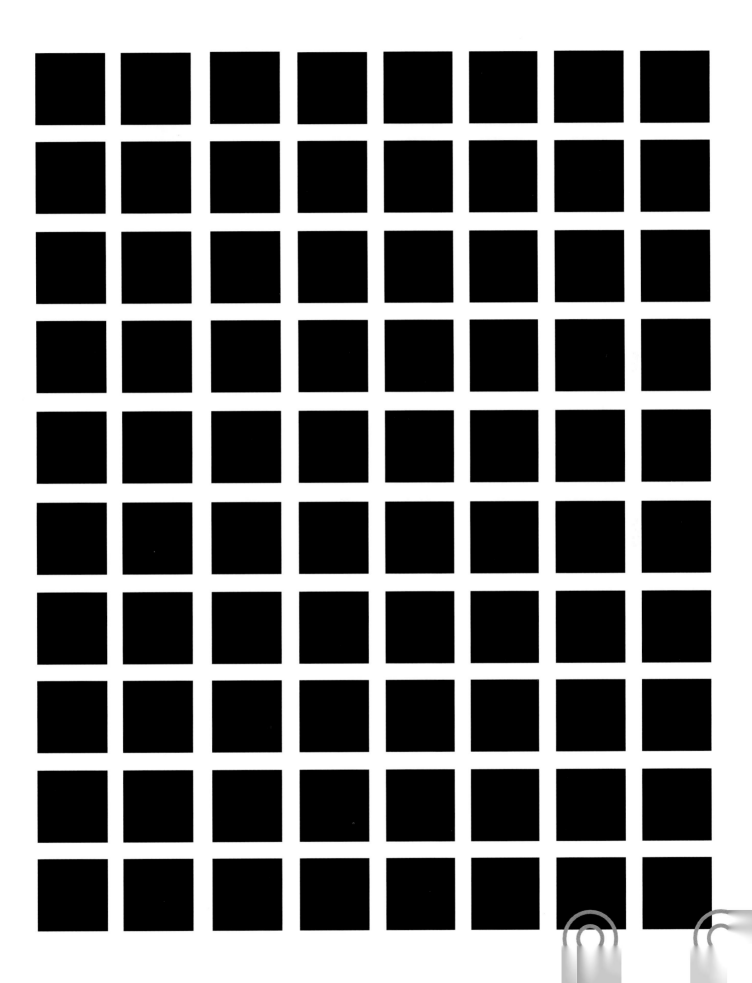

Greater sensitivity to abrupt than to gradual changes is true for many sensory perceptions due to center/surround organization. This image illustrates this point for luminance. Most people perceive the entire left half of the panel above to be lighter than the entire right half, though actually the left and right outer fourths are identical. The actual luminance profile is graphed below the panel. Going from left to right, the luminance is at first constant, and then it gradually increases, abruptly decreases at the midline, and then increases before becoming flat again, at exactly the same level as on the far left. The center/surround organization of the cells in our visual system makes them more responsive to the abrupt light-to-dark transition at the middle than to the gradual changes on either side. Therefore, the entire left side seems lighter than the right.

Many visual perceptions, such as luminance, color, motion, and depth, exhibit greater sensitivity to abrupt than to gradual change, and in each modality this selectivity is due to an underlying center/surround organization. The image above illustrates this point for luminance with the Cornsweet illusion. The center/surround organization of the cells in our visual system makes us more sensitive to the light-to-dark transition at the middle than to the gradual changes of exactly the same magnitude on either side of this discontinuity.

As biological entities we are interested in obtaining information about surfaces around us; we are usually not interested in information about the nature of what is lighting them, either how bright it is or its color. We see just fine over a 100,000-fold range of light levels, and the wavelength composition of the illuminant can change drastically without our noticing much difference. If we look at a newspaper in bright sunlight, for example, we see the headline as black and the page as white. If we look at that same newspaper at night in a room lit by a single forty-watt bulb, we still see black type on a white page, even though the white of the page in the darkened room reflects about 1000 times less light than the black headline did in the sunshine. One could argue that much of this adaptation to light level is done by the size of the pupil and by the level of light adaptation of the visual system, but that is not the whole explanation.

In the photograph of the newspaper on the facing page, we can see the headline as black and the page as white, even though parts of the headline are actually lighter than parts of the page. Because our pupil size and the adaptation level of our retinas don't change as we look at this single image, they can't account for this paradoxical luminance percept. So the explanation must be due to the fact that the visual system ignores the gradual change in luminance due to the shadow of the tea canister and instead registers predominantly local differences in luminance—the letters against the page—by virtue of center/surround organization.

As we shall see, artists can take advantage of the fact that our visual systems are selectively sensitive to discontinuities and not to gradual changes in luminance to expand the

 This is the same gray as the center of the **O** in **OFF**

 This is the same gray as the top part of the **S** in **GLOVES**

THE THREE KINDS OF CELLS FOUND IN THE THALAMUS

red center

green center

blue center

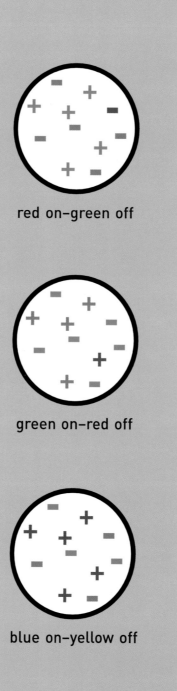

red on–green off

green on–red off

blue on–yellow off

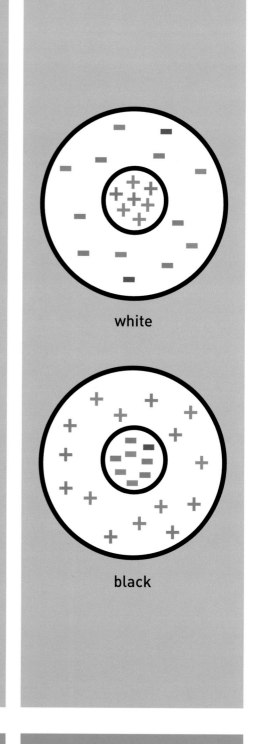

white

black

TYPE 1 CELLS

TYPE 2 CELLS

WHERE-SYSTEM CELLS

apparent range of reflectances of paints. Although a real scene may well contain a very large range of luminances, each part of the scene is analyzed separately by the visual system. Therefore by introducing gradual changes in the background luminance, the artist can induce opposite apparent shifts in the luminance of the foreground, which add to the perceived luminance of the foreground.

Another way artists take advantage of our selective sensitivity to discontinuities is by making line drawings. Line drawings can be excellent representations of reality, yet there are very few lines in real life. There are contours, which are borders between regions of different color or lightness, but there are rarely actual lines, which are thin regions of a different color or lightness than the background. An artist will represent a contour by a line, even though a contour is not a line, and we have no problem interpreting it as it was intended. Even babies, who have not learned the convention of line drawings, have no trouble recognizing line drawings of familiar objects.

In addition to measuring the reactions of retinal and thalamic cells to different kinds of visual stimuli, Hubel and Wiesel distinguished these cells on the basis of which cones provide input to the center and which to the surround of the receptive field. Three types of cells—called, not very descriptively, Type 1, Type 2, and Type 3—emerged. Small retinal ganglion cells and cells in the small-cell layers of the thalamus have receptive fields like the ones labeled Type 1 here. These cells have tiny receptive fields, with the center receiving inputs from only one cone type; they are color selective because they are excited by one range of wavelengths and suppressed by others. That is, their responses change depending on the color of the stimulus. It is hotly disputed whether the surround of these cells is color selective or not, so it is probably best to stay away from that question for now. Near the center of gaze these cells are so small that the receptive-field center receives input from just a single cone.

Type 2 cells are excited by one color and inhibited by another—that is, they show color-opponent responses—and they are unresponsive to white light. Most researchers now think these cells are the first stage in color perception. They have quite large receptive fields, color-opponent centers, and no surrounds.

Type 3, or Where system, cells are neither color selective nor color opponent: they are colorblind. They respond to local light increments or local light decrements, irrespective of the light's color.

photoreceptors

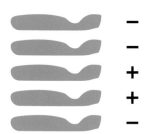

−
−
+
+
−
−

center/surround cell

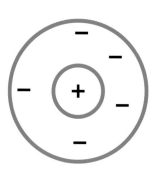

center/
surround
cells oriented cell

receptive field
of oriented cell

oriented
cells extended
contour cell

receptive field
of extended
contour cell

EDGE DETECTORS: THE SECOND STEP

When David Hubel and Torsten Wiesel were young postdoctoral fellows in the late fifties, they set about studying the responses of neurons in the visual cortex. Physiologists study thousands of cells and usually number each one. Embarrassed by how green they were, Hubel and Wiesel didn't want to be seen recording from cells labeled merely 1 or 2, so they numbered their first three cells 3001, 3002, and 3003.

They knew that their mentor, Stephen Kuffler, had found that thalamic cells respond to small but not large spots of light, so they made up glass slides with pieces of black paper glued to them so they could project light and dark spots onto a screen. They found one very nice cell, number 3006, that seemed slightly responsive to a dark spot pasted on a glass slide, so they kept moving the slide around in the projector to try to get the cell to respond reproducibly. After nine hours on that one cell, they finally figured out that it was not responding to the dark spot on the slide, but instead to the faint shadow cast by the edge of the slide every time they moved it in and out of the projector! What's more, they fiddled with the slide and realized that the cell responded only when the shadow was horizontal, and not any other orientation. Later they found other cells that preferred other orientations, suggesting that the next step in visual information processing, after center/surround organization, is edge detection.

Hubel and Wiesel realized that retinal ganglion cells, thalamic cells, and visual cortical cells represented a hierarchy in visual information processing. Retinal ganglion cells and thalamic relay cells have circular center/surround organization, in luminance or color, as discussed above. But in the visual areas in the brain, further integration of signals from the thalamus leads to selectivity for contours of various orientations, as diagrammed here. That is, retinal and thalamic cells are selectively responsive to discontinuities, regardless of their orientation, but many cortical cells are selective for the orientation of these borders. You could imagine a border being coded by tiny dots, each representing a single ganglion cell, or by one or two lines, representing the elongated cortical cells.

We have cells in our visual cortex representing each orientation at each point in the visual field. In the first cortical visual area, cells are responsive to contours of a particular orientation. At each successive stage in visual processing, neurons become selective for more precise features, such as extended contours, corners, curvature, and so on, over larger and larger regions of the visual field. We do not yet understand very much about higher visual areas and what complex features they code for, though neurons that are selectively responsive to faces have been described.

The first three steps in visual information processing. Top: Center/surround cells in the retina and midbrain are excited by inputs from some photoreceptors and suppressed by adjacent ones. Center: In the primary visual cortex (in the brain), groups of several center/surround cells with aligned receptive fields create orientation-selective cells that respond to oriented contours, or edges. Bottom: At subsequent processing stages, inputs from several oriented cells are integrated to generate responsivity to extended contours, or to discontinuous or occluded contours.

THE ROLE OF THE WHAT SYSTEM IN VISUAL PERCEPTION

As we have seen, in the initial stages in the visual system (in the eye, midbrain, and first cortical visual areas) the Where and What subdivisions are intimately interdigitated, but they become separate later on. The higher levels of the Where system are located above the ears, in the parietal lobe, and the higher levels of the What system are located in front of the ears in the temporal lobe. Because these areas are distinct, people can experience damage (such as a stroke or injury) to one system without the other being affected at all.

When people suffer damage to the What system, they have trouble recognizing objects, animals, people, or colors, and, in some lesions, the visual losses can be surprisingly specific, indicating a high degree of functional specialization. People can lose the ability to recognize colors but not the ability to recognize objects, or vice versa, in some kinds of strokes, evidence that the What system is further subdivided into a Color system and a Form system. The process of object recognition must also be further subdivided, because strokes can occasionally result in surprisingly specific losses of object recognition abilities, such as the ability to recognize only living things, or the ability to recognize fruits or vegetables. Not uncommonly, small lesions in the temporal lobe can result in the selective loss of the ability to recognize faces, but not any other kind of object.

Oliver Sacks has written about an artist who had a brain injury that caused him to lose his color perception while retaining all other visual abilities. He was still able to recognize and render objects, but his entire world—even the world he saw while thinking and dreaming—became gray and drab. He was profoundly disturbed by the wrongness of the appearance of everything he saw. He said that people looked like "animated gray statues," and he found their gray flesh abhorrent, so he began to shun people and social intercourse. Foods looked disgusting to him, so he had to close his eyes to eat. Finally, he began to eat only achromatic foods, like black olives, white rice, black coffee, and yogurt, because only they appeared relatively normal.

Look back at the three boat paintings on page 34. On the right is the copy this artist made after his injury. It shows that his form perception and drawing ability were intact, but his color perception was completely gone. He was much more profoundly colorblind than the red/green colorblind patient.

Some patients with What system (temporal lobe) lesions can quite accurately copy drawings of objects without having the slightest idea what the objects are. People with a lesion in a slightly different part of the temporal lobe find that they cannot recognize previously familiar faces, either famous people, or family members or friends. One such stroke victim told his doctor, "I can see the eyes, nose, and mouth quite clearly, but they just don't add up. They all seem chalked in, like on a blackboard. . . . I have to tell by the clothes or by the voice whether it is a man or a woman. . . . The hair may help a lot, or if there is a mustache." He continued, "At the club I saw someone strange staring at me, and asked the steward who it was. You'll laugh at me. I'd been looking at myself in a mirror."

The Color part of the What system has a considerably lower acuity (lower resolution) than either the Form part of the What system or the Where system; this is consistent with the much larger receptive fields of color-opponent cells. The Form part of the What system, however, is much higher resolution and is responsive to color borders at all relative lightnesses because of the different color selectivities of various Type 1 and Type 2 cells.

People with strokes in the temporal lobe can lose the ability to recognize objects, even when they can still see them perfectly well. One such patient was given a pen and was asked to copy the drawings in the left column. Not being able to recognize any objects, he was functionally blind, but he could slavishly copy contours quite accurately (from Farah, 1990).

The low acuity of the Color system may explain a comment the colorblind artist made about his vision shortly after his accident in a letter he wrote to Oliver Sacks: "Within days I could distinguish letters and my vision became that of a eagle—I can see a worm wiggling a block away. The sharpness of focus is incredible. BUT—I AM COMPLETELY COLORBLIND." Perhaps his vision seemed to be of higher resolution because of the loss of the low-acuity Color system.

THE ROLE OF THE WHERE SYSTEM IN VISUAL PERCEPTION

Imagine a red spot on a green background. In a black-and-white photograph, it would appear as a gray spot on a gray background, with the spot and the background differing only in luminance. Imagine that you varied the relative brightnesses of the red spot and the green background, so that the spot was exactly the same shade of gray as the background in your black-and-white photo. That point when the red and green have the same luminance is called equiluminance—or equal value, as artists put it. This book contains many examples of surprising effects that can be achieved by using equiluminant colors.

These effects come about because the Where system, which plays particular roles in perception, cannot distinguish between equiluminant colors. To explain the role of luminance in perception, and the special effects that can be achieved by stimuli that are invisible to that system, I will discuss what is known about the function of the Where system in vision.

When the Where system is damaged, people have trouble telling where objects are; they have trouble seeing motion and depth, reaching for things, telling left from right, and seeing complex objects as whole. Much of our knowledge of the function of the Where system comes from neurological studies of symptoms of people who have suffered damage to the parietal lobe. One of the best descriptions of the result of parietal damage was written by a patient himself, a Russian soldier named Zasetsky, who suffered a bullet wound to his left parietal area during World War II. Zasetsky described his vision as being severely disorganized and spatially fractured, though his recognition of individual objects was unimpaired. He had trouble grasping objects that he could plainly see because they would turn out to be to one side or the other of where they appeared to be. He had trouble seeing entire objects or scenes and could only see one small part at a time. He could not distinguish right from left. The Where system is responsible for motion perception and spatial perception; Zasetsky says the world would "glimmer fitfully and become displaced, making everything appear as if it were in a state of flux."

The neurologist Josef Zihl recently described a stroke victim who had had bilateral damage in her parietal lobe that apparently selectively affected just her motion perception. She said it was as if the world were entirely static. She had trouble crossing streets because she could not judge the speed of approaching cars: "When I'm looking at the car first, it seems far away. But then, when I want to cross the road," she reported, "suddenly the car is very near." She eventually learned to estimate the distance of cars by their sound. She had trouble pouring a cup of tea, because the fluid appeared frozen, like a glacier. What's more, she could not stop pouring at the right time since she was unable to perceive the rising level of the tea in the cup.

Special Properties of Equiluminant Colors

An object that can be seen by both subdivisions of the visual system will be perceived accurately. It will appear to move correctly or appear stable and appropriately three-dimensional. But if the two subdivisions are not balanced in their response to an object, it may look peculiar. For example, an object defined by equiluminant colors can be seen by the What system but is invisible (or poorly seen) by the Where system. It may seem flat, it may seem to shift position, or it may seem to float ambiguously because there is too little luminance contrast to provide adequate information about its three-dimensional shape, its location in space, or its motion (or lack of it). Conversely, something defined by very low contrast contours is seen by the Where system but not the What system and may seem to have depth and spatial organization but no clear shape.

Equiluminant colors have long been recognized by artists as being special because they can generate a sense of vibration, motion, or sometimes an eerie quality. This strange quality arises because the What system can see something that the Where system cannot; with only What system activation in isolation we can identify a particular object, but its position and motion (or lack of motion) are indeterminant.

Some art schools offer entire courses devoted to the study of color value. This is partly because in order to use luminance effectively for, for example, shading, an artist must be able to judge value independent of color. In addition, being able to recognize equiluminance is important because of its interesting effects.

There are several reasons why true equiluminance is difficult to achieve. The Where system is very sensitive to luminance contrast (that is, it has a very high contrast sensitivity), so only a small luminance contrast is enough to stimulate it maximally. Moreover, people differ in their equiluminance points, so a color combination that is exactly equiluminant for me may not be for you. Lighting conditions can also alter color values, so that a pair of pigments that may be equiluminant under sunlight may not be equiluminant under tungsten illumination. Lastly, for most people, the equiluminance point varies with distance from the center of gaze. Nonetheless many artists do attain equiluminance, at least for some people, often with compelling results.

For example, *Plus Reversed* by Richard Anuszkiewicz gives a jarring, jittery impression because the red and green are equiluminant. The figure/ground reversal is compounded by the difficulty in perceiving a figure/ground organization with equiluminant colors. The What system can see the shapes because of the strong color contrast, but the Where system can't see them well, or even at all, depending on your personal equiluminance point. If the Where system can't see them, it can't assign them positions, so the figures seem unstable and jittery. If you take this image into places with different kinds of illumination—fluorescent, tungsten, or sunlight—you may find that it becomes more or less jittery, because the relative luminances of the two colors will vary slightly with illumination. Because the Where system has a very high sensitivity and transient responses, it interprets both of these equiluminant colors as being simultaneously lighter and darker than the other, which makes the painting appear to pulsate. Every time you move your eyes, you renew the conflict in which each figure seems to be both lighter and darker than its background.

The red and green in Richard Anuszkiewicz's 1960 *Plus Reversed* seem to move around because they are equiluminant. The What system can see the shapes because of the strong color contrast, but since the Where system can't (because it cannot distinguish equiluminant colors), it can't assign them positions, making the image seem unstable and jittery. (©Richard Anuszkiewicz/Licensed by VAGA, New York, NY)

5:

ACUITY AND SPATIAL RESOLUTION: CENTRAL AND PERIPHERAL VISION

Opposite: Our vision is sharpest right at the center of gaze. Acuity decreases dramatically as distance from the center of gaze increases. If you fixate on the center dot in this illustration, all the letters are equally readable because their size has been scaled in exact proportion to your changing acuity (from Stuart Anstis).

WE HAVE SURPRISINGLY low visual acuity (resolution) in parts of the visual field that are not at the center of where we are looking—the center of gaze. We are not aware of this, because we usually move our center of gaze to whatever we want to look at.

To see for yourself how dramatically acuity falls off with eccentricity (distance from the center of gaze), try looking fixedly at a single letter in the center of this page, and then notice how well you can see letters at either edge or the top or bottom without moving your eyes. You will probably find that you can see the letters beyond the one you are fixating on, but you can resolve only a few of them. The diagram opposite shows how dramatically acuity falls off with eccentricity.

The reason that our vision is so much sharper in the center of gaze than in the rest of the visual field is that the part of the retina at the very center/back—the fovea—is specifically designed to have the highest possible acuity, limited only by the requirement that photo-receptor cells be some minimum size consistent with being alive. If you look at the fovea with an ophthalmoscope, it appears as a tiny, pale spot, pale because all the blood vessels and cell layers in front of the photoreceptor layer are shifted aside so that light has the clearest possible path to the photoreceptors.

The fact that our vision has the highest acuity in the center of gaze does not mean that vision in the rest of the visual field is inferior—it's just used for different things. Foveal vision is used for scrutinizing highly detailed objects or surfaces, whereas peripheral vision is used for organizing the spatial scene, for seeing large objects, and for detecting areas to which we

O

H J

D W T

A K

P

F Q B

U H O

R

K N G A Y L

Z Q M

B W T

V G J

M

P

B

C

S Y

R

F

ganglion cells

bipolar and horizontal cells

cell bodies ⎫
outer segments ⎬ photoreceptors
pigment cells ⎭
blood supply

CROSS SECTION OF AN EAGLE RETINA THROUGH THE FOVEA

ganglion cells

bipolar and horizontal cells

cell bodies ⎫
outer segments ⎬ photoreceptors
pigment cells ⎭

The center of the eyeball is upward in these retinal cross sections. Light comes in from the top and passes through the various cell layers before hitting the photoreceptor outer segments (the part of the photoreceptors that catch the light). Any light that is not absorbed by the photoreceptors is captured by the pigment layer, preventing it from reflecting back, which would lower acuity. At the center of gaze (the fovea) there is a pit, or depression, in the layers above the photoreceptor outer segments. This pit is formed because the ganglion, bipolar, and horizontal cell bodies shift to the side (to reduce interference in the light path) though they remain connected by processes to the central photoreceptors. The photoreceptor cell bodies are also displaced away from the fovea, remaining attached to their outer segments by fine connecting processes, and the outer segments themselves are longer and thinner in the fovea, to allow tighter packing. This permits much higher resolution in the center of gaze than is possible even a few degrees away.

Eagles have exceptionally sharp vision; their acuity is several times higher than that of humans. As you can see in this cross section of the fovea of the golden eagle, the eagle's foveal pit is very deep. Eagles' foveal photoreceptor outer segments are even thinner than humans', which means that they can be packed more tightly together. This increased density of photoreceptors requires many more ganglion cells and other retinal cells that receive inputs from the photoreceptors. The greater number of retinal cell bodies that are shifted laterally in the fovea creates the greater depth of the foveal pit (from Polyak, 1948).

should direct our foveal vision. Our foveal vision is optimized for fine details, and our peripheral vision is optimized for coarser information.

Even though our central vision has the highest acuity and seems more directly connected to our conscious visual perception, our peripheral vision is also important in a different way. Try looking at the world through a paper-towel tube, and you'll see what I mean. Because our peripheral vision is tuned to coarser information than our foveal vision, it can actually see things our central vision can't: for example, Mona Lisa's smile!

It can be hard to look at a famous painting such as Leonardo da Vinci's *Mona Lisa* and really see it—"A fame as great as that of Leonardo's *Mona Lisa* is not an unmixed blessing for a work of art," says art historian E. H. Gombrich in *The Story of Art*. "We become so used to seeing it on picture postcards, and even advertisements, that we find it difficult to see it with fresh eyes as the painting by a real man portraying a real woman of flesh and blood."

But it is a worthwhile exercise nonetheless, to "forget what we know, or believe we know, about the picture, and to look at it as if we were the first people ever to set eyes on it," Gombrich continues. "What strikes us first is the amazing degree to which Lisa looks alive. She really seems to look at us and to have a mind of her own. Like a living being, she seems to change before our eyes and to look a little different every time we come back to her. Even in photographs of the picture we experience this strange effect, but in front of the original in the Louvre it is almost uncanny. Sometimes she seems to mock at us, and then again we seem to catch something like sadness in her smile. All this sounds rather mysterious, and so it is; that is so often the effect of a great work of art."

I took Gombrich's advice and looked at the *Mona Lisa* (see page 72) as if I had never seen the painting before, and indeed I noticed something I had not seen previously. See if you experience the same thing I did. Look at her mouth, and then look at the background. Look at her mouth again, and then her eyes. Look back and forth between her mouth and other parts of the painting. As I did this, I realized that her smile seemed most apparent and cheerful when I was looking away from it, and it seemed less evident when I looked directly at it.

The fact that her expression changed systematically with how far my center of gaze was from her mouth suggested to me that her lifelike quality might not be so mysterious after all, but rather that her smile must be differentially apparent in the different ranges of image detail characteristic of the different parts of the visual field. To see how Mona Lisa's smile would look at various eccentricities, I processed an image of her face to selectively show fine, medium, or coarse components of the image (see page 73). A clear smile is more apparent in the coarse and medium component images (left and center) than in the fine detail image (right). This means that if you look at this painting so that your center of gaze falls on the background or her hands, Mona Lisa's mouth—which is then seen by your peripheral, low-resolution, vision— appears much more cheerful than when you look directly at it, when it is seen by your fine-detail fovea. (Of course you would never see anything like the right panel normally, because the region of fine-detail vision is so small that you aren't able to see her entire face with it.)

This explanation goes beyond the popular idea that Leonardo blurred Mona Lisa's mouth (used sfumato) to make her expression ambiguous. That hypothesis would mean that her smile would vary depending on the viewer's imagination or state of mind, but I think its variability is more systematic than that. I suggest that her smile is more apparent in the coarse-information component of the image, and is therefore more apparent to peripheral than to central vision. This explains its elusive quality—you literally can't catch her smile by looking at it. Every time

you look directly at her mouth, her smile disappears because your central vision does not perceive coarse image components very well. People don't realize this because most of us are not aware of how we move our eyes around or that our peripheral vision is able to see some things better than our central vision. Mona Lisa smiles until you look at her mouth, and then her smile fades, like a dim star that disappears when you look directly at it.

Facial expressions may be more apparent in the coarse image components than in the finer ones even in real life, because they depend on deep facial muscles, and changes in underlying muscle activity can be effectively blurred by subcutaneous fat. Therefore it may be that our ability to correctly interpret facial expressions in general is better in our peripheral vision than in the center of gaze. To extend this idea, I suggest that the image components used in identifying individual faces may be different from the image components used to identify emotional states. Images or movies of people that mimic the blurring effect of peripheral vision might aid in judging their true emotional state or their skill in portraying emotional states. For example, in psychological studies, people turn out to be better at judging whether other people are lying if they can't hear what they are saying. This result has been interpreted as showing that high-level cognitive processes, such as language, can override low-level processes, like interpreting emotional states. I suspect that people might be even more accurate at judging truthfulness if the faces of the liars/truth-tellers were somewhat blurred. Also, I do not know how actors are chosen in auditions, but I suggest that casting directors might want to try using either their peripheral vision or blurred video recordings to best determine how effectively actors portray emotions.

Opposite: *Mona Lisa*, Leonardo da Vinci (1503–06). Mona Lisa's expression changes depending on how far the viewer's center of gaze is from her mouth.

Below: A clear smile is more evident on Mona Lisa's face in details that show the coarse and medium image components (left and center) than in the one that shows only fine details (right). This means that her expression varies depending on where the viewer is looking.

coarse components
(peripheral vision)

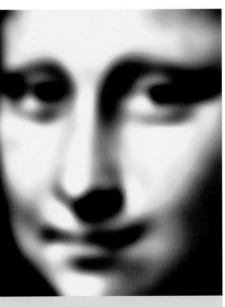

medium components
(near peripheral vision)

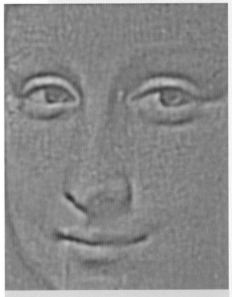

fine details
(central vision)

By looking fixedly at the black dot
between each set of letters here,
you can see that your peripheral
vision is spatially imprecise, not
simply blurry.

Opposite: The spatial imprecision
in *Rue Montorgueil in Paris,
Festival of June 30, 1878* (1878),
is more than simple blurring:
Monet's approach reflects the
way in which our peripheral
vision works. The spatial impre-
cision generates a vitality
because it is consistent with a
single glance, a moment in time.

The lower acuity of peripheral vision is not simply blurred vision; it seems to involve loss of precise spatial information. To see how spatially imprecise your peripheral vision is, hold this page about twelve inches from your eyes and look at the black dot in the center of the upper row in the illustration below. If you keep your gaze fixed on the center dot, you will find that you can probably identify only the nearest two letters, the purple C and A. The other letters—particularly the ones in the middle of each set—may be difficult to decipher. They are not exactly blurry; they are just hard to read. Now look at the second row, in which the same letters are blurred. When you look at the black dot, you will probably still be able to identify only the C and A, but you will probably nevertheless see quite distinctly that the letters are blurred. Paradoxically your peripheral vision is spatially imprecise enough that you cannot read the letters, but it is able to detect a slight blur.

The spatial imprecision of our peripheral vision has interesting implications for our perception of some Impressionist paintings. In *Rue Montorgueil in Paris, Festival of June 30, 1878* by Claude Monet, as in many Impressionist paintings, details are spatially jumbled. This spatial imprecision was a significant departure from the highly precise work of the antecedent more realistic style; one early critical reaction to the Impressionist movement was that the paintings were "unfinished." If you look at the flags just to the left or right of the center, for example, you can see that the red, blue, and white brushstrokes, representing the stripes of the tricolored flag of France, are not always well aligned or even adjacent to one another. This spatial imprecision is different from a simple blurring and is similar in an interesting way to the spatial imprecision in our peripheral visual field.

Another property of the spatial imprecision of our peripheral vision is that we can occasionally make erroneous correlations between objects. If you look at the colored letters again, you may find that you can "see" a blue B or a green D. That is, your visual system may assign the color of one object to the shape of an adjacent object. This phenomenon is called "illusory conjunction" and occurs when items are presented either peripherally or transiently. The flags along Rue Montorgueil look fine when you first glance at the painting, but not if you look directly at them, or after you study those parts specifically. The painting's spatial imprecision is not so noticeable at first because our own spatial imprecision allows illusory conjunctions to complete the objects. That explains why we see complete flags in *Rue Montorgueil*, even though many of them are just a single stroke of paint. Therefore low spatial precision may lend vitality to a painting because the visual system completes the picture differently with each glance.

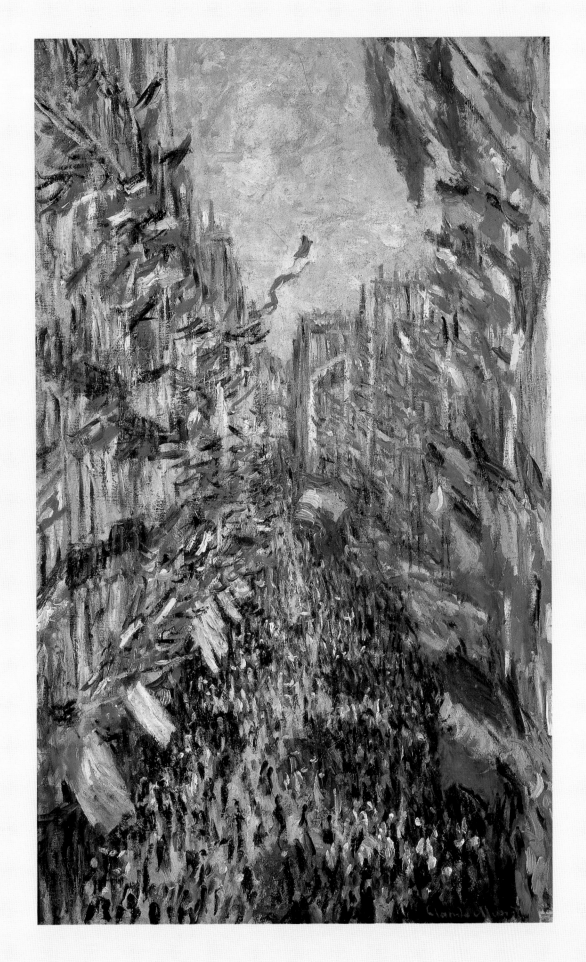

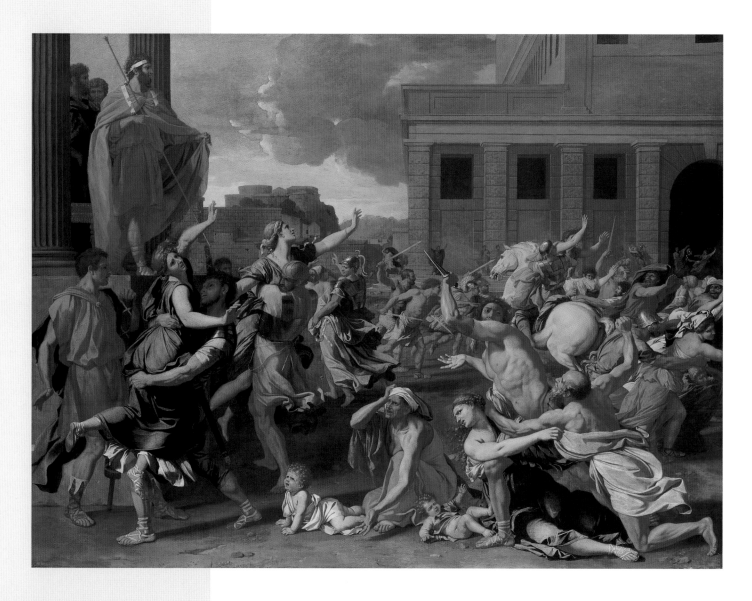

Nicolas Poussin's *The Rape of the Sabine Women* (1634) depicts a lot of action, yet it seems more static than Monet's *Rue Montorgueil*. This is because it would be impossible to register this many details from such a transient situation. (Nicolas Poussin. *The Rape of the Sabine Women*. 1634. Oil on canvas, 154.6 x 209 cm. The Metropolitan Museum of Art, Harris Brisbane Dick Fund)

Moreover, the spatial imprecision gives the painting a transient feel, because such spatial imprecision is compatible with a single glance, a fleeting moment in time. Because of the low spatial resolution of peripheral vision, we cannot take in a detailed percept of the entire scene in a single glance; we see clearly only the part of the scene that the center of gaze happens to light on. The highly detailed, action-packed *Rape of the Sabine Women* by comparison looks relatively static, because you can see hundreds of details. Seeing so many details is incompatible with the (presumed) transience of the incident depicted—by the time you moved your eyes from one act of savagery to another, the scene should have changed. "The visual sensation that imprints itself on the retina lasts but a second, or even less," wrote Gustave Caillebotte, a master of the art of capturing a fleeting moment. "That's the impression that we had to pursue." Art historian William Seitz adds that Monet painted the Rue Montorgueil scene "very differently from a camera image—which would freeze such a scene in a thousand details that no participant could experience."

Henri Matisse put it this way: "Movement thus understood corresponds to nothing in nature: when we capture it by surprise in a snapshot, the resulting image reminds us of nothing that we have seen. Movement seized while it is going on is meaningful to us only if we do not isolate the present sensation from that which precedes it or that which follows it."

Lastly, this painting technique may mimic our memory, which probably relies more heavily on the evolutionarily more recent What system than on the more primitive Where system. Thus the spatial imprecision of the Impressionists may simultaneously mirror a single glance, a single moment in time, and a memory of an event.

The spatial imprecision of Impressionist painting must have been an impetus to the development of Cubism, in which the spatial imprecision is more extreme. What part of visual processing might Cubism represent? I suggest that it might resonate with the spatial imprecision of the What system at higher levels than the visual cortex, perhaps at the level of visual memory. As you go higher in the hierarchy of the visual system, neurons become selective for more specific stimulus features over larger and larger regions of visual space. Drawings by patients who have suffered damage to their parietal lobes (the higher centers of the Where system) show spatial imprecision that is interestingly similar to Cubism.

I am not suggesting that Braque or Picasso had a defective parietal lobe, but rather that Cubism may reflect an aspect of visual memory that taps into the What system selectively. Indeed at high levels in our What systems, there are neurons that will respond exclusively to a particular object, at various viewing angles. This means that at least some memory templates in our brains are view invariant; that is, you can recognize an object or person seen from any angle, even if you have never seen them from that particular angle before. Perhaps it is not too farfetched to suggest that Cubism is pleasing because it resonates with a view-invariant part of our memory system.

These drawings (of two bicycles, a cross, and a clock) by four patients who suffered bilateral damage to their Where system demonstrate how spatially imprecise the What system is on its own. In each of these drawings the patient got the details of the object, but jumbled them all up spatially. The What system may be more important than our Where system in visual memory, and research on how visual memories are coded may hold the key to a new way of looking at Cubism.

77

SPATIAL RESOLUTION AND ECCENTRICITY

If our eyes move all the time, what determines where we look? A. L. Yarbus, a Russian psychologist working in the 1950s, put trackers on contact lenses on subjects' eyes and monitored where their gaze fell while they looked at a series of pictures. The illustration opposite shows the traces of a viewer's eye position as he looked at the upper image, a reproduction of I. I. Shishkin's painting *In the Forest*, for ten minutes. Yarbus found that the subjects tended to look most at those parts of the picture that contained high-contrast and fine detail, as well as items of biological significance (like other humans). It must be that our peripheral vision picks out those areas of the visual scene with high detail and contrast or potential interest and sends a message to the eye-movement system to plan the next eye movement so that the fovea lands on a part of the visual scene that is rich in information.

Renoir painted several portraits in which fineness of detail and contrast differ in different parts of the painting. In *Madame Henriot* (page 80) the subject's eyes and facial features are shown at high resolution and high contrast, which tends to draw the viewer's gaze.

Degas does the same thing in *Woman Ironing* (page 81).

The eyes are a very expressive part of a person: in all human cultures the eyes are considered emotionally important. Monkeys consider eye contact to be a sign of aggression. So finding one's gaze repeatedly drawn to the subject's eyes doubtless produces emotional impact. I suggest that some of the emotional impact of these two paintings arises from the tendency for the gaze to be drawn to the subjects' eyes, even though they are drawn for such an unemotional reason as image detail and luminance contrast.

Decades before Renoir's *Madame Henriot*, Ingres used the same technique in some of his drawings (pages 82–83). They—though not his finished paintings—show much higher resolution selectively in the face. The higher resolution, and often higher contrast, of the faces in his drawings give them considerable artistic interest and focus the viewer's gaze and attention on the most emotionally important and informative part of the person.

Opposite: The lower panel shows traces of a subject's eye position as he looked at the top image, I. I. Shishkin's *In the Forest*, for ten minutes. The eye position trace is shown in black overlaid on a low-contrast copy of the picture he viewed. Yarbus found that subjects tended to look most at the parts of a picture with high–contrast contours and detailed information.

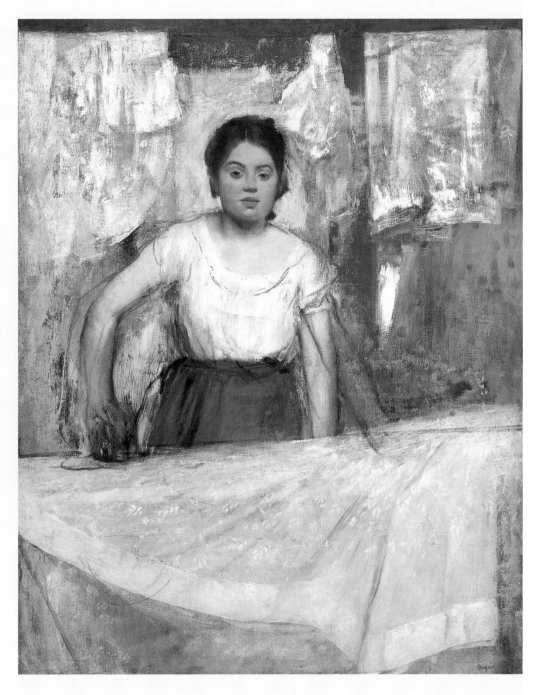

Pierre-Auguste Renoir painted
several portraits in which
resolution differs in different
parts of the painting. In *Madame
Henriot* (ca. 1876), opposite, the
face and eyes of the woman are
detailed and high-contrast, but
her extremities and the back-
ground are noticeably blurrier.
This repeatedly draws our gaze
to her eyes and mimics the
resolution of our visual system
when we direct our gaze at the
subject's eyes, as does Edgar
Degas' approach to *Woman
Ironing* (1869), left.

Half a century before Renoir and Degas, Ingres also used much higher resolution selectively in the face of some of his subjects. This technique appears only in his drawings—such as *Docteur Jean-Louis Robin* (ca. 1808–09), right, and *Mrs. Charles Badham* (1816), opposite —not in his finished paintings.

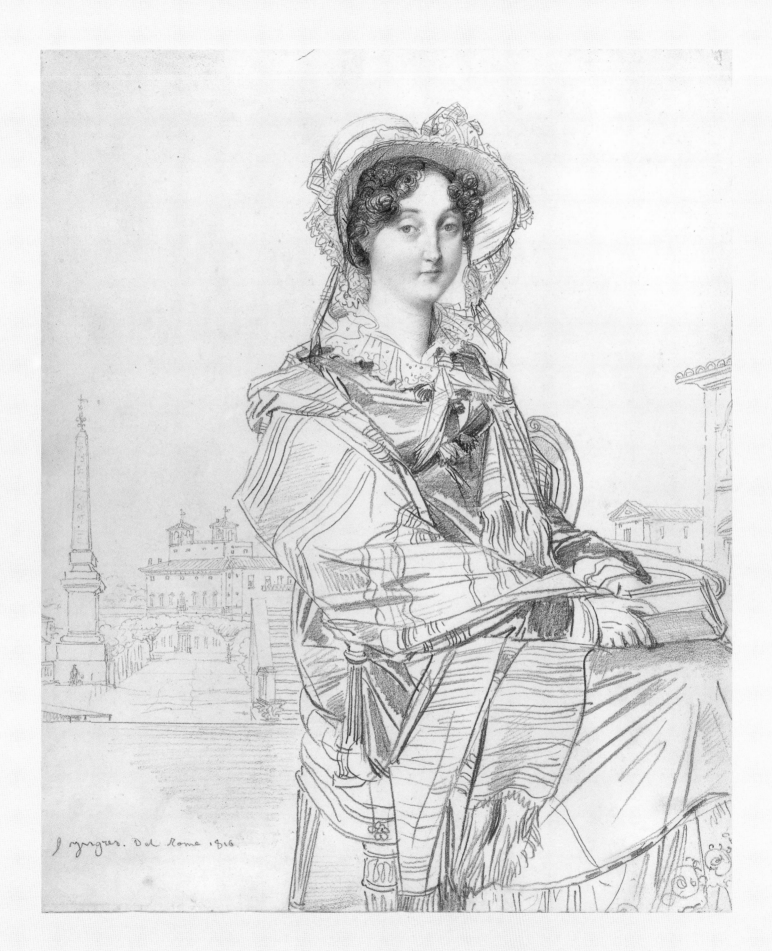

Ingres. Del. Rome 1816.

6:

THE NEXT LEVEL OF COLOR PROCESSING: SURROUND EFFECTS

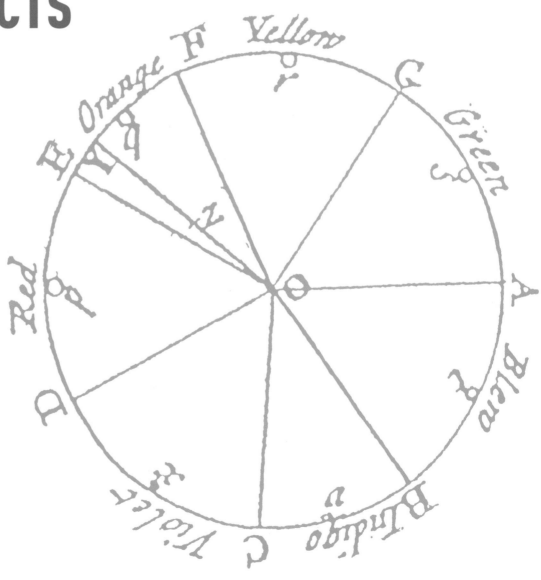

ONCE YOU UNDERSTAND the nature of light, you might expect that understanding the perception of color would be simple, but it is not. Even Isaac Newton, who made some of the most profound discoveries about the nature of light, wrote, "To determine . . . by what modes or actions Light produceth in our minds the Phantasms of Colours is not so easie."

While light is a physical entity, color is a perception—a concatenation of the wavelength of light and the way our brains process information about wavelength. There are myriad schemes for categorizing colors, and in most of them some colors are considered more fundamental, or primary, than others. In many of these schemes color is plotted in a circle. But circular schemes do not have any basis at all in the physical properties of light—instead, they reflect the way our brains deal with color. This situation is quite different from music, for example, in which the notes that comprise harmonics, chords, or melodies bear clear mathematical relationships to each other.

Even when we know something about the pigments in our eyes that respond to light, our perception of colors remains mysterious. Light we would call red has wavelengths substantially longer than the peak of the longest wavelength cone. What's more, there's nothing about the visible spectrum to indicate why some colors should be complementary to others, either in the artistic sense that they look nice when adjacent to each other or in the Newtonian sense that when mixed together they make white.

The most surprising thing about our perception of color is that, as reflected by the fact it is often represented as a circle, color seems to form some kind of closed continuum perceptually, seamlessly grading from red through orange, yellow, green, and blue to purple and then smoothly back to red again, while physically there is absolutely no continuity between the longest-wavelength red light that we can see and the shortest-wavelength blue light.

Despite the continuous linear relationship between color and wavelength, for centuries people across cultures have agreed that certain colors should be considered preeminent over others: red, yellow, and blue are usually considered "primary." (That works for pigments. When we are talking about light, red, blue, and green are primaries.) We also agree that certain pairs of pigment colors are complementary in that when mixed they give gray: red and green, yellow and purple, blue and orange. Again, there is nothing about a linear spectrum that would predict, or even support, either of these ideas. The underlying reason for both the continuity of the color experience and its internal complementarity is the same as I gave earlier for our ability to see red—the fact that our visual system compares the signals from three classes of cones. In other words, in the color-processing stream, inputs from the

Isaac Newton found that mixing some pairs of colors of light creates white light; such colors are called complementary. As he went from one color to the next along the spectrum, he noticed that its complement shifted systematically in wavelength. Oddly, considering that the spectrum is linear, Newton conceived of the colors as circling back on themselves, going from long-wavelength red through purple and back to short-wavelength blue. His circle, opposite, shows that colors progress systematically and gradually from one to the next, and that there is a systematic complementarity, or opponency, between any color and the one directly across from it.

different classes of cones act in opponency to each other at subsequent stages of processing.

There has been a controversy for more than a hundred years among vision aficionados as to whether three-cone mechanisms or opponent-color processes are more fundamental to our perception of color. Evidence given in favor of trichromacy (three receptor types) are the facts that we need only three primaries to reproduce any color; that there are three major types of color-vision defects; and (from quite modern research) that there are indeed three kinds of cones with different spectral absorptions. But there is nothing about trichromacy that would predict color complementarity.

Several types of observations support the two-opponent model, which was suggested by Goethe in 1810 and formally proposed by Ewald Hering in 1874: that across cultures red, green, yellow, and blue are usually considered "primary"; that two pairs of these primaries—

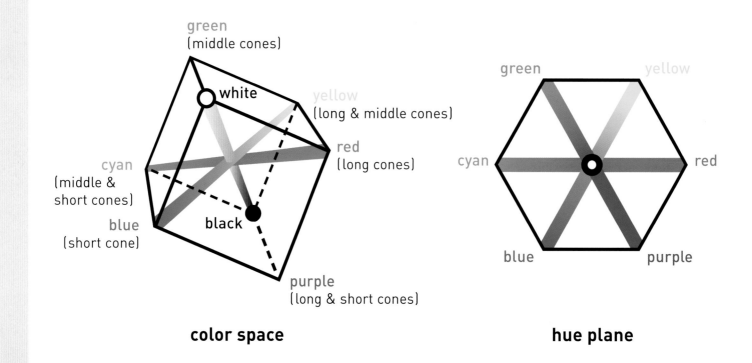

color space **hue plane**

red and green, yellow and blue—are mutually exclusive (that is, although we can imagine a yellowish red or a bluish red, we cannot imagine a greenish red; similarly we cannot imagine a bluish yellow); that pairs of colors of light, like red and cyan or blue and yellow, when mixed together give white (that is, they are complementary); and that when you look for a while at a color and then look at a neutral field, you see its complement—a cyan spot after looking at red, a blue spot after looking at yellow, and so on.

All these arguments are persuasive, and in the end both sides have turned out to be correct. The first stage in color processing, the photoreceptors, involves three cone types, but at subsequent stages our color perception codes colors by opponency between cone types. So, like light, which is both particulate and wavelike, color vision also has two faces: it is both trichromatic and color opponent.

FROM THREE TO MILLIONS

We can perceive millions of colors, but—amazingly—we do so using only three kinds of light receptors, each of which can give only a binary signal. Why isn't there an information bottleneck in color processing? How can we perceive so many different colors by the binary signaling of only three receptor classes? First, let's acknowledge that this must not be as big a problem as it sounds, because we know we can reproduce a lot of colors using varying amounts of three colors of ink (color printing), three colors of pigments (color photography), or three colors of pixels (television and computers). Since each pixel in a typical computer monitor can generate 256 levels, a computer monitor should be able to generate almost 17 million distinct colors (256 x 256 x 256).

Let us examine how color information is coded by the three cone types and then how this information is transformed in our brains. Ignoring for the moment the immense amount of spatial information carried by the retinal signal, all the available information about the color, luminance, and saturation (purity) of light at any given point in the visual scene must be a function of only three variables—the activity in the three cone classes. To represent how all colors can be coded by this activity, we can plot all possible visible colors in a three-dimensional space in which each axis represents the level of activity in a single cone type.

Despite the fact that color must be a three-variable entity, it is frequently mapped on a plane (a two-dimensional surface). The most commonly used map is the one generated in 1931 by the Commission International de l'Eclairage (International Commission on Illumination, or CIE). The CIE plane (page 88) is equivalent to a flattening of three-dimensional color space along the luminance, or black-white, axis. The wavelengths of the most saturated colors in color space lie along the circumference of the CIE plane. Note that there are no wavelengths indicated along the bottom, which represents mixtures of red and blue, since there are no wavelengths of light in this region. The absence of spectral colors there does not stop us from perceiving colors that smoothly grade from blue to red.

If something defined by three variables is reduced to being defined by only two variables, some information must be lost. So what is missing in a flat color map, whether it's Newton's circle or the CIE chart? Information about luminance. In these flat representations, luminance is absent, hue is represented as position around the circumference, and saturation is represented by distance from the center.

To continue our attempt to understand how the visual system represents colors, we now want to be able to uniquely define any hue (color independent of luminance) using cone response levels, since that is what our eyes and brain must do. We have seen that hue can be represented on a two-dimensional map. Since any point on such a plane can be uniquely represented by two variables, we should be able to identify any hue by two variables involving the three cones. (Of course we could represent any hue except purples by a single number— its wavelength, but that's not how the visual system does it.) We can define two axes in this hue plane—the red-cyan axis and the perpendicular blue-yellow axis (where yellow is red plus green)—and any point on this hue plane can then be described by its position along these two axes.

That is, hue, independent of brightness, can be expressed solely as a function of two comparisons: 1) the activity in the red cone versus the activity in the blue plus green cones (red-cyan axis) and 2) the activity in the blue cone versus the sum of the activity in the red and green cones (blue-yellow axis). These are not the only axes possible, but they are what our visual systems use.

Opposite left: Since we have only three kinds of cones, it is possible to plot all the colors we can possibly see in a three-dimensional space. Each axis represents the activity in one cone class: increasing long-wavelength-cone activity is plotted toward the front/right; increasing middle-wavelength-cone activity is plotted toward the back/left; increasing short-wavelength-cone activity is plotted toward the left/front. Increasing activity in all three cone classes (white) is mapped toward the top/front; black lies at the bottom/back. All possible hues and all their levels of saturation at all levels of brightness lie somewhere in this space.

Opposite right: If you flatten the three-dimensional color space along the black-white axis, you get a plane in which all hues are represented, independent of luminance. This hue plane forms a color circle that is a mirror image of Newton's. (This orientation difference does not imply that Newton was in error, since the orientation of the space is arbitrary.)

In 1931 the Commission International de l'Eclairage (International Commission on Illumination, or CIE) created this two-dimensional map of colors. Wavelength is represented along the rim of the horseshoe shape, and white is in the center. This map allows colors to be specified by two numbers, x and y, representing the horizontal and vertical axes, as indicated. People in science and industry use this system to specify a color, for a dye or paint, for example, and don't have to transport samples.

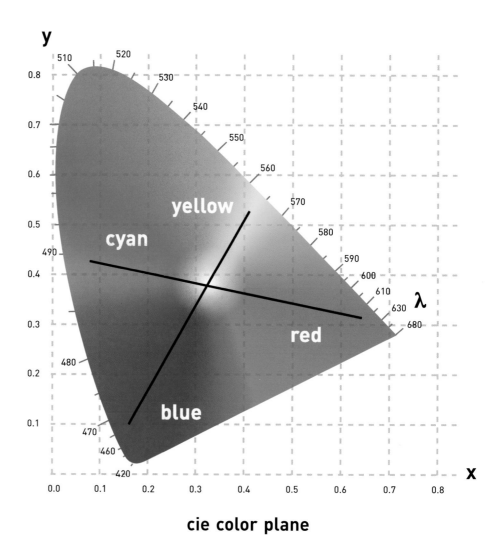

cie color plane

We can now express any color as a function of its position on our hue plane and, adding a third dimension, its position along the luminance axis. That is, we have transformed the axes of our color space from three cone axes to two color-opponent axes (defining a hue plane) and a luminance axis.

(If the thought of transforming the axes of a three-dimensional space gives you the willies, try thinking about locating a building in Manhattan. Since this building is on the earth, its precise location could be given by three numbers representing its position along three mutually perpendicular axes intersecting at the center of the earth. Alternatively, you could define its position in two dimensions on the plane parallel to the surface of the earth at the location of New York City. The two axes you use to define position on this plane could be north-south and east-west, or they could be the grid of numbered streets and avenues. The information lost by transforming your three-dimensional space map into either of these two-dimensional representations is how far from the center of the earth you are, which, depending on your task, may or may not be very important.)

This axis transformation happens to the cone signals before they even leave the eye: in the retinal ganglion cells the three cone signals are transformed into two color-opponent

signals (in which the activity in the different cone classes are compared, or subtracted) and a luminance signal that represents the sum of the activity in all three cones.

In performing this conversion we have not lost any information; we have just recoded it. Any point in the color space diagrammed on page 86 can be uniquely defined equally well by three cone signals or by the two cone-opponent signals (that define position in the hue plane) and by a luminance signal (that defines the position along the axis perpendicular to that plane).

Why do we convert the three-cone signal into two color-opponent signals and a luminance

SUMMING AND SUBTRACTING CONE SIGNALS

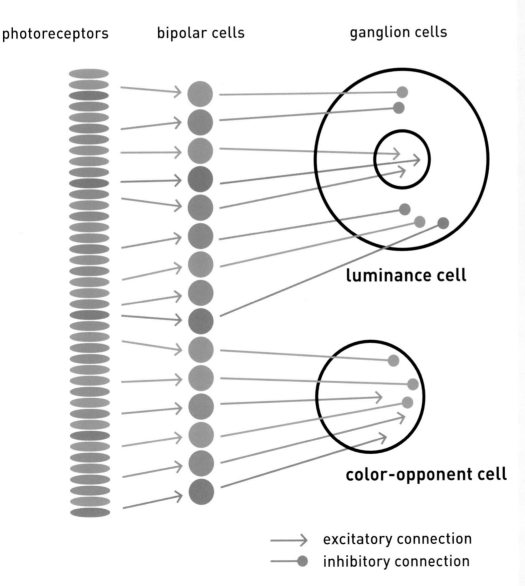

photoreceptors bipolar cells ganglion cells

luminance cell

color-opponent cell

→ excitatory connection
─● inhibitory connection

This diagram shows how nerve cells can sum or subtract the inputs from the different cone types. The three cone types are shown on the left, as if arrayed in a mosaic in the retina. These photoreceptors give excitatory connections to the next cells in the hierarchy, the bipolar cells. Bipolar cells, in turn, connect to retinal ganglion cells, but the type of connection can be either excitatory (indicated by arrows) or inhibitory (indicated by circles). (Inhibitory inputs actually involve an intervening cell, which I left out for the sake of simplicity.) Excitatory inputs make the cell fire more quickly, and inhibitory inputs make the cell fire more slowly.

Two ganglion cells—a luminance cell and a color-opponent cell—are shown. The luminance cell receives excitatory inputs from all three cone classes in the center part of its receptive field, and it receives inhibitory inputs from all three cone classes in the surround part of its receptive field. The color-opponent cell (this one is a cyan excitatory/red inhibitory cell) receives inhibitory inputs from the long-wavelength cones and excitatory inputs from the short- and middle-wavelength cones.

signal? There are two ways to answer this question. The first is that it may be useful or efficient for our brains to analyze color information separately from luminance information. For example, as I have discussed previously, it is more efficient to code a variety of visual features independently from color. In the same way that Thomas Young deduced that it is inefficient to code many colors at every point in space, it is inefficient to code the three-cone signature of every point on an object at every instant in time, rather than independently coding its color, shape, position, and trajectory. Moreover, as pointed out before, the function of our visual systems is not simply to reproduce the pattern of light falling on the retina (so that someone inside our heads can look at the picture) but to extract biologically important information from our environment. Intuitively, the color of an object would seem more biologically important than how effectively it activates each cone type, because the hue tells us something about the object's surface chemistry, whereas the individual cone responses, as shown on page 27, are ambiguous, depending on both surface properties and the illuminant. (Because each cone has a broad spectral sensitivity, a given response can indicate either a particular amount of one color of light or more light of a color to which the cone is less sensitive.)

The second answer to the question is an evolutionary rationalization. Early mammals probably had only one cone type—blue. Color perception evolved after the establishment of a well-developed luminance pathway, which we still have. The first step in developing color vision was the evolution of a second kind of photoreceptor that simply broadened the range of visible light over which the animal could see. Indeed, nonprimate animals have only two kinds of cones, and their visual systems predominantly sum the inputs from the two kinds of cones to give a simple luminance signal. The ability to compare (subtract) the activity in different cone classes evolved only very recently. Therefore it was evolutionarily simpler to overlay the color system on top of the luminance system, rather than to replace the old black-and-white system with a new color system or to modify the old luminance system to be able to handle color. In order to add a color system on top of a pre-existing luminance system, an evolutionary shortcut would be to add only the hue signal, in the form of a two-variable opponent signal, rather than to add the entire three-cone signal, which would be redundant.

Retinal ganglion cells either sum or subtract the inputs from different cones. Thus, before signals about light leave the eye they are already subdivided into luminance and hue signals.

ARE BLACK AND WHITE COLORS?

People often contend that black and white are not colors. But, subsequent to the photoreceptor stage, luminance is one of the three axes in color space. Although you can uniquely define any hue using only two variables, as shown above, you cannot define every color without employing luminance. For example, the difference between brown and yellow, or between maroon and pink is solely a difference in luminance, i.e., the position along the black-white axis. So black and white are indeed colors; they just don't have any hue.

Take two flashlights and put a red filter on one and a green or blue filter on the other. Place a tomato or some other red object on a piece of white paper on a table. Make sure the room is completely dark, and then shine the red light on the tomato. It and everything else will probably appear to be a pretty washed-out pink; in fact, the tomato will look just as white as the table, even though the light reaching your eye from both is long wavelength.

Now illuminate the same scene with the other flashlight. The table will still look white (a greenish white), but the tomato will appear black. (It does not reflect green light.)

If you turn on first the red light and then the green light, the tomato will suddenly look very red. Why is this? Adding the green light didn't add anything to the light reflected to your eye from the tomato, which does not reflect green light. All you're doing by turning on the green light is adding green light to the surround. This shows that the sensation of redness requires not only that an object reflect more red light than green, but also that it reflect more red light than adjacent areas.

The Where system uses information almost exclusively from the ganglion cells that sum the cone inputs, and the What system uses information from cells that sum and from cells that subtract the cone inputs. In the What system the signals are further subdivided into a Form system, in which color and luminance information are combined to define shape, and into a system that is interested in color per se. The Color system converts the three-cone signals into an additive luminance signal plus two subtractive cone-opponent signals, so that a luminance signal is part of the Color.

Because color is first determined by activity in our three cones, and then subsequently recoded into a color-opponent signal, a fundamental distinction can be made between the kinds of colorblindness of people who have problems in their photoreceptors (three-cone axes) and people who have problems in their brains (two color-opponent axes, plus luminance). The paintings on page 34 illustrate this difference: people who lack one kind of cone pigment are either "red/green" or "yellow/blue" colorblind. That is, they can see many colors, but they confuse pairs of colors along a single axis in color space, reflecting the role of that single cone type. People with cortical colorblindness (color blindness as a result of a stroke involving the color part of the temporal lobe) see all colors as shades of gray "like black and white TV." They also have trouble seeing shades of gray, because at the level of the visual cortex in the brain, color processing involves luminance as well. One woman who had cortical color loss manifested her inability to see shades of gray as a conviction that all the draperies in her house looked dirty, so she had them cleaned. She also thought the snow looked dirty, but to her chagrin, "Nothing much could be done about that."

COLOR OPPONENCY AND MIXING PAINT

What are the consequences of the fact that our brains code color in an opponent fashion? The first is that certain pairs of colors neutralize each other: that is, when you combine red and cyan light you get hueless white. Blue and yellow light also mix to make white, as do any pair of colors of light in which the red-green and blue-yellow opponent activities are balanced. In other words, we see hue only if at least one of the color-opponent channels gives an unbalanced signal. You can see some evidence of this kind of hue cancellation in the pigment spectra on page 18. Both Ultramarine French Blue and Cobalt Blue look like pretty pure blues, even though the light reflected from Cobalt Blue extends into the green wavelengths, and should therefore look more greenish blue than the Ultramarine Blue. Cobalt Blue, however, also has a peak in the long wavelength (red) end of the spectrum. Since red and cyan are opponent, when they are mixed, they neutralize each other's hue. Therefore the reflected red light cancels the reflected cyan light, leaving only the blue perception.

A second manifestation of our opponent color coding is the fact that we see colored afterimages. If you stare at a red spot you will see a cyan afterimage, if you stare at a blue spot you will see a yellow afterimage, and so on. Goethe described this phenomenon in 1810: "I had entered an inn towards evening, and, as a well-favoured girl, with a brilliantly fair complexion, black hair, and a scarlet bodice, came into the room, I looked attentively at her as she stood before me at some distance in half shadow. As she presently afterwards turned away, I saw on the white wall, which was now before me, a black face surrounded with a bright light, while the dress of the perfectly distinct figure appeared of a beautiful sea-green."

Lastly, in the primary visual cortex, the first visual processing stage in the brain, color-opponent cells become wired up so that they are not only color opponent but also spatially opponent—these cells are known as double-opponent cells—which results in a third manifestation of color opponency: colors that neutralize each other when mixed enhance each other when they are adjacent. This occurs because color opponency operates not only at each point in the retina, but also across space to nearby regions of the visual field. These cells represent the next step in color processing after the type 2 cells diagrammed on page 60.

This opponency can also result in induced colors because a red-excitatory double-opponent cell will be excited either by increased red in its center or by decreased red (increased cyan) in its surround. As discussed earlier, surround antagonism in luminance makes the visual system selectively sensitive to contours and insensitive to changes in level of illumination. Surround antagonism in color also makes the visual system selectively sensitive to color contours and makes us able to see objects as constant in color despite wide variations in the color of the illuminant.

What is the reason for this? Why should the brain compare the color at one point in the visual scene with the color of adjacent regions? Why not just code the luminance and color at every point in the scene?

The reason for surround antagonism is to make the visual system responsive to changes in reflectance, and thus to edges. As previously discussed, the maximum information about the shape of an object is contained in its edges. Just as you don't need to define the luminance at every point in a scene, you don't need to define the color at every point inside a homogeneously colored expanse; you only need to define the colors at every color-change contour. Therefore the fact that cells in our visual system are wired up so that they respond only to contours and not to homogeneous surfaces is informationally efficient. Furthermore, in the same way that surround antagonism in luminance allows us to see white as white and black as black despite

Bevil Conway's *Goethe's Girl* (1999) depicts a woman similar to the one Goethe described having seen in an inn. If you stare hard at her mouth for at least twenty seconds, and then look at the gray area to the right or the white area beyond that, you should see the afterimage Goethe described. We see afterimages because neural processes are easily fatigued (their signaling slows because they run out of signaling molecules). If you fatigue one side of an opponent process, the other becomes more active, like a released seesaw.

Color and luminance responses at any point in visual space are opposed by responses of the same color or luminance from surrounding points in space. They are also facilitated (disinhibited) by opposing colors or luminance at adjacent points in space. In luminance this means that an area looks lighter when it is surrounded by dark and darker when surrounded by light; in color this means, for example, that an area looks less blue (that is, more yellow) when it is surrounded by a blue background, and it looks more blue if it is surrounded by a yellow background.

The line in the center of this diagram is a continuous single shade of gray. It does not change at all, but the effects of the yellow and blue background may make it seem to grade from bluish on the left to yellowish on the right.

MAPS OF THE INPUTS OF THE THREE CONE TYPES TO A DOUBLE-OPPONENT COLOR CELL

LONG

MIDDLE

SHORT

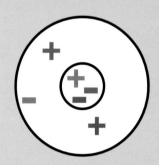

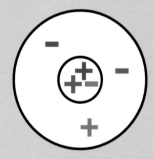

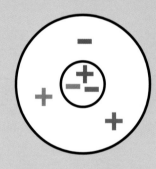

RED+/CYAN-

CYAN+/RED-

BLUE+/YELLOW-

YELLOW+/BLUE-

The figure on top shows maps of the organization of cone inputs to an actual color-opponent cell in the brain. Each map covers the same region of visual space. White areas are where this cell was excited by the cone, and dark areas are where it was inhibited. This cell is excited in its center by long-wavelength cone inputs and inhibited in its center by middle- and short-wavelength cones. Its surround is the

opposite, inhibited by long-wavelength cones and excited by middle- and short-wave-length cones. That is, this cell shows both chromatic and spatial opponency; it is a typical double-opponent cell. (Data from Bevil Conway.)

The diagram above shows the organization of cone inputs to four kinds of double-opponent cells. The real double-opponent cell at the top is represented by the first diagram. The pluses

indicate where the cells are ex-cited by light and minuses indicate where they are suppressed by light. Red, green, and blue indicate inputs from the three cone types. These four types of double-opponent cells define the red-cyan and blue-yellow opponent color axes (yellow is represented by the summed activity in the long and middle wavelength cones).

Double-opponent cells show color opponency in the center

and opposite-color opponency in the surround. Double-opponent cells make it possible for us to see colors as the same under widely different illumination conditions.

Unlike cells in the Where system or in the Form part of the What system, cells at higher levels in the Color system are not selective for contour orientation, probably because their job is to carry information about color, but not shape.

huge variations in the level of illumination, surround antagonism in color allows the visual system to distinguish surface properties of objects under wide variations in the color of the illuminant (light source). If our visual cells did not have surround antagonism, our perception of the colors of objects would vary with the brightness and color of the illuminant.

The fact that the visual system can give different responses to different wavelengths of light is biologically important because it gives the visual system another way—in addition to shape and luminance—to distinguish various kinds of objects. If the visual system did not have a center/surround organization of color-selective cells, our perception of the color of an object would vary depending on the color of the illuminant. Indeed, because the visual system codes color with double-opponent cells, I bet you are quite happily unaware of how very different the wavelength composition is of various common illuminants. The difference in the wavelength composition of sunlight, an ordinary tungsten lightbulb, and an ordinary fluorescent lightbulb surprised even me.

There are a couple of everyday situations that demonstrate how different ordinary tungsten illumination is from daylight. If you have ever taken photographs inside under tungsten light using daylight film, you may have found that the pictures came back too reddish. This is because tungsten light really is redder than daylight. Another time you might become aware of the significant color difference between the two kinds of light is when you are outside at dusk looking at a house that has lights on inside. The windows may look orange, compared to the bluer waning daylight. A typical lit-up office building will not look orange, though, since offices are usually lit by fluorescent lights, which are about the same color as daylight.

As mentioned earlier, a CD can be used to break white light into its component colors by diffraction. A CD can therefore demonstrate the difference between incandescent and luminescent illumination. If you hold a CD under a tungsten light or sunlight you can see a beautiful continuous spectrum; under fluorescent light you see discrete bands of color.

You can see the effects of the color of the illuminant in the phenomenon of colored shadows. We see colored shadows when we look at the shadow of an object that is lit by illuminants of different colors. Leonardo da Vinci put it well: "The shadow is not illuminated by the source that casts it." Let's consider the shadow of a haystack on a sunny winter day (so that the shadow will be cast on white snow, not colored ground). The snow will be illuminated by both the yellowish direct light from the sun and by the indirect bluish light from the sky. In the shadow of the haystack, the snow will be lit only by the scattered light from the sky, which is more bluish than the direct sunlight, so the shadow will look bluish, compared with the mixed light surrounding it. Claude Monet captured the phenomenon of colored shadows in several of his haystack paintings.

Colored shadows and lousy photographs are among the very few manifestations of the differing colors of illuminants, which we usually don't even notice; the illuminant usually creates a global, diffuse color difference, to which we are insensitive. We see colored shadows because they create a local color contrast that is apparent to our center/surround color cells.

You can see for yourself the importance of the surround organization of the color system by looking at some objects you know are colored under a source of pure yellow light, like sodium vapor light (those very bright highway lights used to deter crime). Under them, colors don't appear very natural—in fact, we can't see color at all! Sodium vapor lights emit monochromatic light of a wavelength of precisely 589 nanometers, which, if we could see it surrounded by other wavelengths, would look bright yellow. Even though the wavelength

The wavelength composition of three common light sources: daylight, an ordinary (tungsten) lightbulb, and fluorescent lighting. The differences in the wavelength composition of light from these sources is impressive. If the visual system's color-selective cells did not have a center/surround organization, our perception of the color of an object would vary depending on the color of the light in which we see it.

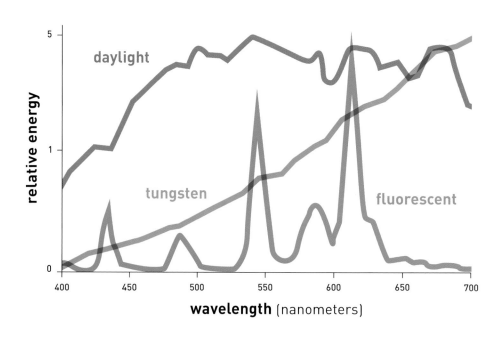

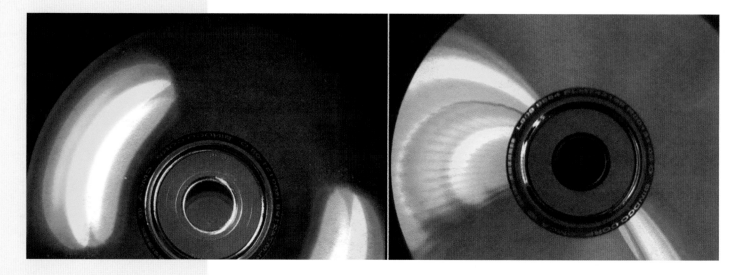

Above left: A CD illuminated by a focused tungsten light source. It made a beautiful rich spectrum, changing gradually from deep violet, through vivid blues and greens to the deepest red. (Unfortunately, it is almost impossible to reproduce a continuous spectrum with the printing processes used to reproduce this image here. If you want to see a lovely spectrum, look at a CD directly under daylight or tungsten illumination.) Above right: If you hold a CD under fluorescent light you will see something strikingly different: discrete bands of pure color, reflecting the fact that fluorescent light is made up of discrete peaks of narrow-band light (see above).

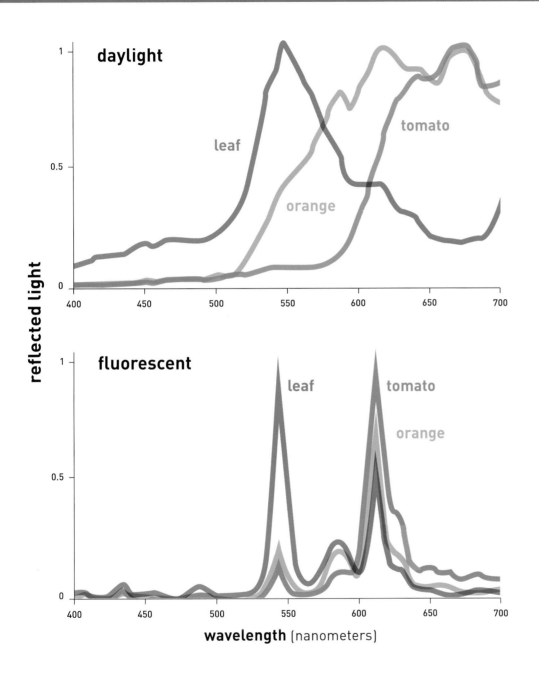

To me, a bright red tomato, an orange orange, and a green philodendron leaf look the same whether they're illuminated by daylight or my office fluorescent lights, but my spectrophotometer certainly revealed a big difference. These graphs show the light reflected from these three objects in daylight (top) and under fluorescent lighting. We see an object's color consistently, regardless of how it is illuminated, because of the double-opponent organization of our color cells and the fact that our color perception depends on the ratios between the three classes of cones, not on the precise wavelength composition of the light. The philodendron leaf, for example, reflects quite a lot of the longest fluorescent waveband, but relatively more of the middle waveband, so it looks green. The ratio of the long to the middle waveband increases between the leaf, the orange, and the tomato, and that ratio is what perceptually defines their color. The ratios between the three cone classes for these objects are similar under these different lighting conditions, and what differences there are in the cone-activation ratios for the light reflected from each object are compensated for by similar differences in the cone ratios for light reflected from the surround. Therefore each object produces similar responses in our double-opponent cells under different lighting conditions, and therefore looks the same.

that fills the visual field is the same color as a lemon, we still see everything as if it were lit by white light. This is because we can't really see "yellow" unless we have other wavelengths surrounding it for comparison, because of the organization of our double-opponent color cells.

You can do the same experiment with red light by looking through a piece of red plastic or glass. If you can get the red filter close enough to your eye that you can't see the edges, you will find that things seen through it, instead of looking bright red, look desaturated. Red (and white) objects look whitish, because they reflect the most light, and blue and green objects

Claude Monet painted a series of haystacks in which he explored the effects of light. In *Grainstack in the Morning, Snow Effect* (1891), the shadow is blue (in contrast to the relatively yellowish sunlight). Monet also painted a locally induced opponent yellow just surrounding the blue shadow.

Most of us are not aware of the color changes of reflected light (or for that matter of colored shadows), though Leonardo da Vinci points out that "the colors of illuminated objects are impressed on the surfaces of each other in various parts."

Opposite: In his *Young Woman in the Sun* (1875–76), Auguste Renoir captured the color of light reflected from leaves. Albert Wolf, an influential critic for the French newspaper *Le Figaro*, clearly did not appreciate Renoir's attempts to reveal the colors of the illuminant. After seeing the painting, Wolf wrote, "Try explaining to M. Renoir that a woman's torso is not a heap of rotting flesh, with green and purple patches, like a corpse in an advanced state of putrefaction."

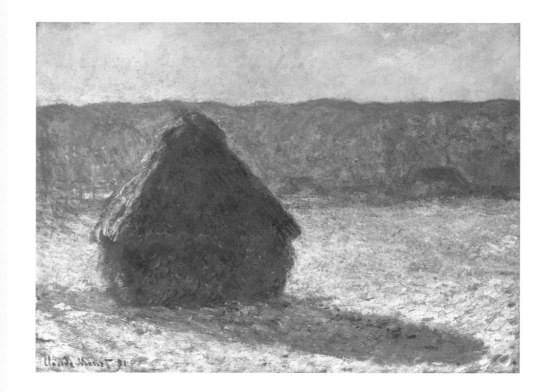

look dark. After a while the whole scene may cease to look very red at all. Again, this is because nothing is redder than anything else, and you need spatial contrast to see red.

Although we are remarkably good at not seeing the color of the illuminant, lighting conditions can alter a color's value, so that a pair of pigments that may be equiluminant under sunlight may not be equiluminant under tungsten or fluorescent illumination. For example, reds will appear relatively lighter than blues under tungsten illumination than when the same two colors are compared under sunlight. That is because tungsten light is redder than sunlight and will therefore be reflected more efficiently by red objects. If you look at the picture of the bowl of cherries on pages 42–43, the cherries and the bowl look about equally light under fluorescent light, but the cherries appear lighter than the bowl under tungsten light.

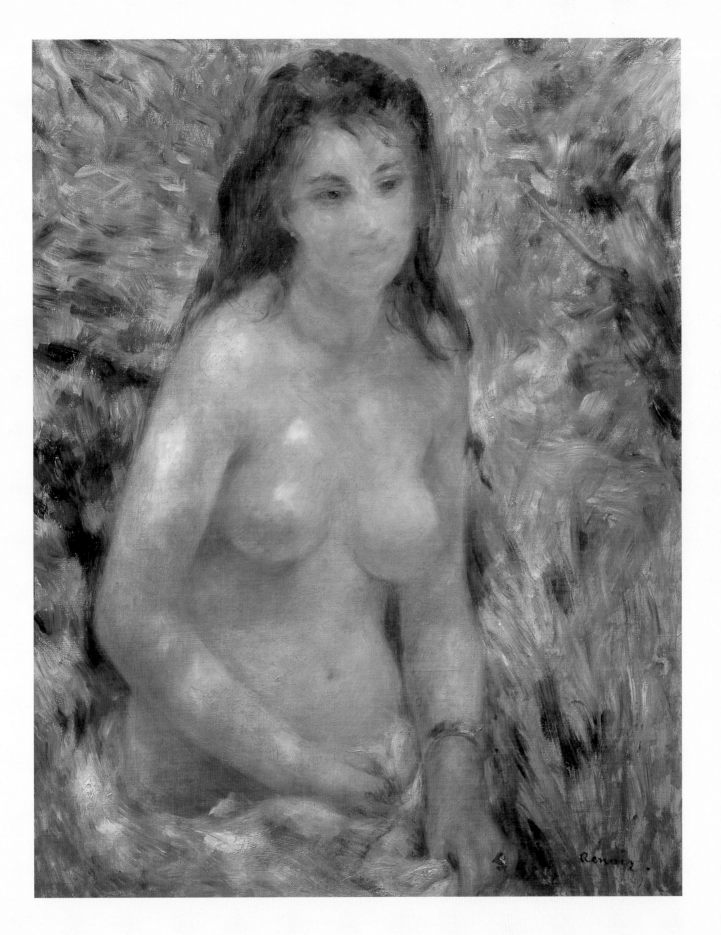

99

7:

FROM 3-D TO 2-D: PERSPECTIVE

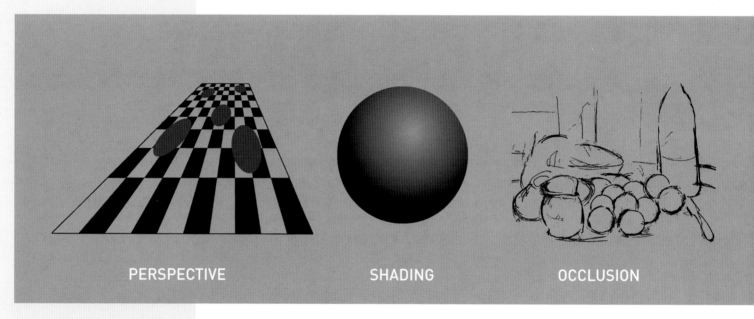

PERSPECTIVE SHADING OCCLUSION

Our brains use various cues to convert the two-dimensional retinal images into information about the three-dimensional spatial relationships among objects in the world. The major cues are:

PERSPECTIVE: global changes in size and relative position of objects. Perspective results from the fact that light from the entire visual scene must pass through a small opening, the pupil. Therefore the farther an object is from the viewer, the smaller the image it

AS WE LOOK AROUND, most of us think we "see" a three-dimensional world. Yet since each retina is a flat sheet of neural tissue, all the brain could possibly acquire through the eyes are two flat images (one from each eye). The brain must somehow interpret these two flat images as three-dimensional space.

Furthermore, artists aspiring to representationalism face the inverse problem: they want to render the three-dimensional world they see onto a two-dimensional canvas. The challenge is quite formidable if you spell it out explicitly: artists must look at a three-dimensional scene with their two-dimensional retinas and then generate a two-dimensional painting that appears three-dimensional to viewers who look at it with their two-dimensional retinas.

Since the retinal image in the eye is already flat, you would think all artists would have to do is paint what the eye sees, before the brain gets access to that information. The problem is

that we don't have conscious access to that retinal image; our visual perception is available to us only after the brain has processed it into a three-dimensional representation. So how do artists make a painting seem three-dimensional?

It might be helpful to the artist wanting to evoke a sensation of depth to understand how the brain calculates depth. The brain uses many cues to extract three-dimensional information from the two-dimensional retinal images: perspective, shading, occlusion, haze, stereopsis, and relative motion. These cues are automatically interpreted by the brain, even when we are unaware of them. Some—perspective, shading, occlusion, and haze—can be used, or duplicated, by the artist on a flat canvas, but others—stereopsis and relative motion—usually oppose the artist's attempts to evoke a sensation of depth on a flat canvas. In this and the

casts on the retina. This is why receding parallel lines should be drawn as converging.

SHADING: the gradations in reflected light off an object because of its shape.

OCCLUSION: objects in front block the view of objects behind them (sketch by Bevil Conway).

HAZE, OR AERIAL PERSPECTIVE: very distant objects may seem dimmer or lower contrast because of intervening atmosphere.

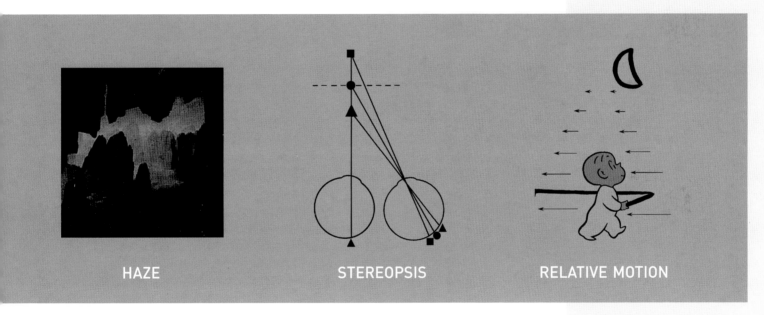

HAZE STEREOPSIS RELATIVE MOTION

following chapters, we will discuss how the brain processes some of these depth cues and how some artistic techniques are based, not on the physical reality of these cues, but on the way the brain handles this information.

Artists interested in depicting three-dimensionality must train themselves to see depth cues per se, and to do so they must free themselves from the cues' effects on their perception of the visual scene. This is not easy. For example, try ignoring the perspective information in the image on page 102. The two gray balls are physically exactly the same size, but the background perspective cues are interpreted by the visual system as indicating that the upper ball is farther away and must therefore be larger than the lower ball. This calculation is automatic, happening well before conscious perception. In fact, the calculation that the upper ball must be bigger is so automatic that you don't even need to perceive depth to experience the illusion. That is, even though you may be consciously aware that this image is quite flat, and you therefore know that the upper ball cannot be farther away, you still experience the size illusion.

(Leonardo da Vinci, *The Virgin of the Rocks*, 1503–06, detail)

STEREOPSIS: a depth perception based on the difference between the two images in the two eyes. The brain interprets the difference as depth information.

RELATIVE MOTION: as you move, near objects seem to move more than distant objects; very distant objects, like the moon, seem to follow us as we walk because they show essentially no relative motion (modified from *Harold's Purple Crayon* by Crockett Johnson).

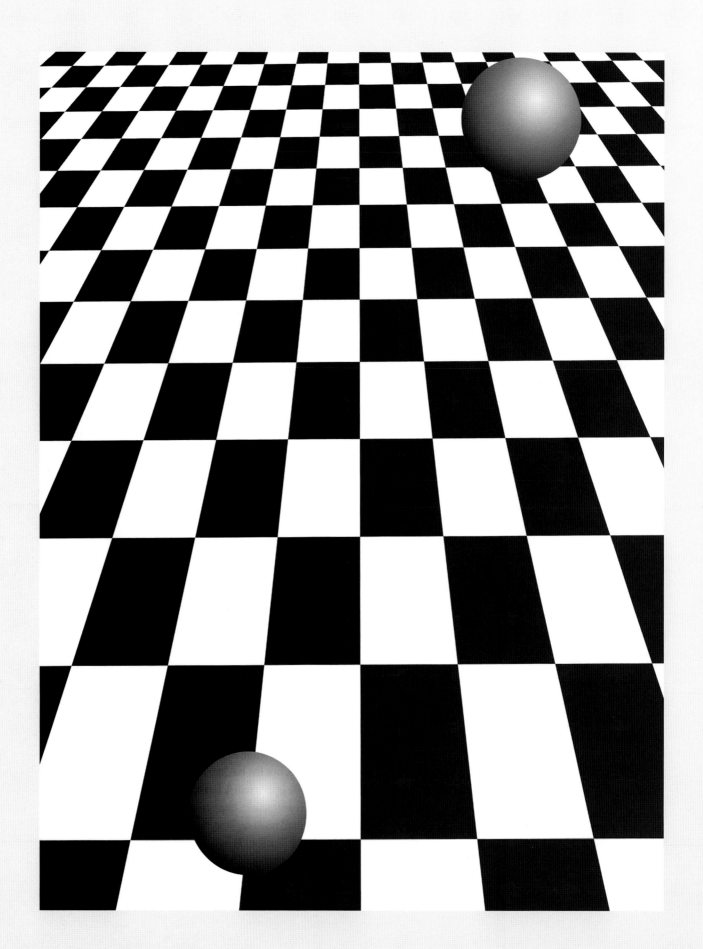

PERSPECTIVE

Painters depicted depth for tens of thousands of years before the Renaissance, when the laws of perspective (the changing of image size with distance) and shading (the gradations in reflected light off an object caused by its shape) were finally fully understood. Both arise from the facts that light travels in a straight line and that we see only those rays of light that travel through the pupil and into the eye. Because light appears to travel in a straight line, the rules of perspective are geometrical, as proposed by Johannes Kepler in 1604, and this realization was rapidly adopted and codified by artists. "Perspective must . . . be preferred to all the human discourses and disciplines," claimed Leonardo da Vinci. "In this field of study, the radiant lines are enumerated by means of demonstrations in which are found not only the glories of mathematics but also of physics, each being adorned with the blossoms of the other."

It took a long time for perspective to be understood, because our visual systems are so adept at converting perspective information into depth information that most of us cannot consciously see receding lines as convergent. It is for this reason that I suspect that those with poor depth perception may have an advantage in art. I suggest that artists who excel at conveying depth paradoxically may have poor depth perception. Seeing the world as flat just might be easier for them.

Many artists have used special equipment to help them see a two-dimensional representation of three-dimensional reality, to literally intercept a visual scene on its way to the eye. When the scene appears to be flat, the cues that are normally used to generate three-dimensionality can themselves be seen and therefore consciously represented by the artist. If the artist does a good job, those cues will then be unconsciously interpreted as depth by the visual system of the person looking at the painting.

Below: Light is reflected in every direction from objects, but we see only those rays of light traveling on a path that passes through the pupil and into our eyes. The large arrow represents an object in the real world reflecting light in all directions. Some of its reflected light casts an image, as indicated, on the retina. An object that is half as large at half the distance would cast an identical image on the retina. If you intercepted the path of the light traveling from the object to your eye and copied it exactly (as indicated by the frame), this image would be indistinguishable from the real object farther away if you viewed it with only one eye. Conversely, when you view a painting or a photograph, it sometimes seems as if there is a real three-dimensional world beyond the frame.

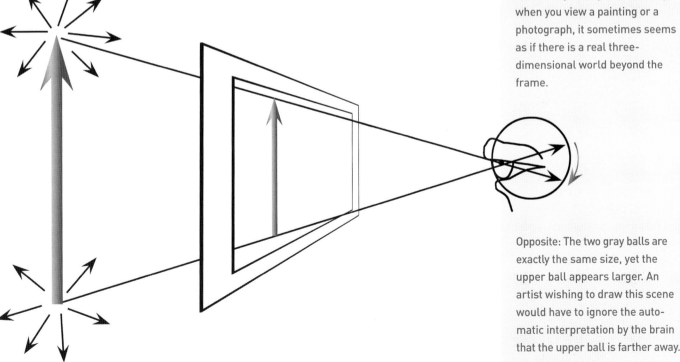

Opposite: The two gray balls are exactly the same size, yet the upper ball appears larger. An artist wishing to draw this scene would have to ignore the automatic interpretation by the brain that the upper ball is farther away.

A screen like the one Dürer illustrates in *Draftsman Drawing a Vase* (opposite) enables artists to precisely replicate what the eye would see beyond the screen and relieves them of the necessity to flatten their visual image. Other artists have been known to use optical devices like a camera lucida.

There are other ways artists can fool their visual systems into seeing the world as flat, which then makes it easier to accurately duplicate perspective and shading. Looking at a scene with one eye closed is a well-known trick. With only one eye, you don't have stereopsis, so it is easier to fool the visual system into interpreting the visual scene as flat.

Some artists frame what they want to paint with their hands, taking one part of the scene out of its three-dimensional context. This technique works even better if you use only one eye.

The familiar caricature of the artist holding out a thumb is based on the technique of actually measuring objects in the visual scene—the thumb is a handy ruler that can be used to measure the size of the image an object would cast at that distance. If you hold page 102 at arm's length you can use your thumb to convince yourself that the two balls really are the same size. For artists who are not too self-conscious or prone to headache, looking at a scene upside-down also helps to flatten it.

Some artists find they can effectively flatten a scene by staring at it. This works (when it does) because the Where system is transient, so if the image doesn't move on the retina for a second or two, the depth information fades.

Other artists' tricks include looking at a scene in a mirror or as it is reflected on a piece of glass, or, of course, using photographs. All of these techniques actually transform a three-dimensional image into two dimensions.

This diagram shows how a 3-D space projects onto a 2-D retina. Each point in the scene reflects light in all directions, but only those rays of light that pass through the pupil are shown. Only the solid contours form images on the retina; dotted contours are not seen. Many contours are dotted because they are occluded by other surfaces. The observer's hand is smaller than the picture on the wall, but it projects about the same size image onto the retina because it is closer to the observer. If you were to move the table closer, the image on the retina would become proportionately larger (from J. J. Gibson).

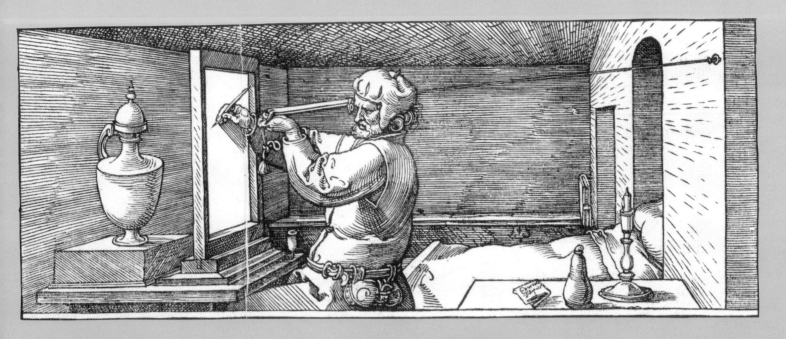

Albrecht Dürer's woodcuts above illustrate two techniques commonly used to make an accurate two-dimensional drawing of a three-dimensional scene. Leonardo da Vinci recommends using the technique illustrated in *Draftsman Drawing a Vase* (1525), top: "Position yourself two-thirds of an arm's length from a piece of glass . . . and mark on the glass what you see beyond." Afterward the marks on the glass are transferred to canvas or paper. Since it is the proportions of objects at various distances that are so difficult to reproduce, even a rough sketch helps. In *Draftsman Drawing a Reclining Nude* (ca. 1527), above, the artist looks through a screen with a grid drawn on it. Not only does he see the scene flattened on the screen, but in addition the proportions and positions of contours can be drawn with reference to the grid lines, which are duplicated on his drawing paper. For this technique to work, the artist must keep his eye in exactly the same place, which he does by aligning it with the little tower on his table. In both these techniques the artist uses only one eye.

The Power of Preconscious Depth Processing

Photocopy this diagram, and cut out the four black wedges. Fold back along the four sides of the center square. Tape the free edges of the flaps together carefully along the cut sides so that you have a flat-topped pyramid with the printing on the outside. Tape your pyramid onto a wall so that the center protrudes toward you. Look directly at the pyramid, and try to get it to look as if the center is receding away from you, as the perspective cues indicate. If you can do this with both eyes open, you probably have poor stereopsis and would make a good artist. Most people cannot force themselves to see the center as receding unless they close one eye, eliminating the stereo cues that the center is actually protruding. So, close one eye, hold your head still, and see if you can get the center to seem to recede. Once you can accomplish that, move your head from side to side. At first, the movement will probably make the center seem to pop out toward you again, but after a few tries you may be able to hold the receding percept and then the pyramid will seem to move in a really weird way as you move your head from side to side. The weird movement arises because your internal three-dimensional representation predicts that the relative movement should be reversed. (Derived from the work of Patrick Hughes.)

FROM 3-D TO 2-D: SHADING AND CHIAROSCURO

WHEN A THREE-DIMENSIONAL object is illuminated by a light source, different parts of its surface reflect different amounts of light, depending on the angle of the light hitting them. We see these differences as changes in luminance, or shading, which is another depth cue that, like perspective, artists must learn to see.

The default assumption of the visual system is that light comes from above, so if you look at the circles here you probably see the first one as bulging out, and the second one as dented inward. (Turn the page upside down, and the two circles reverse depth.) Now, understanding why those particular luminance gradients produce those three-dimensional percepts, try to override your percept. Try to see the surface as flat; try to see the circles as bulging in the opposite direction; try to convince yourself that the image is lit from below. It's quite difficult. Because depth is processed by the colorblind Where system, luminance contrast alone is

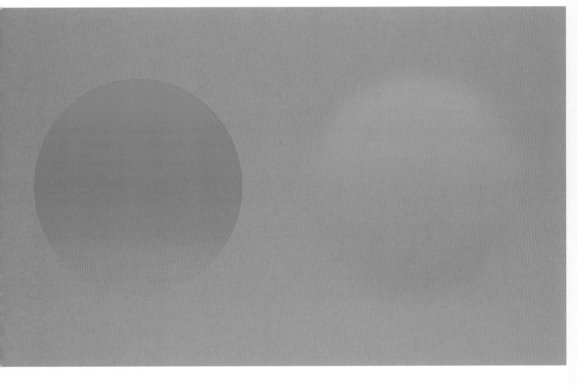

Most of the processing the brain does to interpret changes in luminance is preconscious and not accessible to intellectual analysis or control. The two circles on the left exhibit a luminance gradient that the visual system interprets as shading, so we see these two circles in depth. Gradations in color do not contribute to our perception of depth, so the third circle looks flat. The last circle is generated by a very low-contrast luminance gradient, yet you probably see the illusory depth just fine because the Where system is very sensitive to luminance changes.

enough to give a vivid sensation of three-dimensionality. As you can see in the third circle, color gradients do not evoke a sense of depth.

Another example of how tricky it is to learn to really see shading can be experienced by looking at the corner of the ceiling of a white room with a white ceiling. You will see three planes coming together, and all will look white. But close one eye, and look at the corner with the other eye through a small circle made with your thumb and forefinger. Keep looking until the corner appears to be a flat surface divided into three sectors. At this point, the three sectors will no longer look white, but like three quite different shades of gray! These lumi-

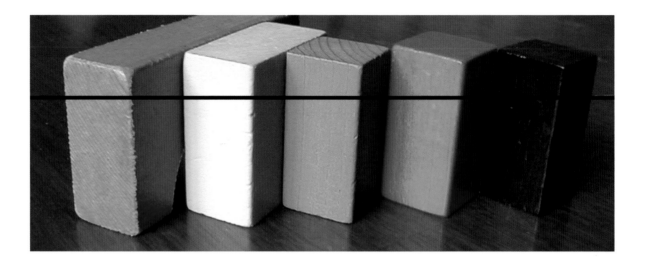

The range of values available in paint or ink is a small fraction of what is in the real world. I found it impossible to reproduce in a photograph the luminances I could see when looking at these blocks in real life.

nance differences—which were not perceptible when they were being used to perceive the depth relationships of those three planes—become apparent only when we take the corner out of three-dimensional context and see the three sectors as part of a single flat surface.

To use shading effectively, artists have to surmount two further challenges. First, they must learn to evaluate luminance independent of color. As discussed earlier, the part of the visual system that determines three-dimensional shape, depth, and overall spatial organization—the Where system—is sensitive to luminance, but not to color. But it is impossible to consciously see only the luminance version of a scene or painting; we cannot simply opt to see with only that part of the visual system (just try to see the world in black and white!), so it is indeed a talent to be able to judge luminance accurately across colors. It is particularly difficult to distinguish salience, or conspicuousness, from value. Colors that are rare in a scene, like a red flower on an otherwise brown forest floor, can seem much brighter than they really are because they are more conspicuous. One way to estimate the correct values in a painting is to take a black-and-white photograph in daylight using film like Panatomic-X, which has about the same spectral response as humans.

Even if artists can trick their minds into seeing luminance gradations and can learn to judge luminance independent of color, a further challenge is that it is often impossible to duplicate those luminance ranges with pigments because of the limited range of reflectances available even with the best paints. The range of luminances (contrast) in a given scene is almost always enormously larger than the range of values an artist can achieve using pigments. Inside a typical room, luminances vary widely: the light source, such as a window or a lamp, might be hundreds of times brighter than the shadowed region under the desk. The luminance in an outdoor scene usually varies by a factor of a thousand. Yet if you measure the light reflected from the blackest black paint and from the whitest white paint, you will find that the white reflects only about twenty times as much light as the black. That is, the range of values available using paint, photographic paper, print, colored papers, or any other reflective medium varies by a factor of twenty at most. (Much higher ranges of luminance can be attained using transparent media, such as slides or stained glass.) So how can a painter convey the range of luminances present in a real-world scene?

To experiment with this, I created this simple composition of colored wooden blocks on the desk in my office and measured the luminance along the blocks. The graph opposite shows the luminance across this little scene at the level indicated by the black line; the luminance of each point is shown directly below it. This row of colored blocks displays a range of luminance from 240 foot-candles (the foot-candle is a measure of luminance once equivalent to the light from one candle one foot away) for the lit side of the yellow block to five foot-candles for the shaded side of the black block. Thus even this limited scene contains a fifty-fold range of luminances.

The photograph of this scene has a smaller range of luminances, showing only a fifteen-fold difference between the same darkest and lightest surfaces. I can easily perceive this deficiency in the photograph: with the real blocks sitting on my desk I can simultaneously see a difference between the lit and shadowed sides of the black block and a difference between the lit and shadowed sides of the yellow block, but in the photograph the lit and shaded sides of the black block look equally dark; also the shaded sides of the colored blocks look grayish in the photograph, whereas in the real scene I can see the colors more vividly on the shaded sides. No matter how good the photographic paper I use, I cannot achieve an adequate range of luminances for all the colors simultaneously! If the picture is made light enough to show the shadows on the black block, the yellow is so light that its shading doesn't show, and the light colors appear too desaturated; if the picture is dark enough to show most of the colors accurately, the black is too dark to show shadows. In the picture here in this book, for example, you cannot see the luminance gradation on the yellow block.

This problem has vexed artists for centuries. Before the Renaissance, artists usually depicted shading by varying the purity of their pigments, by adding white to the lit parts of objects and using the most saturated paint for the shaded parts. This method has several consequences. First, because the human spectral response is not constant across the spectrum, in their most saturated form some colors, such as yellow, have a higher luminance than other colors, such as blue. This means that each colored region may have internally consistent luminances, but the range in luminance is often inconsistent from one area of color to another. This gives a choppy appearance to the luminance profile of the image and hence a fragmented perception of distance and overall spatial organization, resulting in a cartoonish look.

In *Madonna with Child and Pope Pasquale I*, an Early Christian apse mosaic, the lighter robes show a much larger range of contrast than the Madonna's dark robe, as you can see in the luminance version on the right. Her robes therefore look less three-dimensional, and there is a disconcerting discontinuity in depth between the Madonna and the Christ Child.

By using gold highlighting and
a greater luminance contrast,
Cimabue achieved somewhat
more of a feeling of three-
dimensionality in his ca. 1280–85
Madonna and Child Enthroned
(detail).

Second, regions represented by some colors may exhibit a large range of luminances, but regions of other colors may show only a narrow range, with consequent variations in the apparent three-dimensionality of different parts of the painting. Real shading—which is a variation in reflected light as a consequence of three-dimensionality—results in variations in luminance without variations in saturation (except for specular highlights), so varying the saturation of the pigment to obtain variations in luminance is unnatural.

Lastly, when the most saturated paint is used in shadows, the salience of the pure color contradicts the luminance signal that that part of the image should be seen as farther away.

LUMINANCE OVER THE CENTURIES

I am illustrating a small bit of the history of how artists have dealt with the limited range of pigment reflectances using depictions of the Madonna, because traditionally the Madonna was portrayed with a dark blue cloak with a red lining or undergown, and artists had difficulty achieving enough luminance range to show shadows in the dark cloak. This is the same problem I had with the black block in my photograph.

The first example (pages 112–13) shows an early-ninth-century mosaic of the Madonna and the Christ Child. The Madonna's robe is dark and seems flat, because you can barely see the shadows signifying the folds, as they are only a tiny bit darker than the rest of the robe. The lighter robes of the other figures and of the Christ Child do show folds that are significantly darker than the rest of the robe. That is, the lighter robes show a much larger range of contrast than does the Madonna's darker robe, as you can see if you look at the luminance version on the right. The only clear hints as to the folding of her robe are the undulations of its gold edging.

One of the most popularly celebrated Madonnas was painted by Cimabue in Florence in the late thirteenth century (opposite). Again the Madonna's dark robe shows much less luminance contrast than her red gown or the Christ Child's lighter robes. Cimabue overlaid both robes with gold highlighting (chrysography). The gold of course conveys grandeur and otherworldliness, but it also is a mechanism for indicating the folds of the fabric, which are not well delineated by the small luminance contrast the artist gave the darker color.

The next example is a Madonna painted by Bernardo Daddi in the fourteenth century (overleaf). The Madonna's dark robe shows some shading, but it is still relatively flat in comparison with the lighter robes of the Christ Child or the kneeling figures, because of the narrow contrast range available for this dark color. Again the device of gold edging is used to indicate the folds, compensating to some degree for the small luminance contrast range of the dark robe. There is a large luminance contrast between the Madonna's dark robe and its red lining, and the red lining is closer in luminance to the Christ Child's robe. Because our spatial organization and depth perception are colorblind, this luminance profile produces a peculiar discontinuity between the Madonna's robe and its lining and makes the Christ Child seem to float at some indeterminate depth in front of the flat surface of the dark robe.

The art historian John Shearman has written that Leonardo da Vinci was the first artist to use value consistently across colors, achieving tonal unity in which a figure presents "a single, swelling, homogeneously generated volume in contrast to the inevitably fragmented effects of colour-modelling.... [L]ight, colour and form are now related in a way that approximates to, and describes, their scientific and naturalistic behavior." He suggests that Leonardo da Vinci achieved tonal unity by investing every colored object with a common range of value. That is, much of the value continuity in Leonardo's work comes from the fact that he used midrange colors, all displaying the same range of contrasts. He did use some lighter and darker colors, but they are not extreme; they range by only a factor of five or ten in value. Leonardo did this quite consciously, as he has written: "Remember, painter, to dress your figures in lighter colors, darker colors will make lesser relief and be little apparent from a distance. And this is because the shadows of all things are dark, and if you make a garment dark, there will be little variety between the light and darks, while with light colors there will be greater variety." Leonardo also managed to vary the luminance of his colors without changing their saturation, which is what you would see in a real three-dimensional scene with variations in reflected light. Such skillful use of light and dark paints to define three-dimensional shape became known as chiaroscuro.

In *Madonna delle Grazie* (detail), which Bernardo Daddi painted in 1347, the large luminance contrast between the Madonna's dark robe and its red lining makes the lining seem to be an independent element. The Christ Child's robe is so much lighter than his Mother's robe that he seems to float in front of her.

Leonardo da Vinci's *Benois Madonna* (ca. 1478) exhibits midrange colors and a consistent range of contrasts. We can see from the black-and-white version just how skillfully he did this.

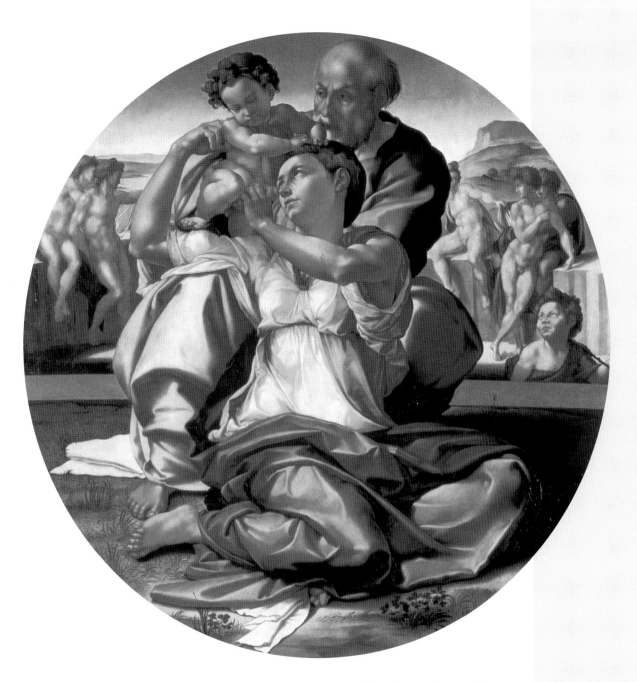

In his painting of the Holy Family, Michelangelo chose yet another solution: he mixed his colors with both black and white to maximize the contrast range for all the colors he used. This means the lighter parts of each color—even the black of Joseph's tunic—are almost white, and unrealistically desaturated. The only color that has a high enough luminance in pure form is the yellow of Joseph's cloak, so Michelangelo did not have to desaturate the yellow to get a high value. Therefore the yellow robe has a different quality from all the others, whose hues vary substantially in saturation, and therefore look somewhat metallic. But by using such a wide range of luminances, Michelangelo certainly achieves vivid depth from shading.

Just a few years after Leonardo achieved what John Shearman calls "tonal unity," Michelangelo tried a different approach in *Doni Holy Family* (ca. 1503).

Artists can induce apparent shifts in the luminance of an image by changing the shading of the background. This circle appears to be shaded but is actually one single shade of gray. Only the background changes (after Shapley, 1965).

Opposite: Influencing the apparent brightness of an object by manipulating the background in the opposite direction—countershading—can produce an illusion of a larger range of luminance contrast than is available in pigments. A textbook example of countershading is the drawing *The Black Knot (Le Noeud Noir)*, (ca. 1881) by Georges Seurat.

CENTER/SURROUND TO THE RESCUE

How can the artist compensate for the problem that the real world usually contains a much wider range of luminances than are available in the reflectances of pigments? It turns out that the dilemma is already partly solved by the fact that individual cells in our visual system can signal only about a ten-fold variation in luminance. So the question then becomes: how can our limited visual system perceive the wide range of luminances present in most scenes?

The answer is that center/surround organization makes the cells in our visual system much more sensitive to abrupt than to gradual changes. Center/surround cells allow us to see over a wide a range of contrasts without needing cells that can code hundreds or thousands of levels of luminance. In other words, when we look at a scene that varies over a thousand-fold range of luminance, we can simultaneously detect the difference, say, between levels 1 and 1.2 and between levels 1000 and 1200, even though no particular visual-system cell can discriminate over that whole range. The visual system discriminates locally, determining how much

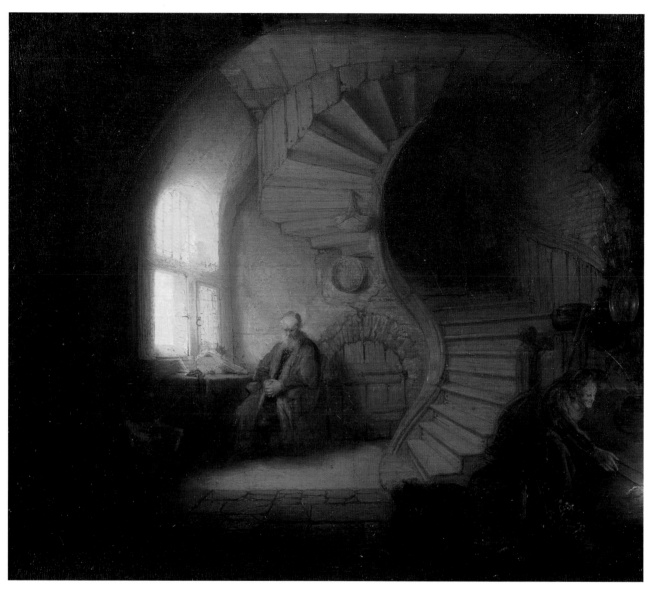

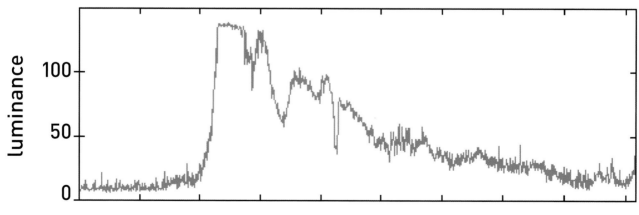

brighter, or darker, any point in the scene is from its immediate surround. In this way, cells that can code a biologically realistic range (about a factor of ten) can be used to represent a much larger range. But photographs and paintings cannot do that—the dilemma presented earlier.

So the solution is that artists can invert the problem and take advantage of the fact that our visual systems code local discontinuities and not gradual ones in order to expand the apparent range of reflectances of paints. Although a real scene may well contain a very large range of luminances, each part of it is analyzed separately by the visual system. Therefore by introducing gradual changes in the background luminance, artists can induce opposite apparent shifts in the luminance of the foreground that add to the actual luminance of the foreground reflectance.

For example, in the image on page 122, I see a circle that slightly bulges out from a flat background, as if the center were shaded lighter on the top to darker on the bottom. In reality the luminance gradient is in the background—it is lighter at the bottom—and the center circle is a single homogeneous gray. The apparent gradation in luminance in the center does not really exist; it is induced by the opposite gradient in the surround. This is a consequence of the center/surround organization of the visual system cells: the opponent surround induces an opposite apparent luminance gradient in the disk (the dark-to-light surround induces a perception of light-to-dark in the disk). This happens because a light-signaling cell will be activated whenever the center is lighter than the surround—and this can be achieved either by making the center lighter or by making the surround darker. Conversely a dark-signaling cell can be activated by making the center darker or by making the surround lighter. Thus, chiaroscuro can involve both subtle gradations of the luminance of objects and skillful opposing gradation of background illumination, which is called countershading.

Rembrandt was a master of the technique of combining gradual background changes in luminance with abrupt local changes to produce the appearance of larger shifts in luminance than are actually there. His *Meditating Philosopher* is a particularly good example. The philosopher's head appears light and the crosspiece of the window frame appears dark, though the head is actually darker than the window frame. This occurs because the head is on a dark background and the frame is on a light background. The differences in the backgrounds are not easily perceptible because they grade gradually into each other. If this were a real scene, the luminance of the window would probably be hundreds of times that of the left corner.

Over the centuries, artists continued to optimize their command of luminance to maximize their ability to represent depth on a two-dimensional canvas. This trend toward representationalism reached a pinnacle in the early nineteenth century with the work of Jean-Auguste-Dominique Ingres, whose paintings have an amazingly photographic quality. Indeed, it has been repeatedly suggested that Ingres used photographs or optical techniques in which an image of the scene to be painted is cast by lenses onto the canvas or drawing tablet.

Then, toward the end of the nineteenth century, the group of artists who became known as the Impressionists aligned themselves against the established style of art, which was epitomized by the work of Ingres. Some chose to experiment with color and luminance, and they sometimes used color gradations that were decidedly not realistic and that sometimes lacked luminance differences entirely.

The Impressionist Claude Monet painted many versions of the same canvas-filling view of the cathedral in Rouen. Because the cathedral is made entirely of beige stone, it is without much contrast except for that which arises from shading. Therefore, these paintings, like his

In Rembrandt's 1632 *Meditating Philosopher*, the paint representing the window reflects only fifteen times more light than the paint representing the shadows in the lower left corner, but we see that section of the painting as being substantially lighter. The graph shows the luminance profile along the gray line on the painting. By using a combination of gradual background changes and local abrupt changes in luminance, Rembrandt simulates a much larger range of luminances than his pigments can supply.

Pages 126–27: Jean-Auguste-Dominique Ingres took the command of luminance to a new level. The luminances are just about perfect in his 1853 portrait *Princess Albert de Broglie, née Joséphine-Eléonore-Marie-Pauline de Galard de Brassac de Béarn (1825–1860)*. It is difficult to tell that the black-and-white version is not a photograph of the woman herself, rather than a photograph of a painting. (Jean-Auguste-Dominique Ingres. *Princess Albert de Broglie, née Joséphine-Eléonore-Marie-Pauline de Galard de Brassac de Béarn (1825–1860)*. 1853. Oil on canvas, 21.3 x 90.8 cm. The Metropolitan Museum of Art, Robert Lehman Collection)

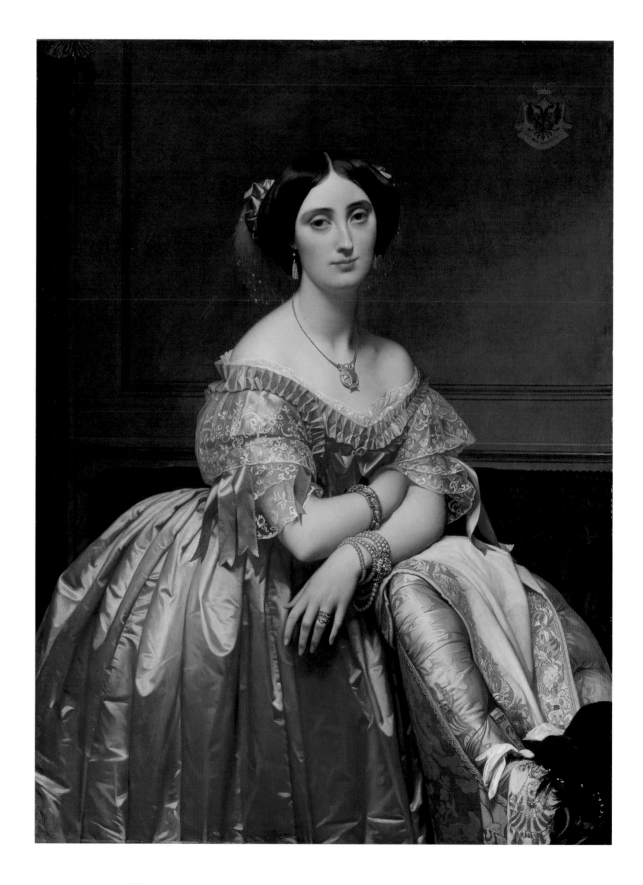

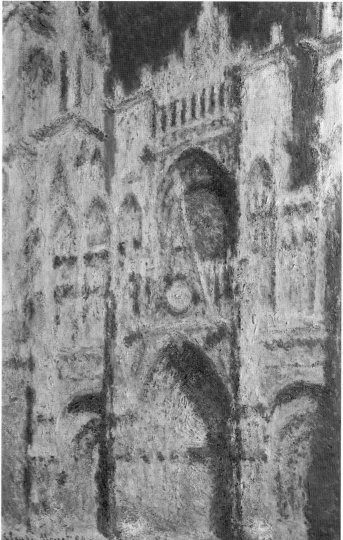

preceding haystacks series, are about light and shadow. Each one shows the building under a different lighting condition. What is of interest to me is that some of them seem distinctly less three-dimensional than others, and, when you analyze their luminance profiles, the ones that show little depth also have little luminance contrast.

Seventy-five years later Pop artist Roy Lichtenstein made a series of prints on the same subject. He used color in a reductive manner to mimic Monet's light effects. In *Rouen Cathedral #2* (pages 130–31), the two colors Lichtenstein chose are close to equiluminant, and it is much harder to make out the cathedral or its three-dimensional shape than in the others in this series, which use color combinations that do have luminance contrast.

These images and the effects they create all reflect the fact that depth from shading requires luminance contrast because the Where system, which is responsible for the ability to see shape from shading, is colorblind and sensitive only to luminance changes. Without luminance contrast, images can have a peculiar shimmery appearance and appear quite flat. Paintings using bright equiluminant colors stimulate the What system but not the Where system.

In some paintings Monet experimented with the use of very low luminance contrast with little or no color contrast, which does exactly the opposite of bright equiluminant colors— very low luminance contrast alone stimulates the Where system but not the What system.

128

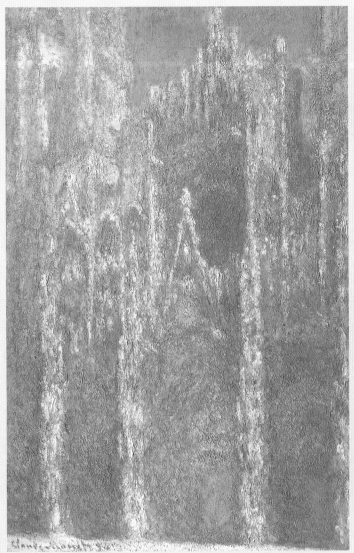 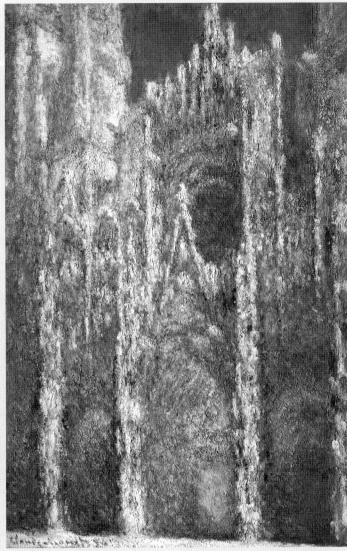

Opposite: Most of Claude Monet's depictions of Rouen Cathedral, like *Rouen Cathedral: The Portal (in Sun)* (1894), display prominent gradations of light across the face of the cathedral. The central doorway is darker than the facade, because it is in the shade. This painting has appropriate luminance contrasts to represent the variations in light that one would normally see reflected from a richly three-dimensional object, and the painting indeed looks quite three-dimensional (especially if you close one eye). (Claude Monet. *Rouen Cathedral: The Portal (in Sun)*. 1894. Oil on canvas, 99.7 x 65.7 cm. The Metropolitan Museum of Art, Theodore M. Davis Collection, Bequest of Theodore M. Davis)

Above: In another depiction of this cathedral, *Rouen Cathedral Façade* (ca. 1894), there is much less luminance variation. In this version, the gold of the doorway (which would ordinarily be in shadow and therefore darker) and the adjacent gray arches are close to the same luminance. It must have been a special, and probably transient, lighting condition to make the deep-set doorway fail to be in shadow. Monet was probably trying to emulate the actual effect he saw when the sun streamed directly into the cathedral doorway. This lack of luminance contrast gives this painting a flatter and more shimmery appearance than the other versions.

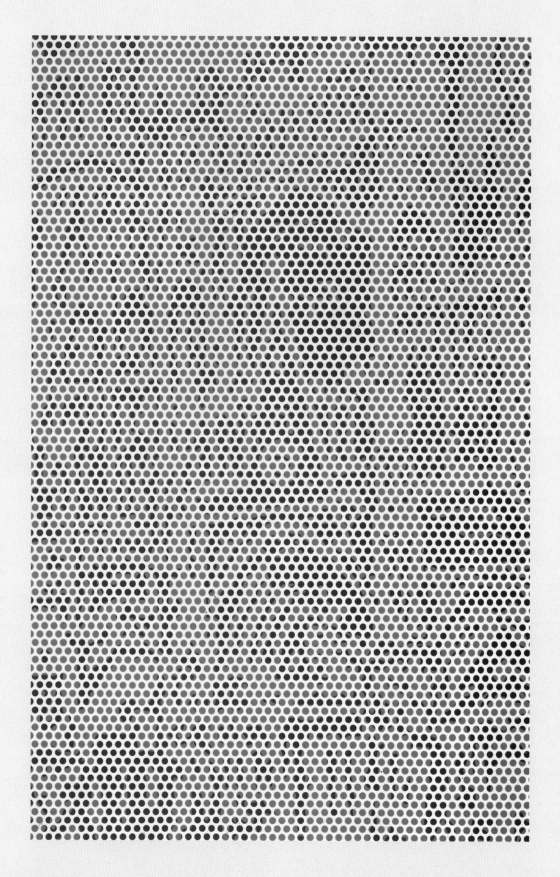

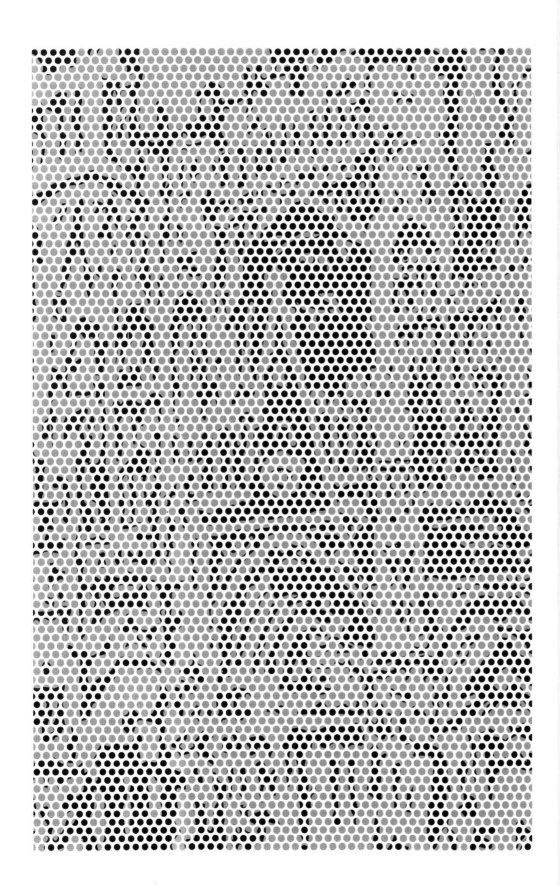

In Roy Lichtenstein's 1969 *Rouen Cathedral #2*, the red and blue are close to equiluminant. If we introduce a luminance contrast, by changing the red to light gray and the blue to black (right), it is much easier to see the shape of the cathedral, defined almost entirely by shading. You can see this transformation for yourself by looking at the left version through a piece of red glass or plastic.

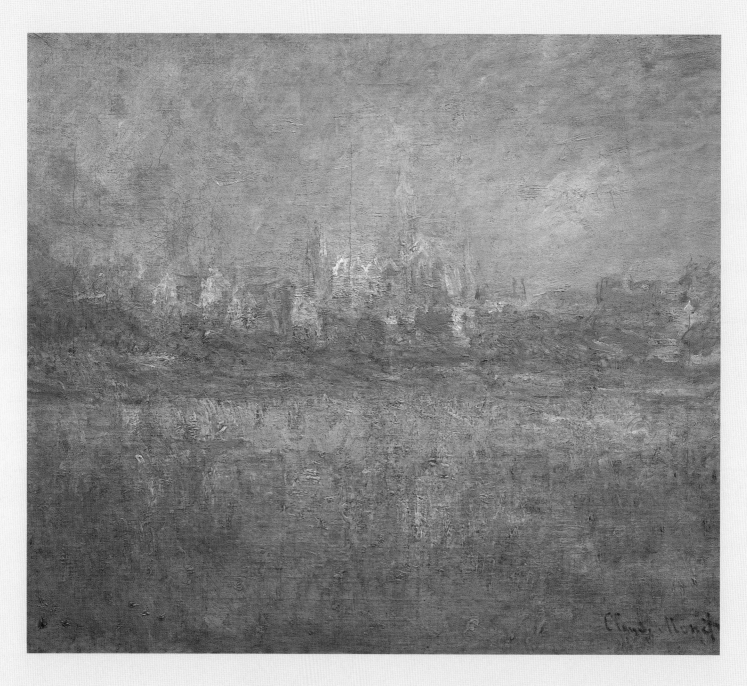

In *Vétheuil in the Fog (Vétheuil dans le Brouillard)* (1879), above, and *Ice Floes* (1892–93), opposite, Claude Monet used a broad range of hues, but all are very desaturated. Because the color contrast is negligible and the luminance contrast is so low in these paintings, you can see overall depth and spatial organization without discrete surfaces and objects being defined. Monet's approach met with an unenthusiastic response. One prospective customer complained, "If I buy your pictures without bargaining, it is for the paint. Here there is no paint.... Go back and put some more paint on, and I may very well buy your picture." (Claude Monet. *Ice Floes*. 1892–93. Oil on canvas, 66 x 100.3 cm. The Metropolitan Museum of Art, H.O. Havemeyer Collection, Bequest of Mrs. H.O. Havemeyer)

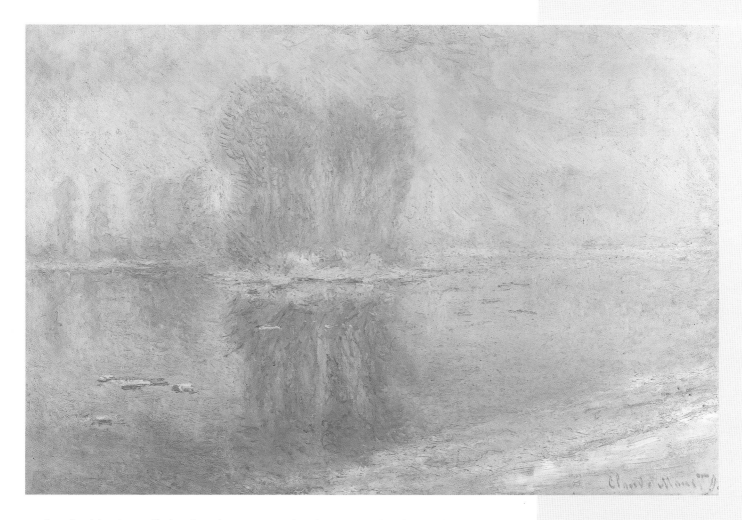

Both *Vétheuil dans le Brouillard* and *Ice Floes* are painted with pigments that differ only very slightly in luminance. Such images stimulate the Where system but not the What system because the Where system has a much higher contrast sensitivity than the What system.

The low-contrast modulations in these paintings give a sense of depth by shading cues and by perspective cues, two kinds of depth information carried by the Where system. Thus most viewers are aware of the overall shape and spatial organization of the paintings (a Where-system function) without being able to clearly or immediately identify the objects in the image (a What-system function). Similarly, you can probably experience the depth sensation of the rightmost disk on page 108, without having a distinct impression of its shape. I suspect that some of the artistic interest in these paintings arises from the disparity between the information in the two visual systems; that is, from the discrepancy between the satisfactory amount of information perceived about the overall geometry of the scene (Where) and the much sparser information about the identity of the objects in the scene (What).

As we have seen, luminance contrast, not color, is necessary for depth perception. A corollary of this is that you can use any hue you want, as long as you have the appropriate luminance contrast, and still portray three-dimensional shape from shading. This is particularly apparent in the work of the Fauves.

For example, in Henri Matisse's *The Woman with a Hat* (pages 134–35), the shadows and most of the planes of her face are peculiar colors. It is hard to imagine what kind of lighting would give blue and mauve shadows; regardless, one's sense of the three-dimensional shape

133

134

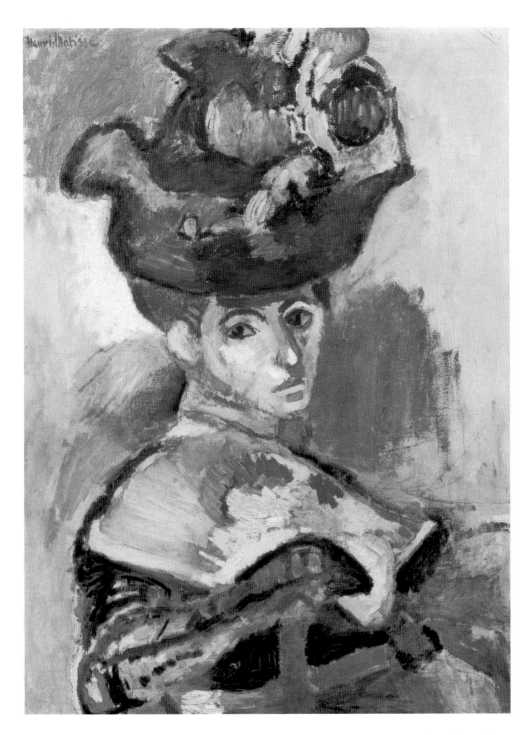

of her face is not unnatural. This is because, even though her face is made up of patches of bizarre colors, those colors have the correct relative luminance to represent planes and shadows. Matisse himself explained: "While following the impression produced on me by a face, I have tried not to stray from the anatomical structure."

Matisse made the remarkable discovery that he could use any hue and still portray the three-dimensional shape he wanted as long as the luminance was appropriate. He employed this technique in various other paintings as well, notably in his 1906 self-portrait. André

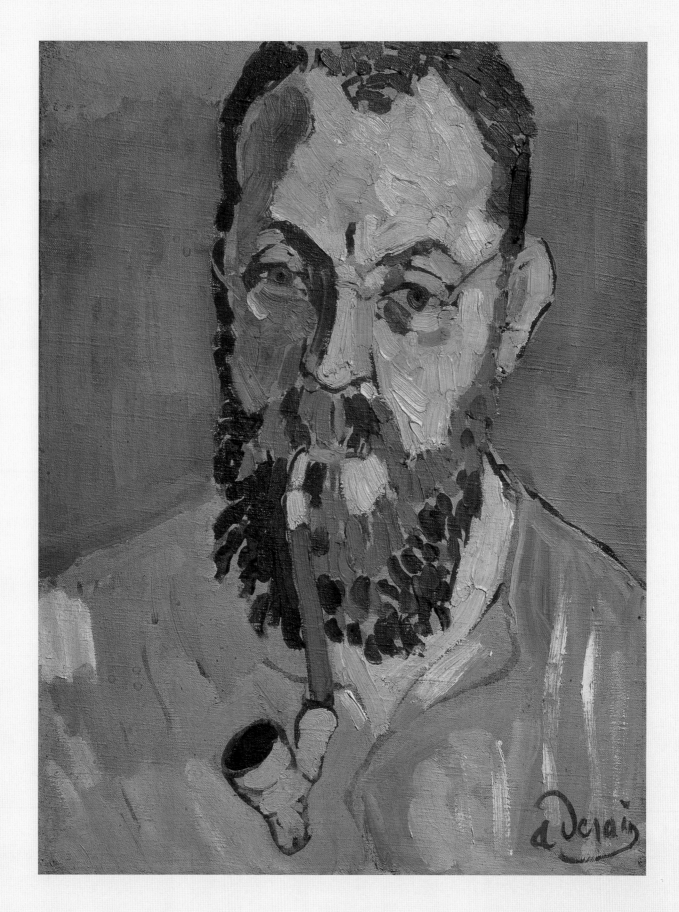

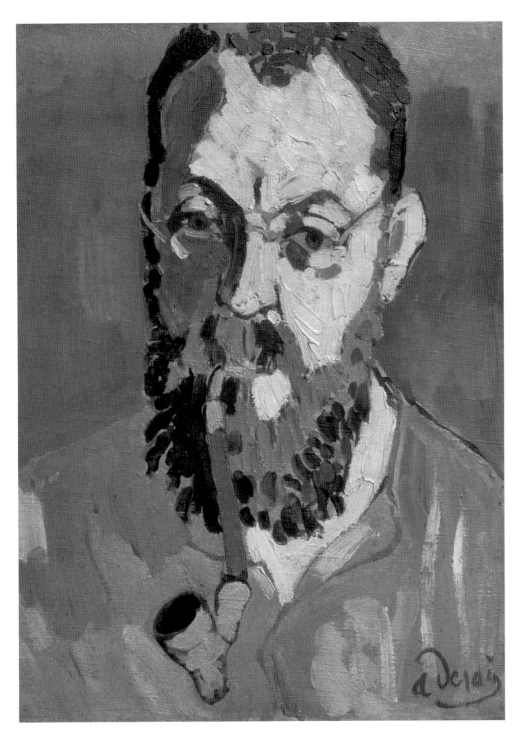

In André Derain's *Portrait of Henri Matisse* (1905), the shadows are not realistic colors, but the luminances of these unusual colors are just right to give the appropriate three-dimensional shape to the face.

Derain also used it in his portrait of Matisse. Without needing color to convey shape, he could select hues strictly to give additional poetic or symbolic meaning to his paintings: "I understood that one could work with expressive colors which are not necessarily descriptive colors," he said. "I used color as a means of expressing my emotion and not as a transcription of nature." The fact that depth is carried by a colorblind system permits such a dissociation between color and shape-from-shading.

plane of fixation
(zero disparity)

9: FROM 3-D TO 2-D: STEREOPSIS

EYES

DEPTH FROM STEREOPSIS

Our eyes each see the world from slightly different positions. Stereopsis is the ability to perceive depth from the differences between the images in the two eyes. When you look at an object—the circle, for example, in this diagram—light from it hits the foveas of both retinas. All objects at the same distance from the observer as that object —the fixation plane—will map onto precisely corresponding locations on the two retinas. Objects such as the triangle and the square, which are closer to and farther away than the circle will cast images on non-corresponding points on the two retinas. These differences in the two eyes' images are interpreted by the brain as depth.

WHILE A PHOTOGRAPHICALLY realistic use of perspective and shading was attained in the late Renaissance, these techniques alone cannot convey a true feeling of three-dimensionality. No matter how convincingly the artist renders shading and perspective, there are two other important depth cues, stereopsis and relative motion, that inform the viewer's brain that the painting is in fact flat.

Since our two eyes view the world from slightly different positions, the images on the two retinas differ slightly. Stereopsis is the ability of the visual system to interpret the disparity between the two images as depth. A stereoscope, a device popular in the late 1800s, presents a stereogram—two slightly different pictures, one to each eye—and gives a vivid sense of depth. The View-Masters many of us enjoyed as children also work on this principle, showing three-dimensional images of dinosaurs, cartoon characters, or landscape scenes.

DEPTH FROM RELATIVE MOTION

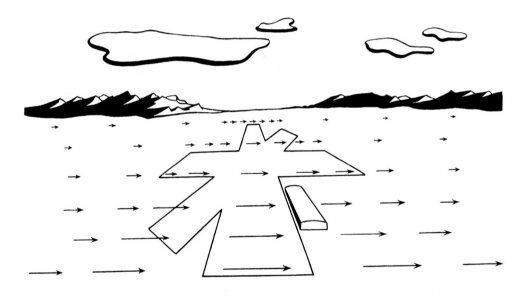

As we move through space, near objects move farther across our visual field than more distant objects. This diagram shows the relative motion of different parts of the environment as the observer moves to the left (from J. J. Gibson).

We also get information about distance from the relative movement of objects as we move past them. For example, as you walk down a street at night, you will find that objects close to you, such as the trees along the sidewalk, seem to pass by more quickly than the houses or trees farther away. Those at even greater distances, such as the moon, seem to move not at all. You can make your way through an entire neighborhood, and the moon would still appear to be in the same place.

We also pick up relative movement cues from the small head movements we make even when we stand still in front of a painting; they are enough to vividly tell our brains that the painting is indeed flat. The same part of the brain that codes stereopsis codes depth from relative motion, probably using the same cells, so movements as small as the distance between our eyes are quite large enough to produce a strong depth signal.

Above: Stereo views of a vase of chrysanthemums. These two images are very similar but not identical. If you fuse them by crossing your eyes, you will see the flowers in depth. To do so, hold the page at arm's length, place a single finger just below the images and four inches from your eyes. Keep your eyes on your finger and move your finger forward and backward slowly until you see a single image of the flowers. When the two slightly different pictures are fused in your brain, the scene has a great deal more depth than can be seen in either image alone, despite perspective and shading cues, because stereopsis is a powerful depth cue. (Conversely, stereopsis is also a powerful cue that a painting is flat—that is, it can contradict or weaken the perception of depth from the perspective and shading cues that the artist has carefully constructed.)

Can you identify the tiny differences between these two images? The Where system is so sensitive to tiny disparities that we can accurately distinguish distances that correspond to a difference in the two eyes' images of less than a photoreceptor's width.

When we look at a painting, no matter how skillfully the artist conveys depth through the use of perspective and shading, the fact that the images in our two eyes are identical and the fact that there is no relative movement between objects in the painting tell our brains that the painting is really flat. To circumvent this, Leonardo da Vinci suggested that paintings should be viewed with only one eye and at a long distance in order to appreciate the illusion of three-dimensionality: "It is impossible that a painting, even in which the outlines, shade, light and color are copied with the highest perfection, can appear with the same relief as a real object in nature, unless this natural object is looked at over a long distance and with a single eye." (Try it; it works.) It was briefly fashionable, several hundred years ago, to hang a dark curtain with a small viewing hole in front of a painting so that viewers could appreciate the optimum illusion of depth without stereopsis or relative movement dispelling the illusion of three-dimensional space.

Above left: If the two images in the stereogram opposite are simply overlaid, the resultant combined image is slightly blurry, because of the slight differences between the two images. The degree of blurriness reflects the magnitude of the difference between the two eyes' images in the stereogram. Because the views of our two eyes differ only slightly, in order to see stereopsis, we must be able to see enough detail to discriminate such tiny differences between the two images. This overlaid image is missing just about enough detail to make it look similar to many Impressionist paintings.

Above: Many Impressionist paintings, such as Claude Monet's *Chrysanthemums* (1882), are sort of blurry. Images lacking fine detail, like this one, are not an effective stimulus for stereoscopic depth perception, and therefore stereopsis cannot give a strong signal that the painting is flat. If stereopsis fails to signal that the painting is flat, other depth cues can give the painting an illusory sense of three-dimensionality.
(Claude Monet. *Chrysanthemums*. 1882. Oil on canvas, 100.3 x 81.9 cm. The Metropolitan Museum of Art, H.O. Havemeyer Collection, Bequest of Mrs. H.O. Havemeyer)

Cross your eyes to fuse these two textured squares; when they are correctly fused, the two dots will also fuse. The diagram at the bottom shows how this stereogram should appear in depth when it is properly fused. From left to right, you should see a flat region that gradually recedes behind the plane of the page, then an abrupt depth discontinuity brings the surface in front of the plane of the page, and then the surface gradually recedes into the plane of the page again. Although the left and right outer thirds of the stereogram have the same disparity (that is, they both lie in the plane of the page), the left side seems farther away than the right because of the local depth discontinuity at the center. Thus, local depth discontinuities are seen more vividly than gradual changes and can spread to assign different depths to adjacent surfaces that are really at the same depth. This sensitivity to local rather than to gradual disparity gradients is analogous to the selectivity for local over gradual changes in luminance.

BRUSH TECHNIQUE AND DEPTH PERCEPTION

In most Impressionist paintings a sense of depth is conveyed through cues such as perspective or shading, rendered in luminance contrast. In addition, I suggest that the blurriness and the elimination of details, characteristic of many Impressionist paintings, also contribute to a sense of three-dimensionality. Blurriness makes it impossible for our brains to use stereopsis. To see stereoscopic depth, the image needs to be detailed enough that we can detect the slight differences in the two eyes' images; if the images are blurry, we can't see the differences and therefore can't use stereopsis. By eliminating some spatial details and blurring others, the artist hinders stereopsis from telling us that the image is really flat. This allows other depth cues in the painting, such as shading and perspective, to produce a more powerful impression because they are not as strongly contradicted by stereopsis.

We have discussed how the center/surround organization of the cells in our visual system makes them more responsive to sudden than to gradual changes in luminance. This phenomenon holds for depth perception as well: the visual system responds better to abrupt than to gradual changes in depth and is more concerned with local than global depth changes. This may be why bas relief looks more three-dimensional than it really is: it has mainly local depth information.

Using a thick application of paint can also produce an illusory sense of depth by taking advantage of the fact that our stereopsis is more sensitive to abrupt depth discontinuities than to gradual depth changes. Such artists as Degas, Cézanne, and van Gogh often used very thick paint, which gives a sculptural quality to the paintings. Thus at some borders that represent depth discontinuities there is a real, though shallow, depth discontinuity. Such discontinuities can contribute to a sense of depth, even though depth is present only at the edge, and the entire object is not at a different depth than the background. In *La Guinguette dans Montmartre* the paint representing the vine, for example, is raised off the background, and appears vividly three-dimensional. Local depth discontinuities in a painting can be quite small, but if they are sharp they contribute disproportionately to a sense of three-dimensionality.

The vines appear vividly three-dimensional in van Gogh's 1886 *La Guinguette dans Montmartre*, because of the bas relief of the applied paint. (Of course the effect does not occur with this flat reproduction.)

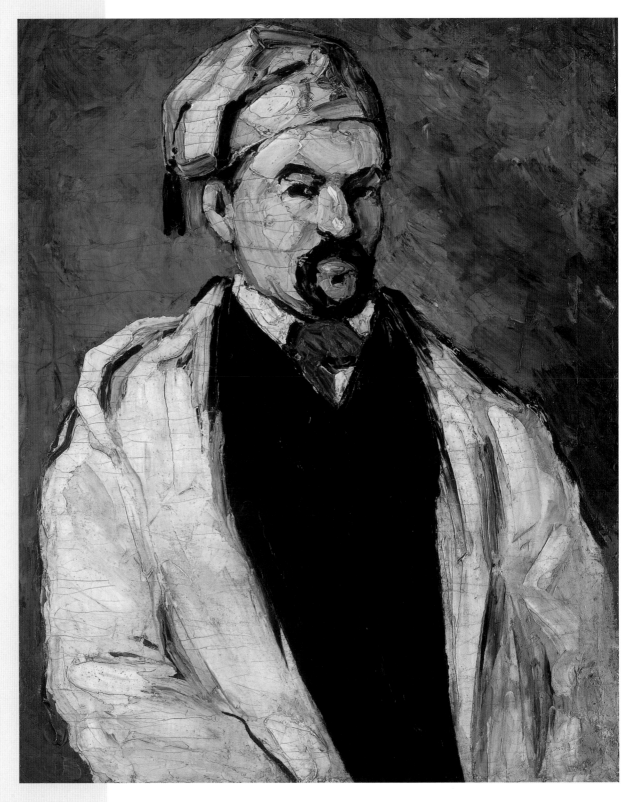

In Paul Cézanne's painting *Dominique Aubert, the Artist's Uncle* (ca. 1866), the paint is laid on in an almost sculptural manner, so that there are real depth discontinuities along the edges of the jacket and the nose. (Of course the effect cannot be seen with this flat reproduction, but I hope you get the idea.)

(Paul Cezanne. *Dominique Aubert, the Artist's Uncle.* ca. 1866. Oil on canvas, 79.7 x 64.1 cm. The Metropolitan Museum of Art, Wolfe Fund)

DEPTH ILLUSIONS WITH REPETITIVE PATTERNS

Single images that contain horizontally repetitive patterns can give an illusory depth impression similar to stereograms. This illusion is called the Wallpaper or the Escalator illusion because both wallpaper and escalators have repetitive patterns. I will discuss two ways repetitive patterns can produce a sense of depth.

The first is by misfusion, which happens when instead of matching identical elements in our two eyes, we match adjacent, non-identical elements of an image. The popular autostereogram images, first invented by Christopher Tyler, are good examples of this. These patterns are, unfortunately, usually designed to be viewed while looking beyond the surface of the

THREE WAYS TO LOOK AT A REPETITIVE IMAGE

NORMAL FUSION

CROSSED FUSION

DIVERGENT FUSION

There are three ways to look at a repetitive pattern: using normal, crossed, and divergent fusion. Normal fusion: if both eyes are looking at the same individual element, they are fixated on the plane of the image. The elements are imaged on corresponding points in the two retinas. Crossed fusion: if your eyes are slightly crossed (converged), each element in your right eye is matched with the element to its right in the left eye. When this happens, the plane of fixation is closer than the image you are looking at. Divergent fusion: if your eyes are fixed beyond the image you are looking at, they are said to be diverged (even though their lines of sight do not actually diverge). With divergent fusion, each element in your right eye is matched with the element to its left in the left eye.

WHY WE SEE ILLUSORY DEPTH WITH REPETITIVE PATTERNS

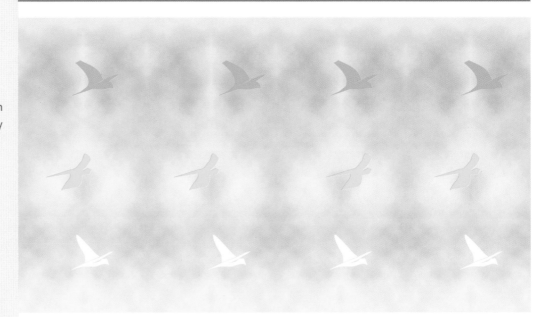

You can view this autostereogram either by crossing your eyes or by focusing beyond the image plane (divergent fusion).

image, by diverging the eyes, not by crossing them, as with the stereograms we saw earlier in this book. (Crossing is easier!) When the eyes cross or diverge, they are not aligned on the same elements of the autostereogram image, but because the patterns are repetitive, each element of the pattern in one eye can be fused with the next element in the other eye. The elements in each vertical row are slightly different in such a way that when non-identical rows are seen with the two eyes this misalignment produces a systematic disparity, giving a sense of three-dimensionality.

The second way a semiregular pattern can induce an illusion of depth is when the visual system matches noncorresponding elements in a pattern, even though the eyes may be perfectly fixated on the plane of the image. When we look at a flat surface, the images on our two retinas are identical; each element of the surface casts an image on corresponding points of the two retinas. When we view a three-dimensional scene, objects in front of or behind the plane of fixation cast images on non-corresponding points of the two retinas. The brain must decide which images in the right retina should be matched with which images in the left. Usually the brain is correct in settling on the most parsimonious explanation. Repeated patterns, however, can confuse the matching process, since several explanations may be equally valid, and this creates an illusion of depth.

Some Impressionist paintings, and some Post-Impressionist paintings, are notable for being able to invoke a sensation of "air" or "atmosphere." I suspect this sensation arises from an illusory depth impression created by a semiregular pattern of leaves or flowers, or just from coarse brushstrokes. Monet's *Rue Montorgueil in Paris, Festival of June 30, 1878* (page 75) and *Springtime through the Branches* and Gustav Klimt's *The Park* (pages 148–49) all produce an

illusion of depth because of the semirepetitive patterns of the flags or leaves. The visual system can perceive the repetitive elements at multiple depths for the two reasons discussed above, giving the paintings a sense of three-dimensionality. This effect goes beyond what can be achieved by the most accurate realism (short of making two slightly different paintings and using stereo viewers) in generating a sense of depth.

potential illusory
targets seen at
other depths

true targets
in plane
of fixation

EYES

With repetitive patterns the brain can make false matches between different points in the two eyes. For example, here four real objects lie in the plane of fixation, but there are twelve additional possible false targets at different depths that are also compatible with the images on the two retinas. This kind of stereogram was invented by Christopher Tyler.

147

Above: "I am pursuing the impossible," said Claude Monet. "I want to paint the air." The repetitive pattern of the leaves, in *Springtime through the Branches* (1878) does give an illusory sensation of a three-dimensional volume because of the many possible false matches at different depths.

Opposite: The semirepetitive pattern of the leaves in Gustav Klimt's *The Park* (1910 or earlier) also produces an illusion of depth—a wallpaper illusion.

(Klimt, Gustav *The Park*, 1910 or earlier Oil on canvas, 110.4 x 110.4 cm The Museum of Modern Art, New York. Gertrud A. Mellon Fund. Photograph © 2001 The Museum of Modern Art, New York)

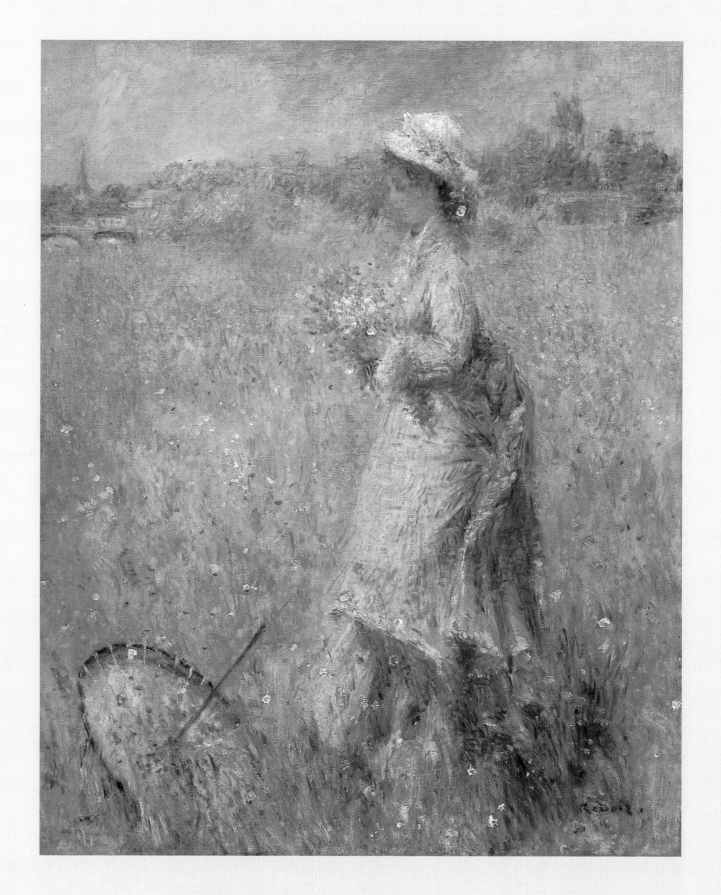

The sensation of "air" or "atmosphere" is particularly striking in Pierre-Auguste Renoir's *A Girl Gathering Flowers* and Charles Angrand's *Couple dans la rue*. I think they produce this impression because the dabs of paint can be mismatched in the images in the two eyes, giving an illusory sense of a three-dimensional volume filled with small elements, like dust, pollen, or leaves.

Some modern paintings—for example, Bridget Riley's *Fall*, reproduced on page 163—have fine repetitive high-contrast lines that also induce powerful illusory stereo depth for the same reason.

10:
ILLUSIONS OF MOTION

ONE OF THE MOST novel accomplishments of the Impressionist artists is the shimmering, alive quality they achieved in many of their paintings. I suggest that some of the color combinations these artists used have such a low luminance contrast—and are in effect equiluminant—that they create an illusion of motion. We perceive illusory motion in images made from equiluminant colors for the same reason we don't see appropriate depth in these images: the Where system can't see equiluminant colors. The Where system is responsible for our ability to see motion and position, as well as depth. Therefore if an image is made of bright equiluminant colors, the What system can see those objects clearly, but their position and stability are not registered by the Where system, so they can seem to jitter or move around. I am certain that David Sedaris was describing the jittery effect of equiluminant colors in this passage from one of his books: "the building was sold and painted hot pink with tangerine trim. The combination of colors gave the house a raw, jittery feeling. Stare at the facade for more than a minute, and the doors and windows appeared to tremble, as if suffering the effects of a powerful amphetamine."

In *The Poppy Field outside of Argenteuil* (1873) Monet paints the flowers with a red that is approximately equiluminant with the green of the grass and the skirt of the woman in the foreground. The What system can distinguish the poppies and the skirt from the grass because it is color selective and the colors are easily distinguishable. But the colors, although bright, do not have much luminance contrast, so the Where system cannot see them clearly. Therefore their position is uncertain. They can seem to move or change position, as if stirred by a breeze.

The What system can see the squares in Piet Mondrian's 1942–43 *Broadway Boogie Woogie* clearly, but the Where system cannot, since the yellow and gray are close to equiluminant with the off-white background. Therefore, the squares can seem to move or jitter. (Mondrian, Piet. *Broadway Boogie Woogie*, 1942–3 Oil on canvas, 127 x 127 cm The Museum of Modern Art, New York. Given anonymously. Photograph ©2001 The Museum of Modern Art, New York)

155

The water seems to shimmer and flow beneath Monet's *Railway Bridge at Argenteuil* (1874).

Monet's *The Poppy Field outside of Argenteuil* is a good example of this. Since the flowers are close to equiluminant with the grass, their identity is clear but their position is not, giving them an illusory instability. Though this illusory motion effect certainly goes beyond realism, it is not clear if this effect was intentional or an accident of the paints Monet had. Certainly others have noticed that his paintings often exhibit illusory motion effects: Louis Duranty, one of the early admirers of the Impressionists, said many of them tried to capture "the trembling leaves, the quavering water."

The positional indeterminacy of equiluminant objects may produce an illusion of movement because of the failure to stimulate the Where system, but simply moving your eyes over a surface covered by patches of equiluminant colors can produce a similar illusion. This reflects yet another function of the Where system: it makes the world we see appear stable even though we move our eyes around. Given how much we move our eyes, our perception of the world would look like a movie shot with a camera held by someone riding a pogo stick if our visual perception simply reflected the images our eyes send to our brains. But we see the world as stationary because the brain remaps retinal images to compensate for eye movements. Since this job is carried out by the Where system, it requires luminance contrast information. Therefore, if we move our eyes over a scene with no luminance changes (sub-optimally stimulating the Where system), information from successive eye fixations can be misregistered (misaligned with the previous fixation, sort of like splicing together movie scenes shot from different camera positions). This can cause illusory motion with each eye movement. Look again at *The Poppy Field*. You may find that the flowers seem to move each time you shift your gaze.

Similarly, Piet Mondrian's more modern painting *Broadway Boogie Woogie* gives a sensation of jazzy, jittery motion because the yellow checks, which are clearly visible to the What system because of their saturated color, are poorly visible to the Where system, because they are equiluminant with the off-white background. Unlike Monet's *Poppy Field*, it is clear from the title *Broadway Boogie Woogie* that this illusory motion effect is exactly what Mondrian intended (or perhaps discovered he had achieved). The grayscale version of *Broadway Boogie Woogie* shows that the yellow and gray squares are indeed very close to equiluminant with the off-white background.

Even though reality usually changes with time, paintings that depict a changing scene are themselves necessarily motionless, and the most action-packed paintings can seem jarringly static because of this discrepancy. The ability to produce an illusory sense of motion in a painting adds a completely new dimension. *The Rape of the Sabine Women* (see page 76) certainly depicts a lot of action, yet it can seem quite inert in comparison with Monet's poppies or Mondrian's *Broadway*. The longer I look at *Broadway Boogie Woogie*, in fact, the more it seems to move, but the longer I look at *Rape of the Sabine Women*, the more bizarrely stationary it seems.

ADVERTISING TRICKS OF THE TRADE

An advertiser's goals are to get us to look at an ad and then read and remember the associated text. Obviously advertisers often try to attract attention by accompanying their message with provocative images. Another trick is to manipulate the text itself in ways that selectively hinder the Where system. Such techniques result in text that both attracts our attention and forces us to slow down (which means we end up spending a few more seconds looking at the ad and may therefore be more likely to remember its message).

Reading is both a Where and a What system task: the Where system conveys the overall shape of words and text for rapid, fluent recognition, and the What system carries the details of the individual letters. It is possible to read with the What system alone, but it is a much slower and more laborious process: it is therefore in the advertiser's interest to make reading an ad a What system task alone by failing to stimulate the Where system.

One way to achieve this is to print letters of one color against an equiluminant background. As we have seen, any area with equiluminant colors is jumpy and jittery (and thus attention-getting); if it is text that is equiluminant, it has the added benefit that it is hard to read and forces you to slow down.

Advertisers also often use letters that are alternately darker and lighter than the background—alternating contrast—which has a similar slowing effect on your reading. How does this work? Because the Where system is sensitive to contrasts, alternating contrast impairs our ability to get the gestalt of the text, forcing us to read it slowly.

The use of contrasting colors, or equiluminant colors in type is not particularly widespread outside of advertising. "[The] initially exciting effect feels aggressive and often even uncomfortable to our eyes," wrote Josef Albers. "One finds it rarely used except for a screaming effect in advertising, and as a result it is unpleasant, disliked, avoided."

This is easy to read, so you can decide to ignore it very rapidly.

Very low contrast text can be read by your Where System alone, as long as the words are easily recognizable, but infrequent or recondite words that you have to read letter-by-letter are much more difficult.

This is also hard to read. It jumps around and seems unstable because your WHERE SYSTEM can't see it. Advertisers use equiluminant writing because the jumpy quality is attention-getting, and the difficulty in reading it forces you to pay more attention.

This is hard to read, even though each letter is easy to see, so you have to pay attention to read it.

Jittering the vertical position or the size of letters forces the reader to slow down.

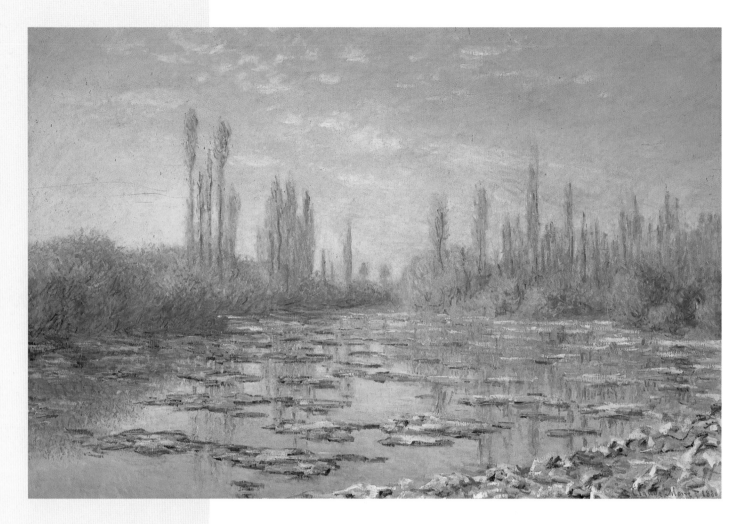

Monet is particularly celebrated for his paintings of water. One review of his work exclaimed, "How his rivers flow!" His water really does seem to move. The water in *The Ice Floes* and in *Railway Bridge at Argenteuil* consists of areas with high luminance contrast juxtaposed with regions of equiluminance or low luminance contrast.

Such a juxtaposition can indeed lead to illusory motion effects. In general, repetitive high-contrast lines will induce motion perpendicular to their own orientation; light shining through horizontal venetian blinds will induce the appearance of vertical motion on an adjacent wall, known as the McKay illusion. Isia Leviant's *Enigma* (page 162) produces a powerful McKay illusion. It is not understood why a large field of high-contrast lines induces an illusion of motion, but I suspect that a mild form of this illusion is responsible for some of the illusory motion seen in Monet's water and certain other paintings.

A contemporary critic said of Monet's *The Ice Floes* (*Les Glaçons*) (1880), "The trees are really planted and the ice is really swept along by the water." The ice floes provide repetitive horizontal luminance-contrast borders that can induce illusory motion in the vertically oriented equiluminant streams of the water.

Juxtaposition of luminance-contrast borders with areas of equiluminance can cause the illusion of motion. An extreme example of this is the McKay, or venetian blind, illusion, evident in *Enigma* (1984), opposite, by Isia Leviant. After looking at this image for a minute or so (be patient), you should notice a streaming effect in the colored circles. The streaming always moves perpendicularly to the high-contrast lines, which induce it.

Another image that induces powerful illusory motion from high-contrast lines, and powerful illusory stereo-depth from repetitive patterns is *Fall* (1963) by Bridget Riley, above.

11:

COLOR MIXING
AND COLOR RESOLUTION

AS WE HAVE SAID, the What system is subdivided into Form and Color subdivisions. The Color system operates at a surprisingly low resolution. That is, cells in the Color system have much larger receptive fields and there are fewer of them than in the Where system or in the Form part of the What system. This means that our perception of color is coarse.

Painters who use watercolors or pastels often exploit the low resolution of our color system by applying their color in a looser or blurrier way than the higher-contrast outlines of the objects to which the color applies. That is, if they use a color that has a low luminance contrast with the background (as is often the case with watercolors or pastels) they can draw high-contrast outlines, and the color will seem to conform to the outlines, even if it actually does not. Examples of this can be seen in Abraham Walkowitz's *Isadora Duncan #29* (page 168), and Ben Shahn's picture of a boy with an ice cream cone (page 169).

We have discussed the center/surround organization of color cells and said that this organization makes these cells responsive to color borders but not to homogeneous areas of color. This means that our color system codes the color of an object by signaling its edges, which defines the color contrast border, and letting the color "fill in" perceptually. (Remember that double-opponent color cells respond to color-contrast borders, but not to large color areas, because of their opponent surrounds.) A tomato looks red not only at the edges, where the "red" cells tell the brain that this object is redder than its surround, but also in the center, where there is no corresponding neural activity—the lack of activity in the center is interpreted as meaning that nothing has changed since the edge.

You may find it surprising that your perception of a homogeneously colored surface depends on color-selective neural activity only at the edges, but you can see manifestations of this in the "watercolor illusion" here and in the following two exercises.

Lothar Spillmann has been studying how our visual system perceives low-luminance-contrast colors as spreading beyond their own color boundaries to be constrained by the nearest luminance-contrast border. This figure, adapted from his research, shows how strong this effect, the "watercolor illusion," can be. The central portion of the blob is exactly the same white as the background.

Opposite: Raoul Dufy's *Still Life with Violin, Hommage to Bach* (1952) carries to an extreme the technique of using loosely applied colors with higher-contrast outlines. We are able to assign colors to various objects even though the colors don't conform to the outlines.

Another good example of how
low-luminance-contrast color
conforms to the nearest high-
luminance-contrast border is
Isadora Duncan #29 (ca. 1915)
by Abraham Walkowitz. The
application of the watercolor is
much less precise than the lines,
yet the color adheres to the
contours the lines define.

Opposite: *Triple Dip* by Ben
Shahn (1952) is almost a
caricature of the way artists
often loosely overlay color onto a
luminance-contrast image.

45-50

Ben Shahn

First, take a two-inch-square piece of colored paper and hold it about one inch in front of one eye. You will find that you "see through" the paper (with the other eye actually), except at the edges. If you try to read this page with one eye covered by the square of paper (or even with the palm of your hand), you can see the text, but you will simultaneously see the color and the edge (but not the middle) of the colored paper. This phenomenon arises because what you see with each eye depends on the activity of cells representing each eye. That is, if there is no activity from one eye for some part of the visual field, activity in the other eye will be seen preferentially. So in the part of your visual field representing the center of your hand or the colored square, there is no activity, so the input from the other eye dominates.

For a more compelling demonstration that does not involve the dominance of one eye over the other, find a piece of red paper, a piece of green paper, and a ping-pong ball. Cut the ping-pong ball in half. Hold or tape a half ping-pong ball over one eye and close the other eye. Place the red or green paper a few inches in front of the eye that is covered by the half ball. You will at first see an appropriately bright red or green color filling your visual field. But after a few seconds (if you have managed to get rid of all contours with your ping-pong ball) the color will fade to dark gray. Your vision completely fades because you need color contours, edges, to see color (and luminance). The reason you see the color at all initially is that a temporal discontinuity is also an edge—in time.

Such fading also happens during "white-out" conditions in a heavy snowstorm: everything goes dark, even though it is still light, because there are no visible contours in the snow.

Some artists take advantage of the fact that our visual systems are sensitive to contours and not to homogeneous areas. Any line drawing, of course does this. Indeed, the mere fact that we find line drawings to be acceptable representations of reality, despite the fact that reality contains no such lines, reflects that fact that our visual system extracts contours! But in addition some artists represent homogeneously colored objects by applying color at the edge of the object and fading the color toward the interior of the object. Cézanne, for example, does this in his watercolor *The Lime Kiln*.

Cézanne also allows his colors to spread, in an extreme, but compelling, way in the watercolor study for his painting *The Cardplayers* (page 172). In this watercolor the blue of the man's smock and the color of his face are conveyed by a few dabs of paint that perceptually spread well beyond their physical extent.

Eugène Delacroix pioneered a technique that was later taken up by the Impressionists, in which he used coarse brushstrokes and didn't mix the pigments before stroking them onto the canvas, claiming that that gave "pure colors" that had "greater energy and freshness." The pigments may have been "pure," but the colors—the light reflected from those pigments— were certainly not pure in any technical sense. A "pure" color would presumably be light of a narrow waveband, and pigments reflect light of many wavelengths.

The Post-Impressionists later carried this technique even further with their Pointillism, in which a single surface is represented by many small dots of paint of various colors. They claimed that applying pigment in this way allowed "optical mixing" of the colors, asserting that that gave more "brilliant" colors. "Optical mixing" means that adjacent colors blend as if light of the two colors were superimposed (additive color mixing) rather than like two pigments mixed on a palette (subtractive color mixing). As we will see, the Post-Impressionists did indeed achieve optical mixing of colors, but I will show you that the "brilliance" of their colors does not arise from that fact.

Opposite: In *The Lime Kiln* (1890–94) Cézanne indicates the colors of the roofs and walls of the buildings and the trees, mostly by colors at their borders. Despite the fact that the colors fade into the interior of each surface, they convey the impression that the surface is homogeneously colored.

170

MIXING COLORS

A brief review of additive and subtractive color mixing may be helpful here. When certain pairs of colors of light (complementary) are mixed, they create white light. This is because white is the experience we have when all three of our cone types are activated in approximately equal proportion. Mixing paints, however, works subtractively: we mix not the light they reflect, but their absorbances, because the molecules become so close together that any light that hits the mixed pigment will hit both kinds of pigment. That is, mixing blue and yellow light yields white light, but the light reflected from a mixture of blue and yellow pigments is green. In additive mixing the reflectances add; in subtractive mixing the absorbances add.

Opposite: The perceptual spreading of colors is illustrated in Cézanne's *The Cardplayer* (ca. 1890–92), in which the artist conveys a lot of information about the colors of entire objects with a mere few dabs of color.

PRIMARY AND COMPLEMENTARY COLORS

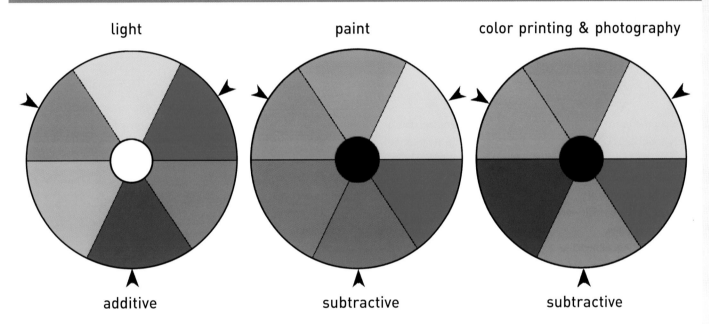

light paint color printing & photography

additive subtractive subtractive

Three color circles showing primary colors (indicated by arrowheads), complementary colors (opposite each other on each circle), and how colors mix (the color between two colors is what you get when you mix those two colors). Because most of us have three kinds of cones, three suitably chosen primaries can generate all other colors. Because our cones have broad absorption ranges, we are not too particular about which colors are primaries. As the color circles here illustrate, primaries and their complements differ, depending on whether we are talking about lights or pigments. Complementary colors are pairs of colors that give an achromatic mixture. The circle on the left is similar to Newton's color circle, and shows primaries and mixtures of light; the middle circle shows colors that are generally considered primary by painters; the right circle shows the primaries used in color printing and photography. For light, red, blue, and green are the optimum primaries. For pigments, cyan, magenta, and yellow are the most efficient primaries and are therefore used in color printing and photography. The reason cyan, magenta, and yellow are the most efficient subtractive primaries is that they each represent the "negative" of the optimum light primaries: cyan is minus red (i.e., it absorbs red light); yellow absorbs blue light; magenta absorbs green light.

color printing

Pointillism

conventional painting

When pigments are mixed, the colors are usually combined subtractively. However, there are three common forms of additive color mixing of pigments, each of which works on a different scale.

Color printing: minuscule dots of colored ink are used in color printing (in magazines and books). Here tiny dots of yellow and blue are interdigitated. The blue dots reflect blue light, and the yellow dots reflect yellow light. These two colors are additively mixed, which gives achromatic (gray) light. The individual dots are very difficult to see without a magnifying glass.

Pointillism: the yellow and blue dots are large enough that you can see the individual dots, but small enough that the colors still merge to give gray.

Conventional painting: regions of yellow and blue oppose each other when the colored regions are larger than a color-opponent cell's receptive field. We perceive homogeneous regions of color, even though our color-opponent cells are active only at the borders.

The dots of paint used in Pointillism are similar in an interesting way to the tiny dots of colored ink used in color printing, except for the difference in scale. This difference has important consequences. The diagram here compares the way color printing, Pointillism, and conventional painting might combine blue and yellow pigments.

In color printing tiny dots of colored ink are either squirted (ink jet) or transferred from a printing plate. The left panel shows how in a magazine illustration tiny blue and yellow dots might be interdigitated. Because the dots are much tinier than any of the visual system's receptive fields, you cannot see the individual dots, so the colors merge (optical mixing), to give an achromatic gray. That is, the reflected light will be the light that is reflected by yellow or reflected by blue. Therefore when an area is covered by a mixture of yellow and blue dots, the result is a gray—achromatic (because yellow and blue are complementary)—and not green—as it would be if the paints were mixed together. (The reason these dots do not create white, as they would if they were yellow and blue lights, is that by putting a pigment on paper,

the amount of light reflected is decreased, compared to the white paper.) So the colors are additive, but the luminance is diminished in proportion to how much white is deleted.

You may be surprised to read that if you mix yellow and blue paint on a palette you get a different color than if you paint tiny dots of yellow and blue, and then stand far enough away that they merge. I tried this, though: I dotted two one-inch square areas on a white board by making interdigitated dots of Winsor Yellow and Manganese Blue with a toothpick. I made the dots close to each other, but not overlapping. I walked about twenty-five feet from the board and saw that the two patches both looked gray, not green. Then I used a toothpick to smear and mix the dots of one of the patches, which resulted in that patch becoming quite green. At a distance the smeared patch looked green, but the unmixed patch of the same two paints still looked gray.

The second panel represents how Pointillists might have placed dots of blue and yellow paint side by side on a canvas. The dots are larger than the dots of a magazine illustration, but if they are small relative to the scale of a single color-opponent cell in the visual system then you can still get optical mixing of the light reflected from those dots.

The third panel represents a conventional painting with adjacent patches of yellow and blue paint, patches large enough that a given color-opponent cell will see either one or the other color, but not both. In this case, the two colors are seen independently, but they each activate the antagonistic surround of cells along the border, giving a more vivid color impression to each patch.

The Pointillists claimed that by using additive color mixing they were able to obtain more brilliant colors. Paul Signac said, for example, "These colors of green and of violet are, in fact, almost complementary and would, if they had been mixed as pigments, have produced a drab and dirty hue, one of those grays that is the enemy of all painting; whereas juxtaposed, they will re-create optically a fine, pearly gray." Yet no one would claim that magazine illustrations are particularly successful in this regard, and magazine printing also uses additive color mixing of dots of color, just on a much finer scale than in Pointillism. So what is it about Pointillism that gives it such vibrancy? What is it that makes Signac's gray "pearly" instead of "drab"? I suggest that it is simply the scale of the dots, and the fact that the scale is somewhere between the resolution of our central and peripheral vision.

The image on the next page is a detail from a painting by Georges Seurat. The entire image is made up of little dots of paint, each about a sixteenth of an inch in diameter, of various colors. Facing it is an enlargement of a magazine illustration. In both images you see a woman's head made up of little dots of color. The detail from Seurat's painting is reproduced at about twice actual size, so you can see that you would ordinarily be able to see the varicolored dots, unless you were standing quite distant from the painting. The magazine illustration, on the other hand, is reproduced at almost ten times actual size, and you would not ordinarily be able to resolve the little dots that make it up. That is, when shown at actual size, the dots are too small for our eyes to distinguish, so they blend together.

The inks in magazine printing blend both additively and subtractively (that is, many of the colored dots are isolated, like in the background, or over most of Marilyn's skin, and therefore combine additively, but others are printed on top of each other, like under Marilyn's chin, so they blend subtractively). In the magazine illustration the red, yellow and blue dots making up the skin or the background mix additively, just like in a Pointillist painting, despite the fact that you cannot resolve the dots. Yet when printed to actual size, there is nothing "brilliant"

Pages 174–75: A detail of Georges Seurat's *Le Cirque* (1890) reproduced at about twice actual size (left). The photograph of Marilyn Monroe on the right is reproduced at almost ten times actual size.

about these color mixes. Moreover, if you shrink Seurat's woman down to a comparable size, as shown here, or if you stand very far away from the painting, so that you cannot resolve his dots either, the mixed colors are nothing special; that is, they don't have the vibrancy that you usually experience with Post-Impressionist art.

Since the additive nature of the color mixing is the same whether the dots are large or small, or whether the viewing distance is close or far, the special, vibrant, appearance of Pointillist paintings cannot be attributed to the fact that the colors mix optically, as claimed by the artists themselves, but it must be due instead to the scale of the dots compared to the resolution of the visual system. Indeed, I find enlarged magazine images to have colors that are just as visually interesting and lively as Post-Impressionist paintings. What makes these variegated surfaces so interesting is the fact that the size of the dots is such that you can see simultaneously both the separateness of the dots and a blending together to form a single larger surface. The artistic interest in these paintings—or the appeal of tweed clothing or marble countertops—lies in the interplay between blending and opposing that happens at a scale that is near the resolution of your color system. That is, because your color system is low resolution, the colors of the individual elements can merge, even at the same time that you can still resolve them. I suspect the vibrancy arises when the size of the dots is between the resolution of your central and peripheral acuity. So the part of the image you see with your center of gaze appears to be made up of dots, but the surround parts, seen by your peripheral vision, are perceived as more homogeneous surfaces. As you move your eyes around, different parts of the painting switch from being dominated by the dot pattern to looking more like surfaces. It is this rapidly changing appearance that is so compelling and lively. It may even be why Signac chose to compare his "divided" colors with a pearl: the colors in a pearl change with viewing angle (because they are interference colors) so they also have a dynamic quality.

Sometimes adjacent colors oppose each other, and other times colors can blend, and whether they blend or oppose depends on the size of the elements. Because the color system is low resolution, colors will blend with elements that are larger than can be easily resolved by your Form system. But there is more to it than just resolution.

WHEN WILL COLORS BLEND?

We think that the visual system defines the borders of objects using a high-resolution Form system, and then it uses a lower-resolution Color system to simply fill in the color. This is much more efficient than having a high-resolution Form system for every color. Thus, colors spread to fill areas defined by the Form system. Therefore whether or not colors blend seems to depend on if they can be perceived as belonging to the same surface. If there is a large luminance contrast between two colors, it is more difficult for the Form system to interpret them as being on the same surface.

The image opposite illustrates the way colors merge as a function of luminance contrast. In each of the three vertical panels are an array of blue lines that switch to different colors at the intersections. At some of these intersections you might be able to see illusory disks in which the line colors spread, or bleed, into the background. Most people find that the spreading is strongest when the colored lines are closest to the luminance of the background; that is, the bleeding into the white background is strongest for the lightest color lines (yellow

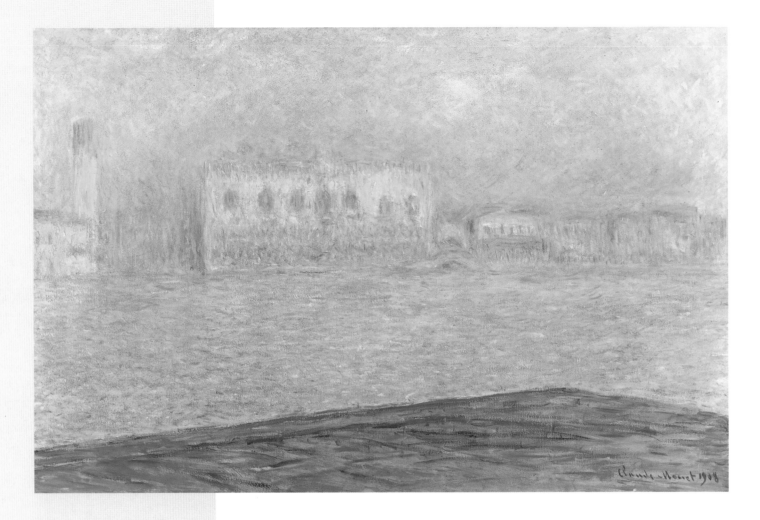

lines on white background); the bleeding into the gray background is strongest for the middle luminance lines (red); the bleeding into the black background is strongest for the darkest lines (purple). The colors are constrained by the illusory border formed by the luminance change in the radial lines. (An illusory border is a border that is perceived where one does not exist. There is no actual circular outline forming those disks; the visual system infers, or extrapolates, a border linking the luminance discontinuities that exist only along the radial lines.) Thus blending of colors is strongest when colors are close to the same luminance and can be perceived as being part of the same surface. The colors bleed until they hit the illusory border, consistent with the idea that object borders constrain the spreading of the Color system.

A similar kind of color spreading can be seen in many Impressionist paintings. Blending of individual strokes of color within an area of approximately equiluminant colors is seen in various regions in Monet's *The Palazzo Ducale as seen from San Giorgio Maggiore*. Each surface consists of many colors of paint that blend even though they are left unmixed on the canvas. The blending occurs within each region, with each region defined by the average luminance of the brushstrokes, as shown by the luminance version on the right.

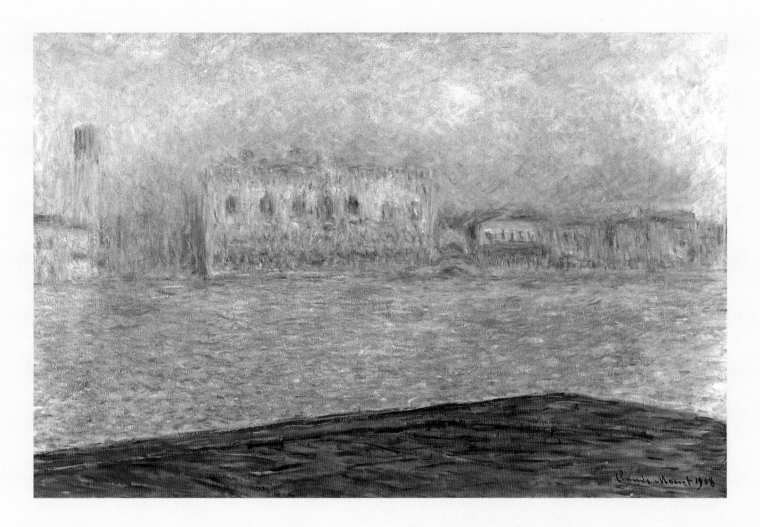

In *The Palazzo Ducale as seen from San Giorgio Maggiore* by Claude Monet (1908), the water, the sky, and the buildings consist of strokes of paint of quite different hues, but within each surface all the colors are close to the same luminance. The colors blend together to form a surface of some intermediate color. The grayscale panel shows how close to equiluminant the variegated colors within each region are.

The multicolored dots within each region of Paul Signac's *View of the Port of Marseilles* (1905) are of approximately equal luminance.

(Paul Signac. *View of the Port of Marseilles*. 1905. Oil on canvas, 88.9 x 116.2 cm. The Metropolitan Museum of Art, Gift of Robert Lehman)

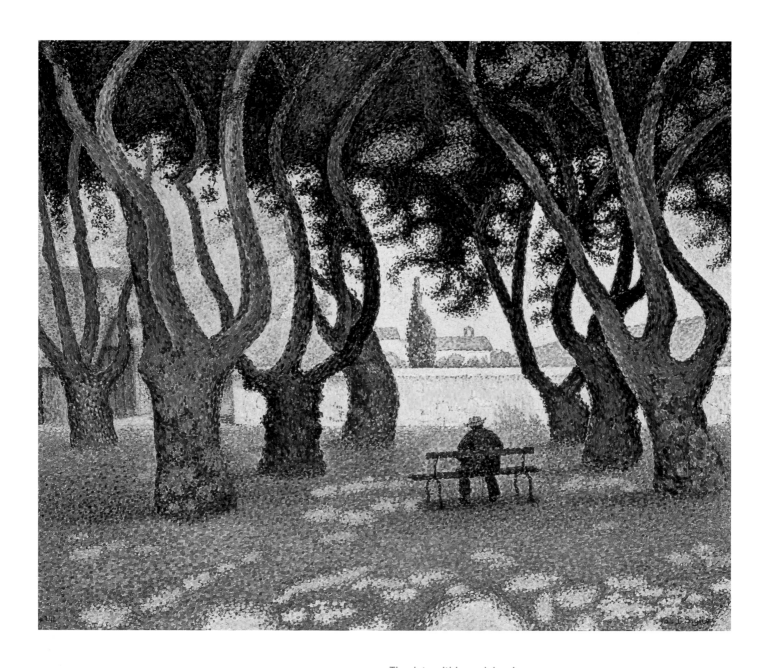

The dots within each luminance-defined surface in *Place de Lices, St. Tropez* (1893) by Paul Signac, are approximately equiluminant, so the colors blend, even though your vision can resolve the individual dots. Part of the artistic interest in this painting is the dynamic interplay between resolution and blending of the dots.

I think the idea of colors blending within regions defined by illusory borders applies particularly well to Post-Impressionist painting. For example, though the dots covering each surface in these two paintings by Paul Signac are multicolored, the grayscale images show that all the dots on any given surface are close to the same luminance. Indeed the borders that define objects and surfaces in Pointillist paintings are usually illusory borders. The visual system blends together dots within regions where the dots have the same luminance, and perceives a border between regions where the dots are of a different luminance.

Recently the artist Chuck Close has been reviving the Pointillist technique, covering surfaces with varied complex shapes and colors instead of with simple dots of colors. In addition, he has taken the issue of resolution much further, as his elements can be several inches across. The self-portrait shown here is almost five feet tall, so you can see that the individual elements are very large, and our ability to perceive the global pattern must occur only at pretty long viewing distances.

Close's self-portrait takes advantage of two properties of our visual systems. First, the different colors that blend are close to equiluminant: if you look at his forehead or cheek you will see concentric patterns of various pale colors, all of which are close to the same luminance. Also, in many places, there are strong, luminance-defined local patterns that compete with—and are in a dynamic equilibrium with—the global face pattern. It is the dynamic tension between local and global patterns that is so interesting in Close's paintings, just as in the earlier Pointillist paintings.

At each successive stage of visual processing, neurons become selective for more precise features, over larger and larger regions of the visual field. For example, in the retina and the thalamus, cells are selective for discontinuities; in the first cortical visual area cells are selective for contour orientation; cells in much higher visual areas can be selective for faces, houses, landscapes, or other complex features. Receptive fields in the retina, thalamus, and the first cortical visual area are tiny, but receptive fields in higher visual areas can cover half the visual field.

Our perception of our environment is produced by the activity in cells at all these levels within the visual system, so we can be simultaneously aware of activity representing both local and global visual information. When the local and global information are consistent, there is no conflict between the information in the different levels of the visual processing hierarchy, but if it conflicts, the different levels can interfere with each other. For example, people asked to rapidly identify the small letters in the images on the left, recognize the *c*'s more slowly by a fraction of a second (as measured by reaction time tests) than the *s*'s. This is because in the first instance, the global percept is *S* and the local percept is *C*, and the two compete with each other. In the second instance the two are consistent.

In Chuck Close's portraits that are made of tiled elements the local and global percepts are inconsistent, so sometimes we see just the local percept, the tiles, and sometimes the global. We can make one or the other dominate by changing our viewing distance, because if we make the local elements smaller by moving away, they become less resolvable.

Carrying this idea even further in 1995, Robert Silver, then a student at the MIT Media Labs, invented the technique of making photomosaics, in which an image is made up from many smaller elements that are themselves images. These images are generated by computer, by matching the local luminance and color of each region of the global target image with the low-resolution features of a large number of images stored on the computer. The computer then assembles the small images at high resolution into one large composite mosaic. These large images have a fascinating dynamic quality because what we see with the center of gaze tends to be dominated by the individual image elements, which are themselves meaningful and often related in subject to the global image, while at the same time our peripheral vision is dominated by the global pattern. So as we move our eyes over the image, different parts of it flip between the local and the global percepts, giving it a wonderfully changing and dynamic quality.

These smaller reproductions of the Chuck Close portrait and Robert Silver's photomosaic of a man's face show that, as with Pointillist paintings and magazine illustrations, what we perceive is all a matter of scale.

Opposite: Robert Silver's photomosaic of a face is composed of many tiny photographs. Like Chuck Close portraits and Pointillist paintings, with photomosaics there is a dynamic interplay between local and global percepts.
Credit: www.photomosaic.com

12:
TELEVISION, MOVIES, AND COMPUTER GRAPHICS

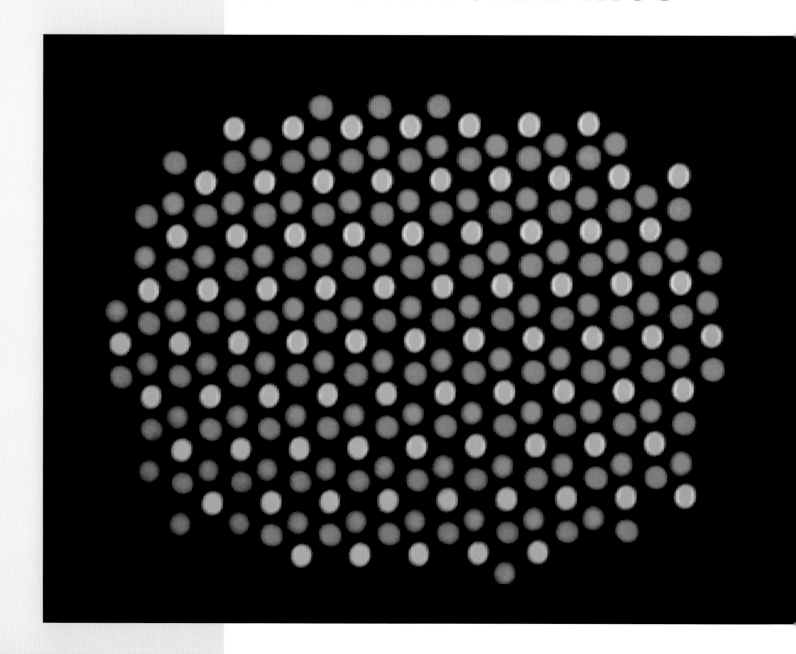

ALL THAT I HAVE SAID about the ramifications of the way we process color and luminance also holds true for how we see television, computer graphics, photography, color printing, and movies. So, for example, a very low-contrast or equiluminant moving object in any of these media will seem to move more slowly or less clearly than it actually does, and it will seem less three-dimensional than a comparable object that has luminance contrast. These technologies are all flat, like painting, so they use the same kinds of cues—perspective, shading, and occlusion—to give an illusory sense of depth. They also have the same problem as paintings in that stereopsis tells the viewer that the image is flat.

But movies and television have the potential for a powerful additional depth cue—relative motion. If you close one eye and gaze steadily at, say, the edge of this book, you may find that it does not seem clearly in front of background objects. But by moving your head slightly from side to side you can make it jump back into proper apparent depth. That is because relative motion of objects at different distances is a strong cue to their distance from the observer. Relative motion of objects in movies and television can be a powerful cue to depth, and can even induce an illusion of self-motion through space in the observer. Who didn't have to grab their seat the first time they saw the opening credits for *Star Wars*?

As discussed earlier, it is possible for a painter to generate all colors by mixing together different ratios of three suitably chosen primaries, but, in fact, most painters use a wide range of paint colors. Movies, television, color printing, and color photography, on the other hand, do use only three primary colors to generate all colors. In color printing these elements are tiny dots of colored ink; in photography they are grains of colored dyes; in television and computer monitors they are tiny colored lights called pixels. (Pixels are spots of phosphor, a luminescent material, that emit light when activated by an electron beam that varies in

This image is a magnification of the pixels making up the picture on a color television. Under normal viewing conditions the eye cannot resolve the individual pixels, so the colors blend. My camera blended the image temporally, as you can see many pixels are lit up simultaneously, even though only one set of triplets is actually lit up at any instant (nanosecond). This is because the camera's diaphragm was open longer than one-thirtieth of a second, so all the pixels were lit up at least once during the exposure.

The emission spectra of the red, green, and blue phosphors of a typical TV or computer monitor. We cannot see the longest wavelength peak of the red phosphor because it is on the very far end of the visible spectrum. Like three well-chosen primary colors of paint, these three colors of light are sufficient to generate all possible colors when mixed in various combinations.

intensity to generate the appropriate brightness.) The magic number is three because that is the minimum number needed to generate all perceivable hues. This, as you will recall, reflects the fact that we discriminate wavelength ourselves using only three types of receptors. Using more than three colors is unnecessary and would lower resolution.

The phosphors in televisions or computer monitors do not, however, have the same spectral profiles as our cones: the blue and green primaries match our blue and green cones pretty well, but the reds are longer wavelength than the human long-wavelength cone. This is because light of the same wavelength as our red cone peak absorption looks yellow, since it activates our green cones almost equally well. The only way to produce a red percept is to stimulate the red cone more than the green cone, and only wavelengths much longer than the red-cone peak do that.

To reproduce a colored image from real life—in movies, television, or photography—three separate reproductions are simultaneously made through red, green, and blue filters. That is, a luminance image is acquired in each of three color-specific channels. A white object will have a high luminance in all three channels; a red object will be light in the red channel but dark in the green and blue channels, and so on. To reproduce the image, the three images

EMISSION SPECTRA OF TV PHOSPHORS

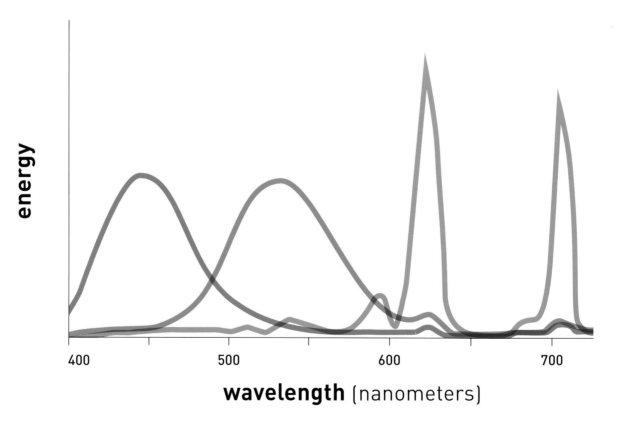

energy

wavelength (nanometers)

400 500 600 700

are combined using three primary colors. On computer monitors and TV screens, colors are generated by mixing various ratios of the three additive primaries, red, green, and blue (RGB). When television was first developed and was only in black and white, there were only white pixels. For every single white pixel on a black-and-white TV, a color TV has a triplet consisting or one red, one green, and one blue pixel. A conventional American color television has 525 rows of pixel triplets with 427 pixel triplets in each row.

Though they are certainly dynamic, neither television nor movie images really move; both are in reality a series of still images presented in rapid succession, usually twenty-four (for movies) or thirty (for TV) images per second. Movies are, of course, usually a series of transparent photographs that are moved rapidly and sequentially in front of a very bright light by a projector. What I find amazing about television, however, is that each individual image is made up from a series of sequentially illuminated minuscule dots. Three tiny electron beams (one for each color) sweep across the screen incredibly fast to activate the pixels. That is, an entire picture is never present at any instant; rather, a television "image" represents a temporal smearing of these moving beams. Each beam starts in the upper left corner of the screen and moves from left to right. Then it jumps back and steps downward a tiny bit and sweeps from left to right again, and again, until it has swept across all 525 rows of elements that make up the screen—all in one-thirtieth of a second. It's sort of like taking a Fourth of July sparkler and moving it incredibly rapidly back and forth and up and down to get a square image. The three beams scan simultaneously, illuminating the rows in an alternating regular pattern called interlacing.

Our visual system blends the sequence of triplets of tiny colored dots in three ways—chromatically, spatially, and temporally—so that we don't see only three colors, a mosaic of individual pixels, or the series of sequential images or pixel illuminations making up each image. There are a number of ways that television technology takes advantage of the properties of our visual systems in order to accomplish this transformation.

We blend the TV image chromatically in that we do not see only various shades of red, blue, and green, but all the colors in between. Our visual systems blend colors, as discussed earlier, because our perception of colors depends on the ratio of activity in our three cone types, and we cannot distinguish mixtures of wavelengths from pure wavelengths as long as each activates our three cones in the same ratio.

We blend the TV image spatially because the individual pixels are too small to be resolved by the photoreceptor spacing in our retinas, unless we are looking very closely at a very large monitor. Similarly, photographs or color prints consist of tiny dots of colored pigments or ink that we blend spatially because they are too small to be resolved.

We blend the TV image temporally in that we see neither the scan pattern nor the fact that the image is presented at a rate of thirty frames per second. If we were to look at a screen that was alternating between black and white thirty times per second, we would perceive this alternation as a flicker. Interlacing is used to minimize flicker. It effectively allows television monitors to present sixty half-images per second, a rate our visual systems are unable to resolve.

SOMETHING REALLY STRANGE ABOUT COLOR TELEVISION BROADCASTING

For computers, most image-manipulating programs make it possible to control the three primaries directly; they are converted to driving voltages for the red, green, and blue phosphors. In television technology, at both the beginning and the end of the process—in the camera and the television set—color images are also coded as red, green, and blue values. However, in the intermediate stage of television—broadcasting and videotapes—colors are coded in a completely different way.

The television broadcast color-coding system is surprisingly similar to the way our visual system handles color. The human visual system first records an image as a three-cone signal and then converts it into a luminance signal plus two cone-difference signals, which are then transmitted to the brain. A television camera acquires three color images (red, green, and blue) of an image and in the intermediate stage—broadcasting—the image-carrying part of the video signal consists of one luminance signal and two color-difference signals.

Why do our visual systems and television broadcasting share this similar approach of converting an RGB image into two color-difference signals and a luminance signal? The reasons may be analogous.

I'll start with television. In 1935 RCA demonstrated the first television system. The next year the Radio Manufacturers Association Television Allocations Committee realized it would have to divide up the usable ranges of the electromagnetic spectrum among all the groups that wanted to broadcast television. The group voted to allocate a range of 6 MHz per channel for this new technology. The bandwidth of each channel (its frequency range) had significant consequences for the television industry, because the bandwidth determines how

much information can be carried in that channel. The 6 MHz figure, of which 4.2 MHz is used for the video signal, was arrived at on the basis of the calculation that for black-and-white TV the highest modulation frequency needed would be if the individual pixels alternated black and white. To do that for a 427-pixel-wide screen, you would need one-half of 427 times 525 modulations in one-thirtieth of a second, which is 3.7 million pixels that must be modulated per second, or 3.7 MHz. Considering that requirement, a 6 MHz bandwidth per station seemed, at the time, a generous allocation.

CBS immediately began working on developing color television, and by 1940 had a working model of a small-screen color television, which recorded, transmitted, and displayed red, green, and blue signals independently. There were two problems with this design. First, in order to broadcast images with as high a resolution as existing black-and-white televisions, it would need three contiguous 3.7 MHz bands, but the Federal Communications Commission refused to license to CBS any more bandwidth because of the large demand for black-and-white transmission. Second, only people with color television sets could receive the color broadcast signals, which were incompatible with the existing monochrome sets the public already owned. After years of legal wrangling over standards for the color television industry, CBS was finally allowed, in 1951, to broadcast its black-and-white–incompatible color TV signal, but since hardly anyone could watch it, it was abandoned after less than four months.

Meanwhile, several groups, led by RCA, eventually did develop a black-and-white–compatible color system. They did so by converting the three color signals (red, green, and blue) into a luminance signal (red plus green plus blue) and two color-difference signals (red minus luminance and blue minus luminance). The fact that the composite signal carried a pure luminance component made it compatible with the existing black-and-white sets the majority of the public already owned. One key insight for minimizing bandwidth requirements was the realization that a third (green minus luminance) color signal was unnecessary because for every point in the image, you only need to know the sum of the primaries and the difference between any two of the primaries and the sum in order to know the value of the third primary. This compromise standard, which is still used today, was settled on in 1953: the luminance signal still uses 4.2 MHz bandwidth, but the red and blue color-difference signals occupy only 1.5 and 0.5 MHz respectively. By overlapping the signals slightly, engineers could still remain within the 6 MHz allocation. (Incidentally, it is this overlap that makes busy patterns like stripes or checks look so weird on TV.) We still use this standard in this country, though it is now being phased out in favor of digital and high-resolution television.

Video (VHS), which must be compatible with television, is also coded in a luminance plus two color-difference signals. That is why you can't view videos on your computer monitor. When television is converted to a high-resolution digital system, that will change.

EVOLUTION OF TELEVISION AND OF THE HUMAN VISUAL SYSTEM

The history of the development of color television is analogous to the evolution of our color vision. Early mammals had a well-developed single-cone luminance, or black-and-white, visual system. When a second cone type developed later, initially it probably simply summed with the first cone type, serving to extend the range of the visible spectrum, so that animals could perceive wavelengths previously invisible to them. Only when primates evolved and began expanding the visual system and using high-resolution object identification did the strategy of subtracting different cone types evolve, because color is another way, besides shape, to identify objects.

At this point, evolution was at the same impasse as the television industry in the 1940s. The new What system needed to be back-compatible with the already existing achromatic Where system. Also, primates still needed to be able to see the black-and-white images rods gave them. (We haven't, yet, evolved a second low-luminance photoreceptor type so we can see colors at night.) It therefore makes evolutionary sense for the new What system to have added two color-difference signals to the already existing luminance signal rather than starting from scratch with three independent cone signals.

How can it be that television can tolerate so much less information in the two color-difference signals (1.5 and 0.5 MHz) than in the luminance signal (4.2 MHz)? The answer is that the Color part of our What system has a lower resolution than the Form part of our What system or our Where system, so a low-resolution color signal doesn't look as bad as a low-resolution luminance signal would. What's more, we tolerate especially low resolution in the blue-difference signal because our blue-yellow resolution is lower still than our red-green color resolution; this is due to the fact that 1 percent of our cones are blue; 99 percent of our cones are red and green. One manifestation of the low acuity of our color perception is that we don't even notice that the color part of the video signal in our television is much lower resolution than the luminance image.

European television has had higher resolution (625 rather than 525 lines) than American television because the European standards allocated more bandwidth for the video signal (5 MHz versus 4.2 MHz) and use a slower scan rate (twenty-five rather than thirty images per second). For some time, engineers have been working on developing significantly higher resolution television, by at least a factor of two, so that television screens can be larger overall, and wider. The American television industry's transition to this high-definition television (HDTV) —it hopes to phase out standard American TV in a few years—has been made possible by digitization of the signal and the use of compression algorithms.

The compression algorithms used in digital TV are of interest because they are similar to the strategies the human brain uses to extract information from the environment. These algorithms are so efficient that a station using them is now able to transmit four ordinary-resolution television shows or one HDTV show in its allocated 6 MHz bandwidth. The compression algorithm used is called MPEG (Moving Picture Experts Group) and it compresses the signal both spatially and temporally. The spatial compression MPEG uses is similar to the JPEG (Joint Photographic Experts Group) image compression used frequently for still images. In some ways it is similar to the compressions our visual system performs on images using center/

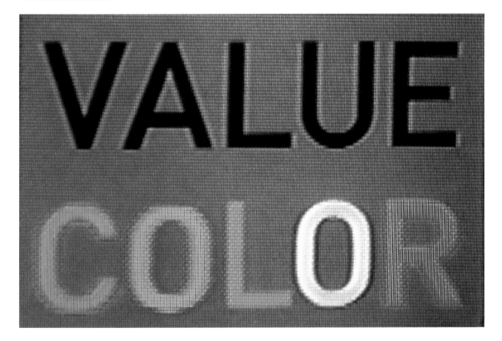

These images show the difference in resolution between the luminance signal and the color signals on a standard video or television display. The top image was displayed on a computer monitor and was then recorded using a VHS video camera, which uses the same coding algorithm as television broadcasting. The resolution of the color signal, especially the blue, is lower than the resolution of the luminance signal in the bottom (video) image, even though in the original image the color and the luminance of the letters were equally crisp. The fact that the blue signal is even lower than the red/green signal can be seen from the degree of blurriness in the blue *c* and in the blue component of the purple *r*.

surround cells and edge detectors. In JPEG, and in the visual system, regions of the image with high information content, such as edges, are signaled, but regions where nothing is changing are not. MPEG temporal compression involves coding an image along with the differences between successive images, which is similar in strategy to the visual system's strategy of coding the appearance of objects by the What system and their position and trajectory by the Where system.

epilogue:
TALENT, MUSIC, AND LEARNING DISABILITIES

SOME PEOPLE ARE really good at drawing or painting; others may be talented musicians, mathematicians, or poets. They may have to work at honing their skills, even spending years becoming expert in them, but they started with an innate ability that not everyone shares. There is no conceivable way, for example, that I could ever be an even adequate singer, while for others singing is more natural. In this chapter I will address several questions, including: what makes someone excel at music or art or poetry? And what is the relationship between language and art and between sight and sound?

First, I want to compare light and seeing with sound and hearing because there are some interesting parallels to be drawn and because I want to discuss why certain aspects of both the biology of seeing and the biology of hearing might be relevant to artistic or musical talent.

Light and sound are both forms of energy that are propagated in waves, though they have very different wavelengths and travel at different speeds: light is electromagnetic radiation that travels at 186,000 miles/second, and sound is oscillatory compression and rarefaction of air that travels almost a million times more slowly. Seeing and hearing consist of detecting these waves, discriminating them on the basis of wavelength (or frequency), and then processing the resultant neural signals by the brain.

The wavelengths of visible light are tiny—between 370 and 730 nanometers (0.00000037 to 0.00000073 meter)—in comparison with the wavelengths of audible sound, which range from 0.02 to 20 meters. Light and sound differ correspondingly in terms of frequency as well: the frequency of visible light ranges from 430 trillion to 750 trillion oscillations per second—while sound consists of vibrations between 20 and 20,000 vibrations per second. Thus the lowest- and highest-frequency sounds we can hear differ by more than a factor of 1000, but the shortest wavelengths of visible light differ from the longest by a factor of just 2. By comparison, a two-fold difference in the wavelength of sound is merely the difference between middle C and the C above middle C. This huge difference in overall range between sound and light may

explain important differences in the way they are transduced (converted) into neural signals.

In order for us to perceive light or sound (or any other environmental input), a physical receptor must absorb light or sound energy and convert it into a neural signal. To distinguish one wavelength from another, that is, one color or pitch from another, we need receptors that respond selectively to one range of wavelengths and not to others. The ear contains the cochlea, a structure that varies in thickness and stiffness along its length and is covered with vibration-sensitive neurons. The neurons on the cochlea signal whenever their part of the cochlea vibrates, so the neurons near the thinner, stiffer end are activated best by high-pitched sounds, and the neurons near the thicker, more flaccid end are activated best by lower sounds, just as large, flaccid things (such as bass drums) produce deep sounds when struck, and small, stiff things (such as wine glasses) produce higher-pitched sounds. These signals are then conveyed to the brain to be interpreted and analyzed. The particular cochlear neurons that signal indicate the specificity of the stimulus since nerve signals are always the same. Thus our ability to hear a range of tones is based a one-tone/one-neuron kind of signaling.

Because visible light comprises a much smaller range of frequencies than audible sound and because the differences in wavelength are on the order of nanometers, differential signaling of wavelengths of light presents a much bigger challenge. It is difficult to design receptors that differ on a mechanical basis that would be able to distinguish between colors of light, because changing something as gross as size or firmness doesn't change an object's color absorption. You usually have to change things at a molecular level to do this. That is probably why light receptors have evolved to use chemical rather than structural differences to distinguish different wavelengths of light.

Despite the fact that we have only three kinds of color-distinguishing receptors, our ability to distinguish different wavelengths of light can be—for some ranges of the spectrum—remarkably sensitive. For example, light of 580 nanometers is greenish yellow, but light of 585 nanometers is yellow. That 1 percent difference in wavelength is so distinct that it warrants a difference in color name. Yet a 1 percent difference in sound wavelength is very difficult for anyone—including most musicians—to detect. The fractional difference between C and C sharp is five times that large. We are not as discriminating at either end of the visible spectrum, however, as light of 440 nanometers looks about the same as light of 460 nanometers, and any light of wavelength longer than 640 nanometers looks red.

The fact that we have many different wavelength-selective auditory receptors means that we can distinguish mixtures of audible tones from each other. This is in stark contrast to the way the visual system works: we have only three kinds of wavelength-selective photoreceptors and cannot distinguish many mixtures of visible wavelengths. That is, we can distinguish a mixture of tones—say, C, E, and G—as a chord, quite distinct from the intermediate notes, D and F, played together. And we can quite clearly distinguish C plus G from D plus E. But to

our eyes, a mixture of red and green light is just as yellow as the light of a single wavelength in the yellow region of the spectrum.

Thus one major difference between sound and light reception is at the receptor level: for sound, each tone represents the response of a different population of neurons; for light, each color represents a different ratio in the response of only three receptor classes.

The way we process sound and light in the brain, on the other hand, is remarkably similar and reflects the fact that the brain is essentially the same from one part to another. The difference is in the source of the inputs. To be more precise, if you examine a region of the brain with a microscope, you will see that it consists of a sheet of neuronal cell bodies, the cortex, which is about one millimeter thick. The cortex consists of several layers of cell bodies and contains about 100,000 neurons per square millimeter. The nerve cells themselves are very elaborate and look like tiny bushes, with lots of branches that provide input to and receive input from hundreds of other neurons. There are quite a few different kinds of neurons in any one bit of cortex, yet if you look at any kind of cortex—auditory, visual, or motor, for example—the neuron types and layering patterns are all about the same.

This gross similarity has led some scientists to wonder if the basic kinds of calculations carried out by the cortex all over the brain might be similar. And, indeed, when the optic nerve was re-routed to auditory cortex in young guinea pigs, those animals were found to be able to use their auditory cortex to respond, in a relatively normal fashion, to visual stimulation. That is, they could "see" with their auditory cortex. This means that the cortex all over the brain performs fundamentally the same kinds of information processing (alignment of inputs, center/surround, and others) on different kinds of inputs. Inputs differ, but simply in the kind of sensory stimulation they represent.

In general each sensory system gets inputs only from a single class of inputs, but sometimes in otherwise normal people the wires get crossed, and inputs to one sensory modality activate a sensation in another; this condition is called synesthesia. Some synesthetics see colors when they hear sounds. Others perceive colors when they see letters or numbers. More rarely, people hear sounds or see colors or shapes when parts of their bodies are touched or when they taste or smell something. These experiences are probably the result of extra connections between sensory modalities in these people's brains and may reflect the fact that, once an input representing sound gets connected by mistake to the visual system, the visual cortex treats it just like any normal visual input, and "sees" it. Though synesthetes have often been dismissed as having an overactive imagination, or being just plain crazy, recent research has shown that these people experience genuine, reproducible sensory perceptions that most of the rest of us do not. The closest I can come to understanding the synesthetic cross-modality experience is my perception that cheddar cheese tastes to me like a tactile quality: sharp.

Scientists have determined that the prevalence of different kinds of synesthesias reflects the closeness of the "cross-wired" areas in the brain. For example, one common kind of synesthesia is seeing colors associated with numbers, and the part of the brain that codes for colors is very close to the part that perceives numbers.

Synesthesia runs in families: the author Vladimir Nabokov, his mother, and his son saw colors associated with letters and numbers. An interesting question is whether, even in nonsynesthetic people, the degree of cross-communication between different modalities varies from one person to the next, accounting for differences in the tendency to make associations, like metaphors or poetry.

DYSLEXIA AND THE WHERE PATHWAY

It seems that different people's abilities and talents can differ as much as, if not more than, their physical appearance. It has always been clear to me that I am not the least bit skilled in art or music; I share this limitation with most of the members of my family. On the other hand, most members of my family are extremely fast and voracious readers, so reading fluency and artistic ability have, in my experience, been mutually exclusive. Some research I've been involved in actually suggests that reading difficulties may predispose people to be relatively talented artistically. I will suggest that the relative strengths or temporal properties of the different subdivisions of the visual system (and perhaps other sensory systems as well) may differ from person to person. Such differences may lead to talents as well as difficulties.

In the 1980s, when my research had led me to trying to figure out which visual functions were carried by the colorblind Where system, I experimented with making all kinds of images and visual stimuli in equiluminant colors, to see what kinds of perceptions disappeared or changed when the Where system couldn't see them. When I realized the effect equiluminance has on text—how it makes the text seem to jitter and makes the words harder to discern (even though the letters are individually easy to see)—I remembered that I had read somewhere, possibly in a news magazine, that people with dyslexia often complain that text looks jumpy and is unpleasant to look at. (Dyslexia is a condition in which children of normal or above-average intelligence exhibit an unexplained difficulty in learning to read, despite being given normal instruction. This difficulty with reading persists into adulthood.)

This sounded so similar to what equiluminant text looked like to me that I thought I should test some people with dyslexia specifically for the functioning of the colorblind part of their visual system. So I arranged an appointment with a local neurologist who did a lot of work with dyslexics, and I told him I thought there might be something different in the colorblind part of the visual system in dyslexia. "Don't be silly," he responded. "Dyslexia is a language problem." I was chagrined. My magazine article hadn't said anything about language; it just talked about text looking awful and jumping around. But about a year later I came across another neurologist who also worked with dyslexics, Al Galaburda. He was much more receptive, acknowledging that while dyslexia is supposed to be a language problem, my idea was well worth looking into.

We did some studies—and others have done related research—that indicate that there is indeed a very slight slowing of the fast, colorblind Where subdivision of the visual system in dyslexia. This slowing probably affects dyslexics' vision particularly during reading, because reading relies so heavily on very rapid sequential eye movements. Reading presents uniquely stringent temporal integration problems for the visual system. Clinical observations that dyslexics often see the world as slightly jumpy, often have poor stereopsis, and experience problems in visual localization are all consistent with a selective difference, or deficit, in the Where pathway.

The Where system is responsible for motion perception and spatial perception. As described earlier, a patient with Where system damage, Zasetsky, said the world would "glimmer fitfully and become displaced, making everything appear as if it were in a state of flux." Similarly, dyslexics sometimes complain that words on the printed page may seem to swirl, or flow. They also occasionally have spatial visual problems, in milder form, that are characteristic of patients with parietal-lobe damage.

The problem dyslexics have with jumping of text during reading may arise from a well-known function of the parietal lobe: the remapping of visual information from eye-centered coordinates to body-centric or real-world–based coordinates. As we move our eyes, the images on our retinas shift correspondingly, yet our perception is that the world is stable. As I pointed out earlier, if our conscious perception consisted of the images that come in from our retinas, because our eyes move around constantly, we would see a very jumpy and constantly shifting world. Thus retinal images must be remapped almost instantaneously as we move our eyes around. There is good evidence that this remapping is likely to be a parietal-lobe function. The Where pathway may not be fast enough in dyslexics to remap the image as fast as the eyes move during reading.

If there indeed are visual differences in some dyslexics, why are so many people convinced that dyslexia is a language problem? Dyslexia has been thought to be a very high level—even cognitive—defect, since dyslexics have been shown to do poorly in some auditory, touch, visual, and motor tasks, and it was thought that a problem that affected all sensory systems must therefore be a higher-level problem. Moreover, dyslexics have particular difficulty with phonetics, the association of sounds with letters, which is thought to be a high-level language function.

How could the visual problems relate to phonological problems? The most likely explanation is that other sensory and motor systems are functionally subdivided just as the visual system is, and it is likely that these systems, like the visual system, are segregated into fast and slow subdivisions, with each specializing in some part of information processing. One theory is that the fast subdivisions of both the visual and the auditory system (and perhaps other sensory systems as well) are affected in dyslexia. A slight slowing of the fast subdivision of the auditory system could lead to problems in distinguishing certain sounds from each other. For example the difference between the sound *bah* and the sound *dah* occurs only during the first forty milliseconds that the sounds are being pronounced. Therefore children with slightly slower auditory systems might have trouble distinguishing *bah* from *dah* and therefore learning the associated letters. A global fast-system deficit (or difference), that is, a difference in the fast subdivision of both the visual and the auditory systems, might arise from effects on common proteins or during common developmental stages.

DIFFERENT ABILITIES AND ARTISTIC TALENT

I have tried to be very careful to refer to the characteristics of dyslexics as differences, rather than defects, because I strongly suspect that dyslexia is not a disease, but rather one end of the spectrum of normal human variability in the timing or relative strength of the fast subdivision of various sensory modalities. I also suspect that in some tasks other than reading, slower might be better. Speed is often inversely related to accuracy. Therefore it may be that people with slower "fast" systems might be at an advantage for certain tasks, professions, or skills that require sensory accuracy rather than speed.

"I have universally observed among all those who make a profession of portraying faces from life, that he who paints the best likeness is the worst of all composers of narrative painting," wrote Leonardo da Vinci. "This arises because it is clear to a man who does one thing better than another that nature has more inclined him to that than to something else, and

on this account he has more love for it and his greater love has made him more diligent. All the love which is concentrated on one part is missing from the rest."

I think it's quite possible that some differences in inclination and talent have a biological basis, perhaps sometimes as simple as processing differences in different parts of our brains. Some dyslexics, for example, exhibit particular abilities that may arise from the same difference that causes their reading difficulty. Slightly diminished spatial processing, which could be a result of Where system slowness, may contribute to artistic abilities by making it easier to render a three-dimensional world into two dimensions. I have long suspected that people who have a gift for drawing three-dimensional scenes may have poor depth perception. That is, I suspect that most of us have great trouble drawing a chair because our perception of three-dimensional shape interferes with our ability to draw in two dimensions. We subconsciously interpret converging lines as depth, and therefore cannot see them as converging lines. People who already see the chair less three-dimensionally might have less trouble drawing it. The artist Chuck Close, who is dyslexic, says, "I have trouble recognizing faces, particularly in three dimensions. . . . I do have a photographic memory for things that are flat." He adds, "Almost every decision I've made as an artist is an outcome of my particular learning disorders."

Similarly, music involves slower auditory transitions than does speech, so people whose auditory system is biased toward slower auditory processing might be particularly perceptive of musical elements. Some of the slowest elements in speech are the changes in tone that carry emotional content. It would therefore not be surprising if dyslexics might be particularly talented in fields like drama, where the emotional content of speech is paramount.

Another possibility to consider is that a slow-pathway bias might be an asset in fields like computer programming or math. If you don't read computer programs and math formulas letter by letter, you will miss important things and do poorly at these tasks.

The idea that some kinds of talent may be the flip side of what is usually considered a disability is something that I think should be contemplated more often in education. Reading is certainly important in our modern world, but it seems to me that there is enough variability in the kinds of jobs people can have that perhaps we could afford to try to teach to children's strengths rather than their weaknesses. Often when children do poorly in reading, they end up spending more time than their classmates working on their "reading problem." I would be more inclined to try to figure out what those kids are really good at and let them forge ahead in those subjects, as long as functional competence in reading could be achieved.

RECENT ADVANCES in our understanding of the human visual system allow us to look at art—and the way we see the world—in a new way. We now know that color and luminance are processed by different parts of our brains, and they carry different kinds of visual information. Artists, advertisers, psychologists, and the technology industry have discovered various phenomena that turn out to be based on the parallel organization of our visual systems, without understanding the underlying neurobiology. It will be interesting to see whether an explicit understanding of the neurobiology of vision will lead to even more effects and illusions and a greater understanding of brain function in general.

Following pages: This figure illustrates an aftereffect discovered by Celeste McCollough. Look at the left panel for several minutes. You don't have to stare at it; just run your eyes over it for a while. Then look at the right panel. You will probably see the inverse colors associated with the vertical and horizontal stripes. Since you don't have to fixate to see this aftereffect, it is more complicated than a simple afterimage. It seems to reflect some kind of learning process, not just a retinal afterimage. And it lasts a lot longer than an ordinary afterimage. In fact, if you look at the left panel for a few minutes repeatedly over an hour, you may find that the effect will last for hours. You may even find that horizontal and vertical contours in your environment take on these illusory colors.

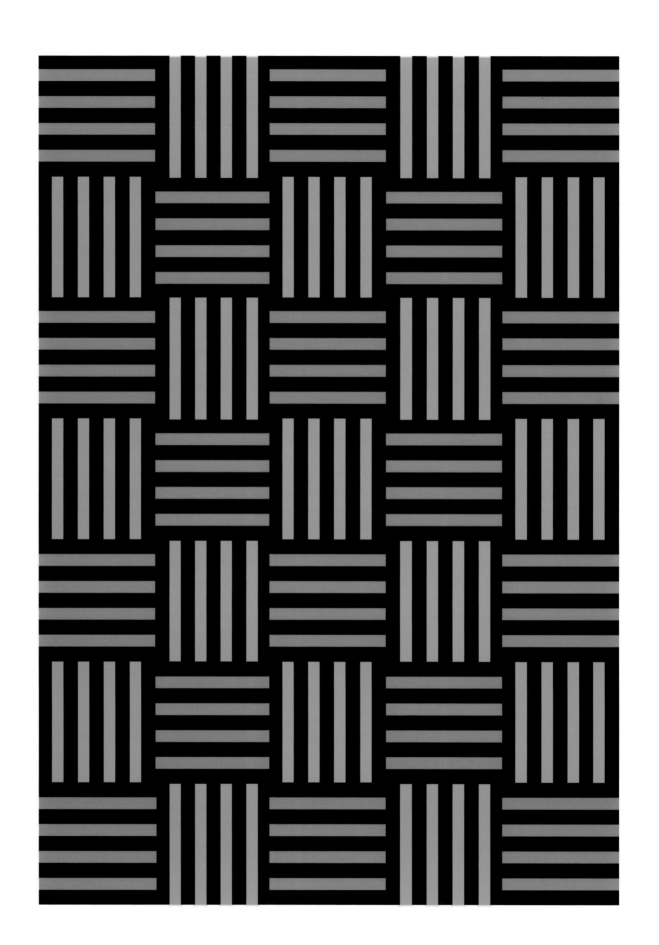

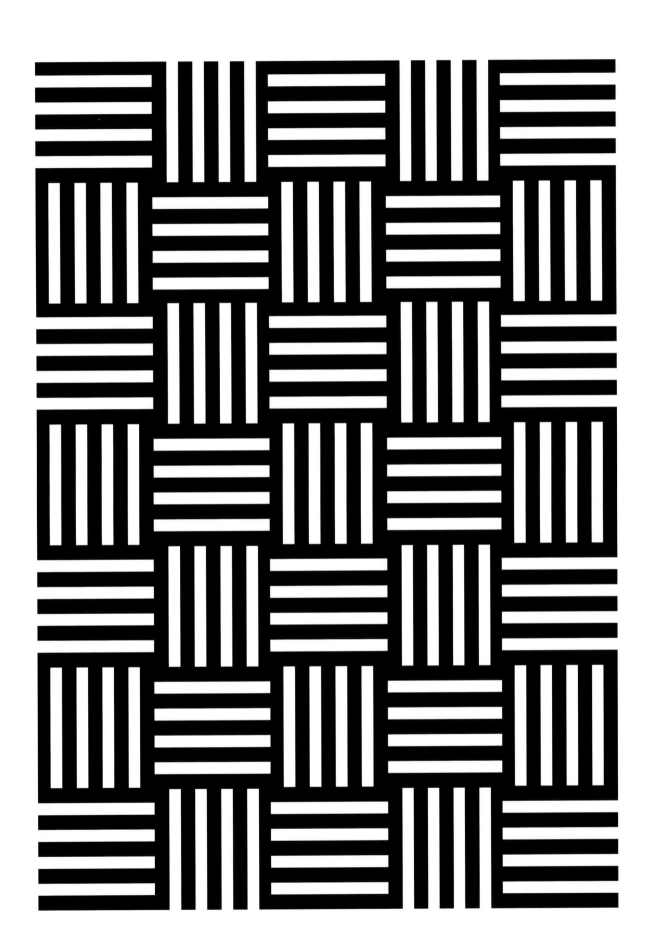

BOOKS ON VISION AND ART

Art and Visual Perception by Rudolf Arnheim, University of California Press, 1954, 1974.
　　The classic, but some of the science is out of date.
The Eye of the Artist by Michael Marmor and James Ravin, Mosby, 1997.
　　Mostly about medical disorders affecting the vision of some artists.
Cognition and the Visual Arts by Robert Solso, MIT Press, 1996.
Inner Vision: An Exploration of Art and the Brain by Semir Zeki, Oxford University Press,
　　1999.

THE CLASSIC ART HISTORY BOOK

The Story of Art by E. H. Gombrich, Phaidon, various editions since 1950.

PSYCHOLOGY BOOKS ON PERCEPTION (GREAT ILLUSIONS IN ALL)

Perception by Irvin Rock, Scientific American Books, 1984.
Odd Perceptions by Richard Gregory, Methuen, 1986.
Sensation and Perception by E. Bruce Goldstein, Wadsworth Publishing Co., 1980.

BOOKS ON VISION (IN DECREASING ORDER OF GENERAL READABILITY)

Eye, Brain, and Vision by David Hubel, Scientific American Library, 1988.
Foundations of Vision by Brian Wandell, Sinauer Associates, 1995.
Colour Vision edited by J. D. Mollon and L. T. Sharpe, Academic Press, 1983.

ORIGINAL SCIENTIFIC LITERATURE THAT IS BEAUTIFUL TO READ

Opticks by Isaac Newton, originally published in 1704. A brilliant mind grappling
　　with a difficult problem. Some of it is tough reading, and the language is archaic,
　　but in places you can see exactly what he did and why, and what he figured out.
The Man with a Shattered World by A. R. Luria, Harvard University Press, 1987, translated
　　by Lynn Solotaroff. A wonderfully moving and fascinating description of the
　　visual world of (and by) a man whose parietal lobe was damaged when he was
　　shot in the head in World War II.
Eye Movements and Vision by A. L. Yarbus. Plenum Press, 1967. Fascinating experiments
　　and pictures.

index

credits

All pictures are courtesy the author unless listed below.
2–3 and 126–27: Jean-Auguste-Dominique Ingres, *Princess Albert de Broglie, née Joséphine-Eléonore-Marie-Pauline de Galard de Brassac de Béarn (1825–1860)*, 1853. 121.3 x 9.8 cm. Metropolitan Museum of Art/ Robert Lehman Collection, 1975. **34:** from Oliver Sacks, *An Anthropologist on Mars,* ©1995 by Oliver Sacks. Used by permission of Alfred A. Knopf, a division of Random House, Inc. **36:** Pablo Picasso, *The Tragedy (Poor People on the Seashore)*, 1903. 41 ½ x 27 ⅛". National Gallery of Art, Washington, DC/Chester Dale Collection; ©Artists Rights Society, New York. **38–39:** Claude Monet, *Impression Sunrise*, 1872. Musée Marmottan, Paris/Art Resource, New York. **48:** Dr. Terence H. Williams, University of Iowa; from *Visual Pathway from optic chiasma to occipital lobes, viewed from the basal aspect;* Virtual Hospital: The Human Brain (www.vh.org). **49:** from S. L. Polyak, *The Retina,* ©University of Chicago Press, 1941. **54:** from *Journal of Physiology*, p. 155, ©Cambridge University Press, 1965. **64:** from Martha Farah, *Visual Agnosia: Disorders of Object Recognition,* ©MIT Press, 1990. **67:** Richard Anuszkiewicz, *Plus Reversed*, 1960. 189.6 x 148 cm. Jack S. Blanton Museum of Art, University of Texas at Austin, Gift of Mari and James A. Michener, 1991; ©Richard Anuszkiewicz, Licensed by VAGA, New York. **69:** from *Vision Research*, vol. 14, p. 589, ©1974. Permission from Elsevier Science. **70:** modified from S. L. Polyak, *The Retina*, ©University of Chicago Press, 1941. **72–73:** Leonardo da Vinci, *Mona Lisa*, 1503. 77 x 53 cm. Louvre, Paris/Erich Lessing, Art Resource, New York. **75:** Claude Monet, *Rue Montorgueil, Festival June 30, 1878*, 1878. Musée d'Orsay, Paris/Art Resource, New York. **76:** Nicolas Poussin, *The Rape of the Sabine Women*, 1634. 154.6 x 209 cm. Metropolitan Museum of Art, Harris Brisbane Dick Fund, 1946. **77 top left:** from MacDonald Critchley, *The Parietal Lobes*, ©Edward Arnold & Co., 1953; **top right and bottom:** courtesy of Mark Tramo. **79 top:** courtesy Tretyakov Gallery; **bottom:** modified from A. L. Yarbus, *Eye Movements and Vision*, ©Plenum Publishers, 1967. **80:** Pierre-Auguste Renoir, *Madame Henriot*, 1876. 26 x 19 ⅝". National Gallery of Art, Washington, DC, Gift of Adele R. Levy Fund. **81:** Edgar Degas, *The Laundress*, 1869. Neue Pinakothek, Munchen /Joachim Blauel, Arthothek. **82:** Jean-Auguste-Dominique Ingres, *Dr. Jean-Louis Robin*, 1808. 28.4 x 22.3 cm. Art Institute of Chicago, Gift of Mrs. Emily Crane Chadbourne. **83:** Jean-Auguste-Dominique Ingres, *Mrs. Charles Badham*, 1816. 10 ⅞ x 8 ⁹⁄₁₆". National Gallery of Art, Washington, DC, The Armand Hammer Collection. **86:** Bevil Conway. **88:** adapted from Commission International de l'Eclairage (CIE), 1931, *CIE Proceedings*, Cambridge University Press. **93 top:** Bevil Conway. **94 top:** Bevil Conway. **98:** Claude Monet, *Grainstack, Snow Effect*, 1891. 65.4 x 92.4 cm. Museum of Fine Arts, Boston; Gift of Misses Aimeé and Rosamond Lamb in memory of Mr. and Mrs. Horatio A. Lamb. **99:** Pierre-Auguste Renoir, *Young Woman in the Sun*, 1875. 31 x 65 cm. Musée d'Orsay, Paris/Art Resource, New York. **100 right:** Bevil Conway. **101 left:** Leonardo da Vinci, *The Virgin of the Rocks* (detail), 1503–06. Louvre, Paris/Scala, Art Resource, New York. **101 right:** from Crockett Johnson, *Harold and the Purple Crayon*, ©1955. Permission of HarperCollins Publishers. **104:** James J. Gibson, *The Perception of the Visual World*, ©1950 by Houghton Mifflin Company. Used with permission. **105 top:** Albrecht Durer, *Draftsman Drawing A Vase*, 1525. 29.6 x 20.2 cm. Museum of Fine Arts, Boston; Horatio Greenough Curtis Fund. **105 bottom:** Albrecht Durer, *Draftsman Drawing A Reclining Nude*, 1527. 29.6 x 20.2 cm. ©The British Museum. **112–13:** *Madonna with Child and Pope Pasquale I*, Early Christian Mosaic, S. Maria in Dominica, Rome/Scala, Art Resource, New York. **114:** Cimabue, *Madonna and Child Enthroned* (detail), c. 1280–85. Uffizi, Florence/Scala, Art Resource, New York. **116–17:** Bernardo Daddi, *Madonna della Grazie* (detail), 1347. Orsanmichele, Florence/Scala, Art Resource, New York. **118–19:** Leonardo da Vinci, *Benois Madonna*, 1478. Hermitage, St. Petersburg/Erich Lessing, Art Resource, New York. **120–21:** Michelangelo, *Doni Holy Family*, c. 1503. Uffizi, Florence/Art Resource, New York. **122:** based on R. Shapley and J. Gordon, *Perception and Psychophysics*, vol. 37, p. 84, 1985. **123:** Georges Seurat, *The Black Knot*, 1881. Musée d'Orsay, Paris/Art Resource, New York. **124:** Rembrandt van Rijn, *Meditating Philosopher*, 1632. 28 x 34 cm. Louvre, Paris/ Erich Lessing, Art Resource, New York. **128:** Claude Monet, *Rouen Cathedral: The Portal in sun*, 1894. 99.7 x

65.7 cm. Metropolitan Museum of Art; Theodore M. Davis Collection, Bequest of Theodore Davis, 1915. **129:** Claude Monet, *Rouen Cathedral Façade*, 1894. 100.5 x 66.2 cm. Museum of Fine Arts, Boston; Julia Cheney Edwards Collection. **130–31:** Roy Lichtenstein, *Rouen Cathedral #2* (detail), 1969. 48" x 32 ½". Gemini G.E.L., Los Angeles; ©Estate of Roy Lichtenstein. **132:** Claude Monet, *Vetheuil dans la Brouillard*, 1879. 60 x 71 cm. Musée Marmottan, Paris/Bridgeman Art Library, New York. **133:** *Ice Floes*, 1892–93. 66 x 100.3 cm. The Metropolitan Museum of Art, H.O. Havemeyer Collection, Bequest of Mrs. H.O. Havemeyer, 1929. **134–35:** Henri Matisse, *La Femme au Chapeau*, 1905. 31 ½ x 23 ½". San Francisco Museum of Modern Art, Bequest of Elise S. Haas; ©Succession H. Matisse, Artists Rights Society, New York. **136–37:** André Derain, *Portrait of Henri Matisse* (detail), 1905. Tate Gallery, London/Art Resource, New York; ©Succession H. Matisse, Artists Rights Society, New York. **139:** James J. Gibson, *The Perception of the Visual World*, ©1950 by Houghton Mifflin Company. Used with permission. **141:** Claude Monet, *Chrysanthemums*, 1882. 100.3 x 81.9 cm. Metropolitan Museum of Art; H.O. Havemeyer Collection, Bequest, 1929. **143:** Vincent van Gogh, *La Guinguette dans Montmartre*, 1886. 49 x 64 cm. Musée d'Orsay, Paris/Erich Lessing, Art Resource, New York. **144:** Paul Cézanne, *Dominique Aubert, the Artist's Uncle*, c. 1866. 79.7 x 64.1 cm. Metropolitan Museum of Art, Wolfe Fund, 1951; Acquired from Museum of Modern Art, Lillie P. Bliss Collection. **148:** Claude Monet, *Springtime through the Branches*, 1878. Musée Marmottan, Paris/Giraudon, Art Resource, New York. **149:** Gustav Klimt, *The Park*, c. 1910. 110.4 x 110.4 cm. Museum of Modern Art, New York; Gertrude A. Mellon Fund. ©2001 MoMA. **150:** Pierre-Auguste Renoir, *Femme Cueillant des Fleurs*, 1872. 65.5 x 54.4 cm. Sterling and Francine Clark Art Institute, Williamstown, MA. **151:** Charles Angrand, *Couple dans la Rue*, 1887. 38.5 x 33 cm. Musée d'Orsay/Erich Lessing, Art Resource, New York. **152:** Claude Monet, *Poppy Field Outside of Argenteuil*, 1873. Musée d'Orsay, Paris/Art Resource, New York. **154–55:** Piet Mondrian, *Broadway Boogie Woogie*, 1942. 127 x 127 cm. Museum of Modern Art, New York. Given anonymously. ©2001 MoMA. **156:** Claude Monet, *Railway Bridge at Argenteuil*, 1874. Musée d'Orsay/Erich Lessing, Art Resource, New York. **160–61:** Claude Monet, *Les Glaçons* (detail), 1880. 38¼ x 58 ¼". Shelburne Museum, VT. **162:** Permission of the artist. **163:** Bridget Riley, *Fall*, 1963. Tate Gallery, London/Art Resource, New York. **164:** Raoul Dufy, *Still Life with Violin, Hommage to Bach*, 1952. Musée National d'Art Moderne, Centre Georges Pompidou, Paris/©Giraudon/Art Resource, New York; ©Artists Rights Society, New York. **166:** Abraham Walkowitz, *Isadora Duncan #29*, c. 1915. 14 x 8 ½". Brooklyn Museum; Gift of the Artist. **167:** Ben Shahn, *Triple Dip*, 1952. 34½ x 27 ¼. New Jersey State Museum, Gift of Mr. and Mrs. James Burke; ©Estate of Ben Shahn, Licensed by VAGA, New York. **168:** Paul Cézanne, *The Lime Kiln*, 1890–94. Musée d'Orsay, Paris/Art Resource, New York. **170:** Paul Cézanne, *The Card Player*, 1890–92. 20 ¼ x 14 ½". Museum of Art, Rhode Island School of Design, Providence; Gift of Mrs. Murray S. Danforth. **174 and 176 left:** Georges Seurat, *Le Cirque* (details), 1890. 18.5 x 152.5 cm. Musée d'Orsay, Paris/Erich Lessing, Art Resource, New York. **175 and 176 right:** The Everett Collection. **178–79:** Claude Monet, *Palazzo Ducale as seen from San Giorgio Maggiore*, 1908. 65 x 100 cm. Kunsthaus, Zürich. **180–81:** Paul Signac, *View of the Port of Marseilles*, 1905. 88.9 x 116.2 cm. Metropolitan Museum of Art, Gift of Robert Lehman, 1955; ©Artists Rights Society, New York. **182–83:** Paul Signac, *Place des Lices, St. Tropez*, 1893. 65.4 x 81.8 cm. Carnegie Museum of Art, Pittsburgh, acquired through the generosity of the Sarah Mellon Scaife family; ©Artists Rights Society, New York. **185 and 187 left:** Chuck Close, *Self-Portrait*, 2000. 149.5 x 120.5 cm. Museum of Modern Art, New York. Gift of the Artist. ©2001 MoMA. **186 and 187 right:** ©Robert Silvers 2001. PhotomosaicsTM is the trademark of Runaway Technology, Inc. www.photomosaic.com. **Endpapers:** M. Schrauf, B. Lingelbach, E. R. Wist, *The Scintillating Grid Illusion* from *Vision Research*, vol. 37, pp. 1033–38, ©1997. Permission of Elsevier Science.

Special thanks to Norman Hathaway for his painstaking and skillful illustration work on most of the diagrams and graphs.